# POETRY,
## *Beauty, &*
### CONTEMPLATION

# POETRY, *Beauty,* &

## CONTEMPLATION

## The Complete *Aesthetics* of JACQUES MARITAIN

JOHN G. TRAPANI JR.

*The Catholic University of America Press*
Washington, DC

LIBRARY OF CONGRESS CATALOGING-IN-PUBLICATION DATA

Trapani, John G.

Poetry, beauty, and contemplation : the complete aesthetics of Jacques Maritain /
John G. Trapani, Jr.

p. cm.

Includes bibliographical references (p.      ) and index.

ISBN 978-0-8132-1825-0 (pbk. : alk. paper)

1. Maritain, Jacques, 1882–1973—Aesthetics.   I. Title.

B2430.M34T50 2011

701'.17—dc22

2010035469

For
Jacques Maritain
. . . et Raïssa

*One philosopher, one contemplative*
*Two Poets in love with Beauty*
*Two Saints in love with God*

# Contents

# List of Figures

# Preface

In the fall of 1965, a young trumpet player walked excitedly into his philosophy of art course at Boston College. This was not his first philosophy class. However, since Boston College did not then offer a major in music, he saw his time there as little more than a son's obedient fulfillment of his father's demand that he obtain a liberal arts baccalaureate degree. Afterward, he would be free to do as he wished, and he thought at the time that his future would be in music. Moreover, since this paternal requirement was nonnegotiable, he reasoned that he might as well put his time to good use; he enjoyed philosophy because it stimulated many kinds of questions, and because, intuitively, he believed that it held the promise of providing true answers to those questions.

He was an accomplished musician, and his music experiences were many and varied, including an extended opportunity to study with jazz alto saxophone legend Phil Woods. Perhaps the greatest alto saxophone player since Charlie Parker, Woods was an inspiring educator; daily interactions with him over several summers provided firsthand exposure to an artist of true genius. This was artistic inspiration of the highest order, the kind that changes lives. For this young man, it was a portrait of an artist's life that even James Joyce would appreciate.

Overlapping these summer years, his time at Boston College supplied additional sources of musical and artistic inspiration. The aspiring musician would spend his sophomore, junior, and senior years performing with the Harvard-Radcliffe Symphony Orchestra, a group of superlative musicians performing great classical masterpieces. These experiences reinforced the enchanted notion of the poet's charmed life.

Boston College's campus, too, was teeming with intellectual and artistic activity. Composer-in-residence Alexander Peloquin, perhaps

the foremost Catholic liturgical composer of his day, was a professor of music history and conductor of the Boston College Chorale. A passionate, inspirational campus icon, Peloquin taught courses that were always filled to capacity. By joining the Boston College Chorale and taking every course that Peloquin offered, this young student made every effort to be absorbed into an exhilarating world of art and culture, and he befriended those who were similarly enamored. While others of their 1960s-era peers went to coffee houses, "mixers," and local pubs, these pubescent poets savored their evenings listening to Miles Davis and John Coltrane. When not otherwise engaged, these aspiring aesthetes immersed themselves in the best of Boston's art and culture.

This artistic and cultural context defined these young friends and it shaped the anticipation of that young trumpet player who was about to take philosophy professor Idella Gallagher's life-changing aesthetics course. Unbeknownst to this impressionable, truth-seeking sophomore, Idella and her philosopher husband, Donald, were close personal friends of the famous twentieth-century philosopher Jacques Maritain and his wife, Raïssa. Although the course itself, with its rather standard aesthetics textbook anthology, was not particularly noteworthy, its bibliography did require Maritain's brilliant book, *Creative Intuition in Art and Poetry*. Even though he could not have known it at the outset of the course, Maritain's book would alter the course of this young artist's life profoundly.

At the time, however, this philosophy student knew nothing about Maritain's life or philosophy: he knew nothing of Maritain's conversion to Catholicism, his philosophical insights, his lifelong friendships with leading philosophers and creative artists, or his abiding commitment to the thought and life model of St. Thomas Aquinas. Never having heard of Jacques Maritain, he could not have known of Maritain's own unique poetic gifts. And yet the youth's experiences and associations from these college years opened his mind and heart to the great insights that Maritain's book would soon reveal. His prior aesthetic experiences, many of true depth and inspiration, had already communicated wordlessly the realities now explained by Maritain's

text. Although he was a philosophical novice, Maritain spoke to him on a deeply personal level and, having been "bitten by Poetry," the seeds of his intellectual transformation were firmly planted.

That was forty-five years ago. Even though age and experience now cause him to smile at the self-absorption of his youthful idealism, the experiences themselves were nonetheless real and enduring. Fortunately, like God, the Muses too (we trust) have a sense of humor. And even though music performance still remains an active and important part of his life, his happy fate was to become a philosopher, one who would find in Maritain, and the Thomist realist tradition he embraced, a way of life that satisfied those deep intellectual longings of his student days. As it turned out, he was discovering Maritain at the very time that Maritain himself, in the waning years of his life, was becoming a religious hermit. Though he never met Maritain personally, he adopted Jacques as his preeminent philosophical and spiritual mentor.

For this reason, this book, a study in Maritain's philosophy of art, is a labor of love that grew out of these forty-five years of accumulated aesthetic experiences, nurtured by serious philosophical study and reflection. It is animated by a deep love for Jacques, and by a firm and sustained belief that, at its core, Maritain's philosophy of art captures and reveals the ultimate spiritual dimension, the true "Poetry," that is at work in any and all occasions of great art.

This book is also an expression of deep and lasting gratitude to those many named and unnamed poets, artists, musicians, philosophers, teachers, contemplatives, and friends, men and women of true goodness and poetic authenticity who have contributed to an aesthetically rich life, filled with love, friendship, beauty, and the enjoyment of those spiritual treasures hidden and revealed by what Maritain calls "Poetry."

⤙

Beyond those already named in this preface—the Gallaghers, Phil Woods, and Alexander Peloquin—there are many others whose positive influence has contributed to whatever value this book might contain. I would like to extend my thanks to John Rowan, Joe Califano,

Ralph McInerny, and Tony Simon, teachers and friends, for their kindness, encouragement, and direction in the early and ongoing years of my study of Maritain's philosophy. Curtis Hancock and Jim Hanink, fellow Maritain admirers, carefully reviewed my manuscript and made helpful suggestions for its improvement. Jim Hanink went well beyond what is required of a reviewer, and his stylistic suggestions were especially helpful and are deeply appreciated. I thank Richard Jusseaume, president of Walsh University, for his consistent, enthusiastic support of Catholic education, my work at Walsh University, and the American Maritain Association, especially during my years as its president.

And finally, my thanks to Sherry Trapani, my wife, patient partner, and dearest friend, for putting up with a philosopher's abstractions and a writer's preoccupations. Fortunately, love, like beauty, truth, and goodness, transcends all else.

# POETRY,
## *Beauty, &*
### CONTEMPLATION

# INTRODUCTION

*At the heart of any great philosophical system there is . . .*
*a very simple yet inexhaustible vision or insight.*

—Jacques Maritain

Jacques Maritain (1882–1973) is arguably the most significant disciple of St. Thomas Aquinas in the twentieth century. Although he made many important contributions to several different areas of philosophy, his philosophy of art is especially noteworthy. Unfortunately, this aspect of the French Catholic philosopher's thought is often overlooked or underappreciated by those who miss the richness and depth of insight that his philosophy of art possesses because they do not have a sufficient background in the philosophy of St. Thomas. Lacking a familiarity with Aquinas's conceptual framework, they are susceptible to misunderstanding the context of Maritain's thought, especially since the comprehension of his specialized uses of several key terms requires a basic foundation in Thomist philosophy. And finally, there also are those who may dismiss or disregard Maritain's aesthetics because they may have an a priori prejudice against thinkers who philosophize in the tradition of St. Thomas.

Regardless of the reasons for this oversight and underappreciation, this book intends to address these deficiencies. Indeed, the essential claim of this book is that Maritain's philosophy of art is much more significant and original than many philosophers, aestheticians, and those generally interested in art might realize. By discussing Maritain's youth (which contributed to his unique suitability as an insightful philosopher of art), his philosophical background and early influences, the metaphysical and epistemological context of his thought, his own creative insights, and a reconstruction of an undeveloped aspect

of his aesthetics, this study provides ample evidence of the originality and significance of Maritain's aesthetics.

Before we investigate Maritain's philosophy specifically, we first begin by discussing some broad and general philosophical principles. It was Aristotle after all who pointed out that fruitful philosophical dialogue needs mutually agreed-upon first principles as undisputed starting points. Accordingly, the subject of this book—a complete exposition of Maritain's philosophy of art—commences with a reflection on the metaphysical principles that concern nothing less than the whole universe. This is no doubt an ambitious undertaking. Fortunately, a book whose title suggests a similar ambition serves as a useful point of departure.

In the title of his masterful *A Short History of Nearly Everything,* science writer Bill Bryson proposes a very presumptuous project indeed.[1] And remarkably, within the book's limitations, he nearly succeeds. Written in a popular, readable style, Bryson recounts the various stories and anecdotes that make up the history of the various fields of experimental science: physics, geology, chemistry, paleoanthropology, astronomy, and biology. Despite the hyperbole of his title, however, of course he does *not* really discuss "nearly everything." Nonetheless, given his fundamentally materialist view of the universe, Bryson would feel that his title is sufficiently justified since, for him, the various sciences are at the foundation of nearly everything else that his history does *not* cover, subjects like philosophy, theology, the arts, religion, economics, and the various social sciences.

Bryson could easily defend his book's title by pointing out that, regardless of whatever field one may wish to explore and explain, no inquiry can hope to be successful unless its basic principles are compatible with the truths of these physical sciences. Bryson's point is compelling. One pertinent example should suffice. If it is true that a fruitful discussion in aesthetics or epistemology requires a sound underlying theory about human nature, Bryson rightly would argue that this theory of

---

1. Bill Bryson, *A Short History of Nearly Everything* (New York: Broadway Books, 2003).

human nature must itself be consistent with the truths of the relevant sciences of biology, anatomy, physiology, biochemistry, and so forth.

And yet, we submit that herein lies the flaw of Bryson's assumption. To maintain, correctly, that the truths of the physical sciences are essential for a full understanding of human nature does not automatically lead to the conclusion that they *alone* explain human nature and the uniqueness of human behavior. In other words, the claim that the human genetic, material makeup may be "necessary *and* sufficient" for the explanation of human uniqueness (what in this case would constitute a materialist reductionism) is different from the claim that this anatomy and physiology may be "necessary *but not* sufficient" for its explanation. Thus, to say that sound science provides necessary explanations of the physical dimensions of human nature does not mean that these explanations are, by themselves alone, also sufficient. This distinction is important because in Maritain's philosophy of human nature, the human person is not simply a biological or physiological creature. While the physical, material, genetic dimensions of the human person are surely necessary, alone they are not sufficient to explain the many different kinds of uniqueness that characterize human behavior. For Maritain, the explanation of distinctively human activities, like artistic creation and receptive aesthetic experiences, requires a spiritual-intellectual dimension of human nature as well. This claim alone would distinguish Maritain's philosophy of art from so many contemporary theories that rely on an entirely materialist explanation of human nature alone. It also enables Maritain to explain aspects of aesthetic experience that these others cannot.

By reflecting on this example, we should see the importance of philosophical principles, logical distinctions, and the simple wisdom of a down-to-earth commonsense realism that goes beyond the limitations of an empirical methodology and a scientific reductionism. Specifically, we should be able to see the value, as starting points, of the following basic metaphysical distinctions. First, within the universe, we can observe that there are physical things (or beings) and there are nonphysical things (or beings). Physical things may be divided into two basic categories, inanimate beings and animate beings. Nonphysi-

cal beings also may be of two kinds: there are those nonphysical things that are functions of matter (e.g., energy, force, memory, or imagination) and, assuming that the evidence can be shown to justify such a conclusion (a separate though logically possible endeavor in itself), there are also those nonphysical things that are spiritual beings in their own right (examples of which might include the human intellectual soul, angels, and God).

Nonliving (inanimate) beings are divided into the categories of elements and compounds. Living (animate) beings also can be divided into categories (though not always neatly) according to whether their properties or activities are vegetative only; vegetative and sentient; or vegetative, sentient, and intellectual. (These divisions leave out of consideration things like viruses, which may be difficult to classify . . . but that is another matter altogether.)

Depending upon the degree of physiological complexity of these many and varied kinds of beings, so they will act. "A being acts in accordance with its nature" says the Principle of Operation, and it validly applies to all beings. When we consider conscious beings, specifically, we find that they will have, proportionately, many different kinds of activities—experiences, knowledge, and desires—that follow from their unique natures, properties that nonconscious beings will not possess at all. This becomes especially profound when we consider human beings in particular, that is, those beings who are naturally self-conscious, intellectual, and creative. And so, while this book at one time or another may consider the various beings of the universe, its predominant focus will be on human nature in general, and on the various aspects of aesthetic experience in particular.

Generally, the term "aesthetic experience" encompasses two quite complex though distinct areas for philosophical investigation. The first concerns the creative activity of the artist, while the second concerns the experiences of those who encounter and enjoy works of art. Historically, Maritain's philosophy does not discuss both of these aspects equally. And yet, it is to his great credit that his metaphysical principles, the basics of his philosophy of human nature, his realist epistemology, and his writings on creativity, beauty, and contempla-

tion, when integrated, enable us to innovatively construct a complete aesthetics that displays Maritain's true significance and originality. While it is certainly true that Maritain is a disciple of St. Thomas,[2] his philosophy of art, though rooted in and logically consistent with the thought of his mentor, is nonetheless significantly more than that. It reflects insights absorbed from his immersion in the culture of early twentieth-century Paris, a culture that itself reflected seven centuries of intellectual and artistic development from the time when Aquinas taught at the University of Paris in the thirteenth century.

By tracing the influences on Maritain's personal, cultural, philosophical, and spiritual life, this book will show that, collectively, these factors disposed him in a unique way to make an original contribution to aesthetics. From his profound friendships with many first-rate philosophers and artists, to his conversion to Catholicism, his embrace of the ideas and saintly life of St. Thomas Aquinas, and his devotion to a life of prayer and spiritual discipline, Maritain is uniquely disposed to philosophically penetrate modern problems of the philosophy of art. Specifically, from his close personal friendships with the French Catholic novelist Léon Bloy and the great French painter Georges Rouault, to the profound influence of the French philosopher Henri Bergson, Maritain was on the cutting edge of early twentieth-century European intellectual life and his thinking develops an original Thomist aesthetics that goes creatively beyond a mere exposition of the thought of Aquinas alone.

Although there are many terms that Maritain and Aquinas both use—for example "art," "beauty," "intuition," and "connaturality"—for Maritain, the meanings of these terms will have subtle shades of difference since he was conversant with the changes in the types and styles of artistic expression from Aquinas's time to his own. Moreover, as a reflection of their historical and cultural differences, it was only natural that Maritain would develop his own terminology and assign

---

2. "I am . . . a disciple, the most unworthy and the latest come, of Saint Thomas Aquinas"; Jacques Maritain, *Art and Faith: Letters between Jacques Maritain and Jean Cocteau,* trans. John Coleman (New York: Philosophical Library, 1948), 113. (Original French edition, 1926.)

intonations of meaning to common aesthetic terms in order to better express his original insights. What often compounds the difficulty of sorting out their differences is that, conversant with philosophical history as he was, Maritain used terminology from the intervening centuries to express contemporary insights. While inherently consistent with Thomas's ideas, these original insights are nonetheless as yet unarticulated extensions of them, especially within the Thomist tradition. A failure to understand these terms according to *his* usage and meaning results in a failure to appreciate the richness of his aesthetics.

Moreover, although his earliest philosophical influence was Henri Bergson, like all original thinkers Maritain's own prodigious intelligence drew upon truths and insights from whomever and wherever he found them. And thus, by tracing the history of Maritain's philosophical development, we will observe how some of his ideas grew and were modified, while others received his early attention and were then left without further development. Collectively, this study will explore and confirm both the significance and the originality of Maritain's philosophy of art, even as it reconstructs and completes aspects of it. Two articles, one older, the other more recent, bear out the necessity for, and legitimacy of, this intention.

In his essay "Maritain, Eco, and the History of Philosophical Aesthetics," Daniel Gallagher begins by observing that

Jacques Maritain's philosophy of beauty and the arts has had a significant impact on numerous aestheticians and artists. However, insufficient scholarly attention has been devoted to understanding Maritain's place in the broader context of the history of philosophical aesthetics.[3]

After noting that Umberto Eco intends to elucidate the original meaning found in medieval theories about beauty, Gallagher acknowledges that Maritain's project is different, namely, to expound upon the original medieval and Thomistic notions by allowing them "to incorporate contemporary philosophical and artistic currents," and to apply these "to new areas in which the power of creative intuition

---

3. Daniel Gallagher, "Maritain, Eco, and the History of Philosophical Aesthetics," *Maritain Studies* 22 (2006): 21.

manifests itself in the modern world."[4] However, as Gallagher points out, the problem for Maritain is that the field of aesthetics as we know it today really only comes into being following Kant's Third Critique, the *Critique of Judgment.* Accordingly, Gallagher notes, Maritain (and Eco) inevitably will be "scrutinized through a Kantian lens."[5] Browse through the table of contents of any history of aesthetics book, Gallagher observes, and we cannot help but notice that it "is predominately written in post-Kantian terms."[6] Since Eco's eventual turn to semiotics is more consonant with the Kantian and postmodern terminology of the history of philosophical aesthetics, Gallagher concludes that Eco's place in the history of philosophical aesthetics, "at least for now, seems more secure than that of . . . Jacques Maritain."[7]

Three important issues emerge from Gallagher's comparison between Eco and Maritain. The first concerns the historical, Kantian starting point of philosophical aesthetics itself and the way that it is, right from the outset, predisposed away from any aesthetic theory in the realist philosophical tradition, the tradition of Jacques Maritain. The second issue concerns the internal consistency of Maritain's thought with that of Thomas Aquinas. Do Maritain's writings in aesthetics exhibit nothing more than an exegesis of St. Thomas's thought (critically, Eco claims they do not), or is there a deliberate growth and development of Maritain's ideas that, traced historically, reveal both his consistency with St. Thomas and his own unique contribution (as this study intends to show)? And finally, without a guide to the unique meaning of Maritain's terminology and the way that it intentionally does go beyond Aquinas, the third issue concerns the danger of misunderstanding Maritain's thought. If Maritain is to gain his rightful place in the history of aesthetics, especially when aesthetics (in Kantian terms) is not readily disposed to a realist theory of art, then a comprehensive study focused on the innovative aspects of Maritain's thought becomes all the more important. This book answers that call by replying to Gallagher's three concerns.

A second, though earlier, study on Maritain's aesthetics comes from Ralph McInerny, the former director of the Maritain Center at

4. Ibid., 22.
6. Ibid., 36.

5. Ibid., 24.
7. Ibid., 37.

the University of Notre Dame. McInerny, too, discusses the issue of Maritain's originality versus his fidelity to Aquinas, and he acknowledges that there are two approaches that one might take in examining Maritain's thought. Using the Thomist notion of "connaturality" as his example, McInerny first proposes an approach that makes a synthesis of selected passages of Maritain's writings while "assuming without proving the essential unity and consistency of Maritain's thought on this matter."[8] Using such an *ahistorical* method leads to the rather obvious though perhaps oversimplified conclusion that Maritain does indeed deviate from St. Thomas.

On the other hand, McInerny also is aware of an alternative method that recognizes the possibility of legitimately extending this notion of connaturality beyond Aquinas, and he acknowledges that, this time, a *historical* approach might in fact be a more "basic way" of examining Maritain's thought:

A basic way of pursuing [Maritain's extension of connaturality] would be to trace the chronological development of Maritain's thoughts on the matter, singling out the persistent strands, drawing attention to aspects which emerge only gradually and late.[9]

Accordingly, this book will use the historical method to examine the growth and development of Maritain's ideas in order to gain access to the essential insights, context, cohesiveness, and originality of Maritain's aesthetics. These benefits are not as easily discernable if one follows the ahistorical method.

Thus, Chapter 1 explores the significant features of Maritain's personal development. Always seeing himself as a philosophical "spring-finder," Maritain not only applied insights of St. Thomas in a fresh and creative way, he also pointed out pathways for future investigation, avenues of thought that he himself sometimes did not develop. Thus in order to understand Maritain's original contribution to aesthetics, Chapter 1 reflects on Maritain's own personal character and tempera-

8. Ralph McInerny, "Maritain and Poetic Knowledge," *Renascence* 34, no. 14 (1982): 204.
9. Ibid.

ment, and on the major influences and inspirations of his early life, as well as the intellectual, cultural, and artistic climate of Paris during his formative years at the beginning of the twentieth century.

Chapter 2 focuses on the specifically philosophical influences and the early foundations of Maritain's ideas by contrasting Bergson's notion of intuition and St. Thomas's notion of intellect. The effects of this contrast establish a philosophical foundation that determines and characterizes the uniqueness of Maritain's Thomist epistemology.

Chapter 3 investigates Maritain's own extended uses of the terms "intuition" and "connaturality" that go beyond Aquinas. These terms are essential for an understanding and appreciation of the unique and innovative meaning that Maritain gives to the central terms of his aesthetics, "Poetry" and "Poetic Knowledge." Please note well: throughout this study, I will capitalize the terms "Poetry" and "Poetic Knowledge" in order to emphasize their special and unique meaning in Maritain's philosophy. While my practice of doing this departs from Maritain's own *inconsistent* use of designating these terms, my intention is to highlight their unique meaning proper to Maritain's philosophy alone.

Chapter 4 explores the basic metaphysical context of Maritain's aesthetics in general, and his philosophy of human nature and epistemology specifically, since both the creative and the appreciative aspects of aesthetic experience involve certain presumptions about the nature of reality and the nature of the human person.

In Chapter 5, the historical method of investigating Maritain's philosophy is temporarily suspended. Since the crystallizing terms in Maritain's aesthetics are Poetry and Poetic Knowledge, this chapter systematically explores these specialized terms according to Maritain's mature thought in order that this analysis might provide a standard against which we will evaluate his developing ideas in subsequent chapters. The chapter concludes by raising some questions that are problematic for the relationship between Poetry and Poetic Knowledge, questions that the next two chapters will answer.

By resuming the historical method in the theoretical analysis of Poetry and Poetic Knowledge, the examination of Maritain's texts reveals that his use of the term Poetry is chronologically prior to his

notion of Poetic Knowledge and, in the latter, he develops aspects that were ambiguously and inchoately found in early discussions of the former. His early work also identifies another legitimately cognitive function of Poetry (beyond the function of the creative knowledge of the artist) that is ordered solely to the joy and delight provided by the appreciation of a work of art. Chapters 6 and 7 explore these issues thoroughly.

Chapter 8 examines Maritain's discussions on the perception of beauty to see the way that they offer the clue to resolving those ambiguities found in the two previous chapters. By again investigating Maritain's writings chronologically, we will observe that he originally identified two distinct pathways, only one of which—the pathway of that special mode of creative knowledge, Poetic Knowledge—he comes to develop fully. The remaining pathway, the pathway of a special mode of cognition that terminates in the joy and delight found in the perception or contemplation of beauty, he leaves undeveloped. This aspect of Maritain's epistemology we will call Poetic Contemplation.

Chapter 9 explores Maritain's ideas about contemplation systematically. The chapter begins by distinguishing natural and supernatural contemplation, and it concludes by discussing the relation between contemplation and the perception of beauty.

The final chapter, chapter 10, discusses the interrelation and integration of Poetry, beauty, and contemplation, leading to a justification of the reconstructed notion of Poetic Contemplation. This reconstruction constitutes not only a legitimate extension of Maritain's aesthetics but a completion of it as well. Taken all together, the chapter concludes that the complete aesthetics of Jacques Maritain makes an original and significant contribution to the philosophy of art, one that deserves more scholarly attention than it has heretofore received.

ONE

# HISTORICAL BACKGROUND
## Maritain's Personal Development

~~~

*Jacques has often told me that his task was to make clear the paths. . . .*

—Raïssa Maritain

Though deeply rooted in the Thomist tradition, Jacques Maritain was also an original thinker; he applied in a fresh and innovative way many of the basic insights found in the thought of his great mentor St. Thomas Aquinas. The philosophy of St. Thomas "is a living philosophy," he maintained, "to read Thomas well, the help of genius is needed."[1] Maritain understood philosophy as "a progress by deepening insight,"[2] and he applied his genius to the investigation of reality, whose "deep things" the philosopher aspires to understand. Thus Maritain's insights into the "inexhaustible intelligibility" of reality occasionally go beyond St. Thomas; some of these insights he developed and some he left unexplored.[3]

Maritain's notion of Poetry provides an excellent example of this originality. By applying and extending the metaphysical wisdom of

1. "Preface" by Jacques Maritain to *The Material Logic of John of Thomas* (Chicago: University of Chicago Press, 1955), vi.

2. "Maritain sees philosophy as calling for a *progress by deepening insight*. . . . The philosopher has his gaze fixed on the *existent* . . . and this existent, whose 'deep things' he endeavors to know, is an 'intelligible mystery'—it is intelligible, but it is inexhaustible in its intelligibility"; Joseph W. Evans, "Jacques Maritain," *The New Scholasticism* 46, no. 1 (1972): 5–6.

3. "*Ouvrir les portes*—to open doors and paths—this has long been the task that Maritain has seen himself called to perform. It is 'new avenues of thought' that he gives us—though it seems that in many cases he himself advances very far along these paths"; ibid., 6.

Aquinas to the notions of art, beauty, intuition, and creative intelligence, Maritain developed an analysis of artistic, creative knowledge worthy of the best in twentieth-century art theory. Yet, we may ask, why is it that this man was so uniquely suited to the peculiar insights concerning the nature of Poetry, insights that are at the heart of, and give life to, all his reflections on artistic creativity and aesthetic enjoyment? Yves Simon, Maritain's friend and former student, offers a provocative answer to this question when he suggests that Maritain's personal life complements the understanding of his ideas and rewards his students with a greater appreciation of his genius.[4]

Specifically, there are two biographical factors that serve as major formative influences on the young Maritain. First, there is Maritain's own innate character and temperament: a powerful intellectual acumen combined with poetic sensitivity and a profound love of beauty and truth, situated in the intellectual, social, political, and cultural climate of fin-de-siècle France. Secondly, the personal influences on Maritain's life combine an extraordinary confluence of great teachers, creative artists, and a host of intimate, spiritual friendships.

### THE MAJOR FORMATIVE INFLUENCES: CHARACTER AND CULTURE

Jacques Maritain was nineteen years old when he met Raïssa Oumançoff as a fellow student at the Sorbonne in 1901. In her memoirs, *We Have Been Friends Together,* Raïssa tells of her first impressions of him. She describes him as tormented by the same profound questions as she, the same desire for truth. For Raïssa, he was a person of maturity, knowledge, experience, and genius; a young man of unaffected goodness and generosity. Not only did he have the greatest respect for his own conscience, he was also one who was "always ready to take

4. Yves R. Simon, "Jacques Maritain," from John Howard Griffin and Yves R. Simon, eds., *Jacques Maritain: Homage in Words and Pictures* (Albany, N.Y.: Magi Books, 1971), 3. (Simon's essay, originally written in 1961, previously appeared in the collection of essays edited by Joseph W. Evans, *Jacques Maritain: The Man and His Achievement* (New York: Sheed & Ward, 1963), 3–24.)

the initiative in a generous action if justice or truth were involved."[5]

In these beautiful pages which describe their early communion of spirit, a union which led to their marriage in 1904, Raïssa makes the following significant remark: "His artistic cultivation had already reached a very high level, greatly aided by his innate sense of poetry and plastic beauty." As if the poetic muse hidden deep within his soul, so constantly revealing themselves in his later philosophical writings, were not a sufficient sign of his artistic temperament, this passage of Raïssa's conveys her lasting impression (her memoirs were not written until 1940) of Maritain's character and "innate sense." She tells us that it was Jacques "who opened up to me the boundless world of painting."[6]

In their 1962 book, *The Achievements of Jacques and Raïssa Maritain: A Bibliography 1906–1961,* Donald and Idella Gallagher give additional biographical evidence of the artistic temperament of Maritain's youth. "The first composition of which we have any record dates back to September 1899 when Jacques, not yet seventeen years of age, was vacationing in Brittany with his close friend Ernest Psichari. . . . They wrote six sonnets in collaboration, signed 'M-P Synnoètes.' These poems reveal, according to Wallace Fowlie [author of a book on Psichari], the influence of Baudelaire, Verlaine, and Mallarmé."[7]

Jean-Luc Barré, author of the relatively recent detailed biography of the Maritains, also mentions the lasting aesthetic influence of this early friendship between Jacques and Ernest: "Ernest and he made passionate efforts to get to know and test each other," he writes. "Together they wrote poems . . . signed with their joined initials. With their easels set up face-to-face in a wheat field, they passed entire days making portraits of one another. They communed in the dazzling discovery of Baudelaire."[8]

This innate poetic sense itself had been nurtured by not only the

5. Raïssa Maritain, *We Have Been Friends Together and Adventures in Grace: The Memoirs of Raïssa Maritain* (Garden City, N.Y.: Image Books, 1961), 42–43.

6. Ibid., 43.

7. Donald and Idella Gallagher, *The Achievements of Jacques and Raïssa Maritain: A Bibliography, 1906–1961* (Garden City, N.Y.: Doubleday & Co., 1962), 8.

8. Jean-Luc Barré, *Jacques and Raïssa Maritain: Beggars for Heaven,* trans. Bernard E. Doering (South Bend, Ind.: University of Notre Dame Press, 2005), 39.

friendships of Maritain's youth, but also by his family and the political atmosphere of fin-de-siècle Europe. Jacques's mother, Geneviève Favre-Maritain, a woman whom he resembled and to whom he was very close, was the daughter of Jules Favre, a statesman who took a leading part in the establishment of the Third Republic. (Maritain's father, Paul Maritain, was a lawyer from Burgundy and had been the secretary to Jules Favre.) His family life, together with the family of Psichari (whose grandfather was the famous French historian of ideas, Ernest Renan), also exercised a strong influence. Raïssa tells us that "in the nineteenth century, the Renans and the Favres were among the most representative of the great intellectual and politically-minded families of liberal and republican France." These family backgrounds were characterized by "the free play and glory of thought," and by "an idealistic love of the people, the republican spirit, and the political struggle for liberty." [9] It was an elegant and liberal world of letters, culture, and noble ideals, an atmosphere shared and mutually reinforced by his friendship with Psichari, whom he had met at the Lycée Henri IV in 1898. From this home and cultural environment would come two sources of lasting influence on Maritain's philosophy: the aesthetic and the social/political. In fact, one could make the case that these two subject areas top the list of Maritain's most original and significant contributions to philosophy.

Outwardly, turn-of-the-century Europe was in many respects the mirror of respectability, culture, and tradition. Inwardly, however, the termites of decadence were silently gnawing at its center, as the Great War of 1914 approached. [10] This cultural milieu exerted its influence upon Maritain's development in two especially pertinent ways. First, the Sorbonne, that fortunate meeting place for Jacques and Raïssa, had a characteristic intellectual climate that dominated the age: in science: positivism, materialism, determinism, and empiricism; in philosophy: "integral relativism, intellectual skepticism, and . . . moral nihilism." [11]

---

9. Raïssa Maritain, *We Have Been Friends*, 146–47.

10. "*Fin-de-siècle* Europe was a hot house, racked by pessimism, the age of Nietzsche"; Julie Kernan, *Our Friend, Jacques Maritain* (Garden City, N.Y.: Doubleday & Co., 1975), 26.

11. Raïssa Maritain, *We Have Been Friends*, 61.

All these theories constituted a more or less acknowledged system which Jacques, several years later, in one of his first books [*Antimoderne, 1922*] was to designate by the name of *Scientism*. . . . "Scientism imposes on the intelligence the very law of materialism: those things alone are intelligible which are materially verifiable. . . . The thesis that everything can be reduced to extension and movement . . . was not for our scientists even something that required demonstration; it was of the essence of thought itself."[12]

That happy union of Jacques and Raïssa was thus tarnished by that unhappy clash between their inner, spiritually oriented dispositions and desires, and the intellectual and academic climate of the scientism that pervaded the Sorbonne. The sensitive Maritains could not live complacently in an atmosphere of skepticism and nihilism.

This general cultural climate of the Paris of their university days was reflected in the changes that were taking place in the arts as well. The young and gifted were everywhere in revolt against the inner decadence that was masked by a veneer of civility and high culture. The superficiality and hypocrisy now manifest to thoughtful and perceptive eyes were the fruits of erroneous ideological seeds sown earlier. Not only in the intellectual and sociopolitical order, but also in the artistic order of traditional, classical, or academic style, there arose a revolution inspired by frustration. The innovations of the paintings of Paul Cézanne provide an early, prime artistic example of this revolt.

Nearly a half century later, having then acquired a certain advantage from historical perspective and personal interchange with many great artists, Maritain traced what he called the "extraordinary diversified evolution" whereby our "Western art passed from a sense of the human Self first grasped as object . . . to a sense of the human Self finally grasped as subject."[13] This evolving process of self-consciousness on the part of the artist's own creative activity suggests that what may have initially appeared as an artistic and stylistic revolution was in reality the artist's painful struggle to express his or her inner subjectivity.

12. Ibid., 56–57.

13. Jacques Maritain, *Creative Intuition in Art and Poetry* (New York: Pantheon Books, 1953), 21.

While this insight does not appear in his first book on art, *Art and Scholasticism,* from 1920, Maritain nonetheless experienced at firsthand the artistic excitement of an age that was exploring these new frontiers.[14] The Maritains were maturing in the very midst of this romantically beautiful city of Paris, teeming with new life and new ideas, even as the ominous clouds of decaying tradition and the imminent collapse of Western Europe would soon culminate in the First World War.

The initial effect of these intellectual and artistic influences upon the enthusiasm of Jacques and Raïssa, yearning as they were for some anchor of truth, was to produce a depression in them that inclined to despair. As they pondered the apparent meaninglessness of life suggested by the materialism of the Sorbonne and the turbulence of the social, political, and cultural worlds around them, a heaviness descended upon them and engulfed their honest but defenseless hearts. Their "metaphysical anguish" led them to that fateful summer afternoon in 1901 in the Jardin des Plantes. They had reached bottom; they were enveloped in the darkest night. Raïssa writes:

One summer afternoon Jacques and I were strolling about in the *Jardin des Plantes.* . . . We had been reviewing the results of our two or three years of study at the Sorbonne. No doubt a rather considerable amount of specialized scientific and philosophical knowledge. But this knowledge was undermined by the relativism of the scientists, by the skepticism of the philosophers. . . .

Nor were we, with our scarce twenty years behind us, among those champions of skepticism who emit their *"que sais-je?"* like a puff of cigarette smoke, and find life good in the bargain. Along with the rest of our generation, we were their victims . . . fainting with hunger and thirst after truth.

This metaphysical anguish, going down to the very roots of the desire for life, is capable of becoming a total despair and of ending in suicide. . . .

It was in an anguish of this kind that [we] then lived. . . .

On this particular day, then, we had just said to one another that if our nature was so unhappy as to possess only a pseudo-intelligence capable of

14. For a detailed account of the literary/artistic environment of the Maritains' home during the 1920s and 1930s, see Jean-Luc Barré, *Beggars for Heaven,* chaps. 6–8.

everything but truth, if, sitting in judgment on itself, it had to debase itself to such a point, then we could neither think nor act with any dignity. In that case everything became absurd—and impossible to accept. . . .

Before leaving the *Jardin des Plantes* we reached a solemn decision which brought us some peace: to look sternly in the face, even to the ultimate consequence—insofar as it would be in our power—the facts of that unhappy and cruel universe. . . .

Thus we decided for some time longer to have confidence in the unknown; we would extend credit to existence, look upon it as an experiment to be made, in the hope that to our ardent plea, the meaning of life would reveal itself, that new values would stand forth so clearly that they would enlist our total allegiance, and deliver us from the nightmare of a sinister and useless world.

But if the experiment should not be successful, the solution would be suicide; suicide before the years had accumulated their dust, before our youthful strength was spent. We wanted to die by a free act if it were impossible to live according to the truth.

It was then that God's pity caused us to find Henri Bergson.[15]

From this bottom of despair and desolation, the very turning point of their lives, Jacques and Raïssa ascended with an even-paced movement toward "The Absolute"—that felt, but as yet unnamed object of their inmost desire. In the academic sphere, signs of movement away from the entrenched materialism of the Sorbonne were taking place down the road at the Collège de France where Henri Bergson's lectures were attracting large numbers. The Maritains first attended these lec-

---

15. Raïssa Maritain, *We Have Been Friends*, 64–69. The full significance of that event for the Maritains is underscored by Julie Kernan, *Our Friend, Jacques Maritain*, 185–86, when she recalls the moving account of the occasion of the last photograph taken of the aging Jacques: "Remarkable as it may seem Jacques made one more trip to Paris . . . in January of 1973, some three months before he died. In Paris he went to the office of *Desclée de Brouwer* to make some arrangements about his books. As he left, he found awaiting him a photographer who wished to take his picture. Although it was suggested that this be done at the *Desclée* office, I am told that Jacques smiled and said that he had another background in mind; could he be taken there? He wanted to go to the *Jardin des Plantes* to the exact spot where he and Raïssa had met during their student days when they were trying to decide whether or not life was worth living. It was in this setting that the last photograph of Jacques was taken."

tures in 1902 at the encouragement of their friend Charles Péguy. The sacred privilege of liberating the Maritains' sense of the Absolute belongs to Bergson; he "dispelled their disillusionment, opening up spiritual perspectives for them, and the possibility of attaining truth."[16] The door opened for them and eagerly they entered.

## THE MAJOR FORMATIVE INFLUENCES: ARTISTS AND SAINTS

On November 26, 1904, Jacques and Raïssa were married after an engagement of two years. In the following year, the Maritains were led to that person, who, after the initial influence of Bergson, would be their second guiding light: Léon Bloy, the "Pilgrim of the Absolute." Their first contact came through reading one of Bloy's novels, *La Femme Pauvre*: "We got and at once read this strange novel which is unlike any other. And for the first time we found ourselves before the reality of Christianity."[17] They followed *La Femme Pauvre* with one of Bloy's journals, and learned from it not only of the magnificence and immensity of his soul, but also of his real poverty and suffering. "It is because we read the poignant pages of this journal that we dared to write to Léon Bloy and send him a small sum of money."[18] Bloy responded, inviting them to his home, an invitation which the Maritains accepted a few days later. Thus began a friendship that would culminate in the eventual conversion and baptism of Jacques and Raïssa to the Catholic faith. Together with Raïssa's sister, Vera, this trio received the "infinite answer of God" (their baptism) at the Church of St. Jean l'Evangéliste on Montmartre, June 11, 1906, with Bloy as their godfather.[19]

Years later, in 1927, Maritain published a small book, *Quelques*

16. Donald and Idella Gallagher, *The Achievements of Jacques of Jacques and Raïssa Maritain*, 37. The nature of Bergson's influence on Maritain's philosophical ideas will be discussed at length in chapter 2.

17. Raïssa Maritain, *We Have Been Friends*, 88.

18. Ibid., 92.

19. Ibid., 140.

*Pages sur Léon Bloy,* which was later adapted to form the introduction to the English translation of Bloy's *Pilgrim of the Absolute.* In it, Jacques recalls the significance of their first meeting with this man with whom he and Raïssa would remain close friends until his death in 1917:

In June 1905, two children of twenty were going up the everlasting stairway that leads to the *Sacre-Coeur.* They bore within them that distress which is the only serious product of modern culture, together with a kind of active despair illumined only—they did not know why—by the inner assurance that the Truth for which they hungered, without which it was almost impossible for them to accept life, would one day be shown them. . . . They had cleansed their minds, thanks to Bergson, of the scientistic superstitions with which the Sorbonne had nourished them. . . . They were going toward a strange beggar who, disdaining all philosophy, was shouting on rooftops the divine truth; and who, a totally obedient Catholic, condemned his times and those who have their consolation here below. . . . They had a terrible fear of what they were going to meet. . . .

They went through a little garden of olden times, then entered a humble house. . . . Léon Bloy seemed nearly shy, he spoke little and in a very low voice, trying to say to his two young visitors something important, something that would not disappoint them. What he was revealing to them is not capable of repetition in words: the tender love of Christian brotherhood. . . . Bloy seemed to us the very opposite of other men. . . . Instead of being a whitened sepulcher like the Pharisees of all times, he was a charred, blackened cathedral. The *white part* was inside, deep in the tabernacle.

From the fact of your having crossed the threshold of his house, all values became displaced, as by the shifting of an invisible ratchet. One knew, or one divined, that *there is but one sadness—not to be a saint.* And all else became twilight.[20]

Thus Jacques and Raïssa traveled from the bewilderment and despair created by their Sorbonne experience, through the dawning of hope and confidence inspired by Bergson's lectures, to the first beginnings of a new life of faith, a precious gift for which they remained

---

20. Jacques Maritain's "Introduction" to Léon Bloy, *Pilgrim of the Absolute* (New York: Pantheon Books, 1947), 21–23.

forever in Bloy's debt. And yet the major sources of influence that would determine and eventually characterize the direction of Jacques's life were still not complete. It would be another three years, after two peaceful and profitable years studying with the famed German biologist Hans Driesch in Heidelberg, before Maritain would finally come into contact with the writings of St. Thomas Aquinas.

The seriousness of their conversion led the Maritains to see the need for a spiritual director. Through the advice of Dom Delatte, abbot at Appuldurcomb, a Benedictine monastery to which Jacques had been sent on a personal mission for his friend Charles Péguy,[21] the Maritains, after waiting a year in prayer, were directed to Father Humbert Clérissac. Going from their home in Paris to Versailles to visit Fr. Clérissac for the first time, Raïssa recalled that in the three years since their baptism "we were now accomplishing our first important advance, not indeed towards the Church but into the very bosom of that Church."[22] For five years, until his premature death in 1914, Fr. Clérissac remained their true friend and spiritual director.

It was through his counsel that Raïssa first came into contact with the *Summa Theologica* of St. Thomas Aquinas (in early 1909): "Everything, here, was freedom of spirit, purity of faith, integrity of the intellect enlightened by knowledge and genius."[23] Jacques in the meantime had initially declined an academic career and had accepted an editing assignment from the publisher Hachette in order to preserve his freedom of spirit and independence as a philosopher.[24] It would be another year before he would begin a direct study of both Aristotle and Aquinas (September 1910). Since the early Sorbonne days, Maritain had felt an innate sense of the great mystery of the intellect and had possessed an insatiable desire for the truth which he believed was its natural intention and object. Through Bergson's influence, he had gained a confidence in man's capacity for attaining the "Absolute," while it was Bloy who had provided the first security in the "Truth," albeit truths of faith. In his encounter with Aquinas, after many years

21. Raïssa Maritain, *We Have Been Friends*, 151–52.
22. Ibid., 175.                    23. Ibid., 182.
24. Ibid., 172.

of reflection and prayer, Maritain was finally ready to engage the one who was to restore to its rightful place the true nature of the intellect with its capacity for not only attaining the truth of being, but also for its creative capacity as well. This was not the intellect of which Bergson had spoken. The tension that had been created through his initial enthusiasm with Bergsonism and the immutable truths offered by faith left Maritain in a quandary. The desire for a resolution of that tension disposed him for what he soon would discover in the writings of St. Thomas. In his celebrated preface to the second edition of his first book, *Bergsonian Philosophy and Thomism,* Maritain recalls this transition:

It was in 1908—while I was deliberating, in the country around Heidelberg, whether I could reconcile the Bergsonian critique of the concept and the formulas of revealed dogma, that the irreducible conflict between the "conceptual" pronouncements of the religious faith which had recently opened my eyes, and the philosophical doctrine for which I had conceived such a passion during my years as a student and to which I was indebted for being freed from materialistic idols, appeared to me as one of those only too certain facts. . . . The effort, unobtrusively pursued for months, to bring about a conciliation which was the supreme object of my desire ended abruptly in this unimpeachable conclusion. The choice had to be made, and obviously this choice could only be in favor of the Infallible, confessing therefore that all the philosophical toil which had been my delight was to be begun again. . . . As far as I was concerned it was upon the indestructible verity of the objects of faith that philosophical reflection rested in its effort to restore the natural ordination of the intellect to being, and to recognize the ontological genuineness of the work of reason. In thus completely accepting, without quibble or reserve, the authentic reality value of our human instruments of cognition I was already a Thomist without being aware of it. When . . . I came upon the *Summa Theologica* its luminous flood was to find no opposing obstacles in me.[25]

In St. Thomas, Maritain found not only this defense of an integral, spiritual intellect, but he also encountered the personification of the

25. Jacques Maritain, *Bergsonian Philosophy and Thomism* (New York: Philosophical Library, 1955), 16–17.

wise man par excellence, that is, one who knew how to put things in their proper place. Thus it was that the man who was to become the most articulate expression and extension of Thomism in the twentieth century was already personally disposed to receive the enlightenment that the thought of Aquinas would provide. Maritain always saw himself as a philosopher,[26] and he learned first and foremost that the dignity of the intellect not only preserves the possibility of attaining truth but that it also ennobles human nature. Concomitantly, he learned of that distinction between the principles of reason and the principles of faith which are the very foundation of the respective sciences of philosophy and theology. St. Thomas's thought and life example became the final inspiration that Jacques needed in order to bring together and solidify all of the various elements and personal influences of his youth. Now his faith could be successfully integrated with, and yet distinguished from, his philosophic activity, which itself received added assurance and guidance through the wisdom of Aquinas. With his vocation as a fervent exponent of Thomism in place, his innate poetic gift soon would be nurtured by his philosophic reflections on art and creativity given through one additional notable and inspiring friendship.

When the Maritains moved to Versailles in 1909 to be near their spiritual director Fr. Clérissac, they had the good fortune of having as a neighbor a man whom they had met years earlier, in 1905, at the home of Léon Bloy. Now they would cultivate their own friendship with this gifted artist and his family, the French painter George Rouault. Although the environment of Maritain's early home life was characterized by a spirit of free inquiry in the arts and letters, and although Jacques himself had some early lessons in painting,[27] it was

26. See Jacques Maritain, *On the Church of Christ,* trans. Bernard Doering (South Bend, Ind.: University of Notre Dame Press, 1973), preface, v.

27. "In childhood, although Jacques' health was poor, his mind was constantly inquiring and perpetually in motion. . . . Although his mother was pleased to see the gifts of her father reappearing in the boy, she was shaken at times by his fever for knowledge. To get him outdoors, she persuaded Jacques to take up sketching and painting. Although he did not develop this talent, he early came to understand a good deal about the techniques, mental attitudes, and problems of the artist—an under-

not until the close, friends-and-neighbors association with Rouault that the opportunity for observing the workings of a great master artist presented itself. An otherwise unsociable revolutionary in the arts, Rouault came almost weekly to dine alone with the Maritains.

Because they did not force his confidence, [Rouault] talked to them freely, telling of his struggles for an "inner order" that would enable him to express in original forms his exasperation with bourgeois values and his intense religious feeling. To do this, he said, he had to depart from accepted forms of beauty, go his own way at no matter what cost, and accommodate himself to the consequent lack of understanding and to poverty. Through this friendship the Maritains were steeped in many problems of aesthetics which they sought to interpret in the light of Aquinas' philosophy.[28]

By moving within the light of his own innate poetic disposition, and that provided by Rouault and his beloved Raïssa, a poet of no small stature, Jacques Maritain turned the penetrating glance of his intellect, inspired and directed by Aquinas, onto the fields of his immediate experiences. Just as his first book, *Bergsonian Philosophy and Thomism* (1914), critically reexamined the philosophy of Henri Bergson, so *Art and Scholasticism*,[29] Maritain's second book (1920), was written with Georges Rouault in mind.[30]

It is interesting to note that, in a general way, Maritain's first twelve books[31] correspond to the four major influences on his early life:

---

standing that he put to good use in later years"; Julie Kernan, *Our Friend, Jacques Maritain,* 16–17.

28. Ibid., 48.

29. Jacques Maritain, *Art et scolastique* (Paris: Librairie de l'Art Catholique, 1920). Although the first English translation of this book was *Art and Scholasticism,* trans. John O'Connor (New York: Charles Scribner's Sons, 1930), the definitive English edition, revised and newly translated, is by Joseph W. Evans, *Art and Scholasticism and The Frontiers of Poetry* (New York: Charles Scribner's Sons, 1962). All citations throughout this study use the Evans edition.

30. Raïssa Maritain, *We Have Been Friends,* 194.

31. In addition to (1) *Bergsonian Philosophy and Thomism* and (2) *Art and Scholasticism,* there are also: (3) *An Introduction to Philosophy,* trans. E. I. Watkin (London and New York: Sheed & Ward, 1930; original French, 1921); (4) *Theonas: Conversations of a Sage,* trans. F. J. Sheed (London and New York: Sheed & Ward, 1933; original French, 1921); (5) *Antimoderne* (Paris: Editions de la Revue des Jeunes, 1922); (6) *Prayer and*

(1) Bergson and the academic climate of the Sorbonne years; (2) Bloy and matters pertaining to faith and Maritain's own conversion to Catholicism; (3) Aquinas, faith, reason, and philosophy; and (4) Rouault and Maritain's natural affinity for art, artists, and poets. While many of these early books are composites of previously published articles and so, in their subject matter, cut across the boundary lines of these individual categories, they nonetheless all fall within these parameters. It was not until 1926, when the Action Française movement led by Charles Maurras came under fire from the Vatican that Maritain, obedient to the Vatican's direction, moved into a new area of thought that would provide yet another major contribution of philosophical significance: his social and political philosophy. The subsequent years of World War II served to reinforce this direction. Maritain always philosophized from the very center of his life.

In any case, *Art and Scholasticism* attracted a great deal of interest from writers, poets, painters, and musicians. And so, together with the Thomist Study Circles[32] which the Maritains began as early as 1919 in Versailles (but which only gained real stature after their relocation to Meudon in 1923), the Maritain home became a sanctuary for sincere intellectuals who desired to deepen their understanding of Aquinas and to see the creative way in which Maritain applied the wisdom of the Angelic Doctor to contemporary problems. Years later, Yves Simon wrote: "I have some notion of the people whose company he liked, for, over a long period, it was my privilege to visit his home on Sunday afternoons. The living room was generally crowded, less by teachers or

*Intelligence,* trans. Algar Thorold (New York: Sheed & Ward, 1928; original French, 1922); (7) *An Introduction to Logic,* trans. Imelda Choquette (London: Sheed & Ward, 1937; original French, 1923); (8) *Saint Thomas D'Aquin, apôtre des temps modernes* (Paris: Editions de la Revue des Jeunes, 1923); (9) *Réflexions sur l'intelligence et sur sa vie propre* (Paris: Nouvelle Librairie Nationale, 1924); (10) *Three Reformers: Luther, Descartes, Rousseau* (New York: Charles Scribner's Sons, 1929; original French, 1925); (11) *Georges Rouault,* trans. Campbell Dodgson (New York: Harry N. Abrams, 1952; original French, 1926); and (12) *Art and Faith,* trans. J. Coleman (N.Y.: Philosophical Library, 1948). For Maritain's books and articles, up to 1962, see Donald and Idella Gallagher, *The Achievements of Jacques and Raïssa Maritain.*

32. For details about the Thomist Study Circles, see Jacques Maritain, *Notebooks,* trans. Joseph W. Evans (Albany, N.Y.: Magi Books, 1984), 133–85.

students than by writers, poets, painters, musicians, persons interested in mysticism, missionaries and friends of the missions. Most of the artists were of the vanguard description."[33] The list of celebrated personalities who passed through the doors at Meudon or who engaged the friendship and mutual admiration of the Maritains during their lifetime reads like a veritable Who's Who of twentieth-century European and American artists, intellectuals, and missionaries. In addition to Bergson, Bloy, and Rouault, the following list of names represents only a random and modest sampling: (1) writers and poets: André Gide, François Mauriac, Jean Cocteau, Julien Green, John Howard Griffin, Max Jacob, Pierre Reverdy; (2) painters: Pablo Picasso, Marc Chagall, Gino Severini; (3) musicians: Igor Stravinsky, Georges Auric, Erik Satie, Arthur Lourié; (4) philosophers: Gabriel Marcel, Etienne Gilson, Yves Simon, Mortimer Adler, Nicholas Berdyaev, Oliver Lacombe; (5) theologians and missionaries: Fr. Charles Henrion, Fr. Garrigou-Lagrange, Abbé Charles Journet, Thomas Merton.

Such was the world and atmosphere, steeped in prayer and contemplation, which surrounded and constituted the Maritains' life and spirit. Always "in the fight," as Raïssa remarks,[34] Jacques's life was characterized less by leisurely reflection producing ordered, systematic, and carefully written works, than by a vital and living faith that first drew its strength from contemplation and then catapulted him into the center of the intellectual life of the ever-changing times. This life, both spiritual and philosophical, never ceased to grow or be open to truth wherever he found it. His vitality and humility gained for him profound respect and international renown. He served as French ambassador to the Vatican from 1945 to 1948. A teacher more by necessity and obligation than by desire, Jacques Maritain was to the end a philosopher whose very being reflected that Divine Mystery to which he had dedicated and offered his life.

Jacques's beloved Raïssa passed away in 1960. He spent the final years of his life (from 1970 to his death on April 28, 1973) as a monk

---

33. Griffin and Simon, *Jacques Maritain; Homage in Word and Pictures*, 5.
34. Raïssa Maritain, *We Have Been Friends*, 352.

and hermit with the Little Brothers of Jesus by the Garonne River in Toulouse, France. And whether in his purely philosophical writings or those with a clearly theological cast,[35] Maritain was first and foremost a man deeply in love with, and "a kind of secret agent of the King of Kings."

What am I, I asked myself then. A professor? I think not; I taught by necessity. A writer? Perhaps. A philosopher, I hope so. But also a kind of romantic of justice too prompt to imagine to himself, at each combat entered into, that justice and truth will have their day among men. And also perhaps a kind of spring-finder who presses his ear to the ground in order to hear the sound of hidden springs, and of invisible germinations. And also perhaps, like every Christian, despite and in the midst of the miseries and the failures and all the graces betrayed of which I am becoming conscious in the evening of my life, a beggar of Heaven disguised as a man of the world, a kind of secret agent of the King of Kings in the territories of the prince of this world, taking his risks like Kipling's cat, who walked by himself.[36]

Whether we consider Maritain as the "spring-finder" or as the one who "was to make clear the paths," the end result is the same. In his philosophy of art and creative activity, he brought the insights of Scholastic philosophy to bear upon the problems of contemporary art. Yves Simon identifies the significance of this lifetime contribution directly: "That an artist should be interested in scholasticism, should find a philosophy of art in St. Thomas, Cajetan, and John of St. Thomas, and should use the principles of this philosophy to understand and explain what is going on in the vanguard of painting, music and poetry in the twentieth century, will remain one of the best surprises that ever confronted historians of philosophy."[37]

35. E.g., Jacques Maritain, *On the Grace and Humanity of Jesus*, trans. Joseph W. Evans (New York: Herder & Herder, 1969), and Jacques Maritain, *On the Church of Christ*.

36. Jacques Maritain, *Notebooks*, 3.

37. Griffin and Simon, *Jacques Maritain; Homage in Word and Pictures*, 7.

TWO

# THEORETICAL BACKGROUND
## Maritain's Philosophical Development

✒︎

*If I . . . am a Thomist, it is in the last analysis because
I have understood that the intellect sees.*

—Jacques Maritain

## BERGSON'S PHILOSOPHICAL INFLUENCE:
## BERGSONIAN INTUITION

Central to Maritain's aesthetics and theory of creative activity is the role played by the intellect and human intelligence. The opening paragraph of *Art and Scholasticism* situates the term "art" as an intellectual virtue distinguished not only from the other intellectual virtues, but from the moral virtues as well. When we recall the biographical notes from the preceding chapter, this distinguishing characteristic comes as little surprise. The philosophical skepticism and scientific materialism that weighed upon Maritain as a young student were lifted initially by the Bergsonian notion of intuition that transported one into the very heart of the Real or the "Absolute"—a transcendent realm closed to the limits and confining constructs of concepts and the investigations of the empirical sciences. This initial "good news" from Bergson was followed shortly by the "Good News" of the Gospels, faith, and eventually the study of St. Thomas Aquinas. In his conversion, Maritain was among the early revolutionaries of his day; today, it is easy to lose sight of how "countercultural" his conversion to Catholicism and interest in St. Thomas were at that time.[1]

---

1. The same was also true for Aquinas and his study of Aristotle in the culture of thirteenth-century Paris.

The specific effect of the ideas of Aquinas upon the development of Maritain's philosophy will be discussed in the next section of this chapter. The initial formation and reorientation of his thinking came from his first contact with Bergson and Bergsonism. Bergson was Maritain's senior by a mere twenty-three years. Born in the year of the publication of Charles Darwin's *Origin of Species* (1859), Bergson grew intellectually in the latter part of the nineteenth century. This era was characterized by the inheritance of the still developing European tradition of modern philosophy and the consequent growth of materialism and positivism. Bergson's own philosophy, like that of Maritain's later, developed as a critical response to this pervasive scientism. Also, again like Maritain, Bergson was gifted with an artistic temperament that revealed itself in his writings.[2] This artistic disposition and poetic writing style is likely to have struck a resonance in Maritain, thus accounting for some of Bergson's initial appeal.

The real attraction, however, was undoubtedly Bergson's criticism of the materialist worldview of the scientists and the alternative theory of reality and epistemology he proposed. In spite of Maritain's eventual criticism of Bergson's ideas years later,[3] initially they liberated the "metaphysical eros" Bergson's enthusiastic admirer desired so ardently: "When Bergson revived the worth and dignity of metaphysics in the minds of his listeners, minds engaged to their sorrow by agnosticism or materialism, when he said, with an unforgettable emphasis, to those minds brought up in the most depressing pseudo-scientific relativism, 'it is in the *absolute* that we live and move and have our being,' it was enough that he should thus awaken in them a desire for metaphysics, the metaphysical *eros*: that was accomplishment enough."[4]

2. From his father "who was an accomplished musician, he doubtless inherited something of the artistic temperament which is reflected throughout his books"; Thomas A. Goudge, "Introduction," in Henri Bergson, *An Introduction to Metaphysics* (New York: Bobbs-Merrill, 1955), 9.

3. Jacques Maritain, *Bergsonian Philosophy and Thomism.*

4. Jacques Maritain, "The Metaphysics of Bergson," in *Ransoming the Time,* trans. Harry Lorin Binsse (New York: Charles Scribner's Sons, 1941), 53; this essay is also chapter 16 in the 1955 Philosophical Library Edition of *Bergsonian Philosophy and Thomism. Ransoming the Time* also appeared under the title *Redeeming the Time* (London: Geoffrey Bles/Centenary Press, 1944).

It is against the background of the late nineteenth-century philosophical and scientific skepticism that one can best appreciate the Bergsonian critique of mind—in philosophy, against Descartes, Hume, and Kant; in science, against Darwin, Spencer, and Taine. From these sources, Bergson understood the prevailing attitudes concerning the knower's relation to reality, the role of the mind in comprehending reality, and the role of concepts in representing reality. From Descartes, Bergson received the fundamental assumption of all subsequent modern theories of knowledge—namely, that the problem of knowledge, the "critical problem," is "how does the mind get to reality?" Descartes's methodic doubt turns the knowing subject in upon the self, thereby offering the knower direct access only to the contents (the ideas or concepts) of his or her own mind. Maritain tells us that Bergson fought against the position that ideas, as mental pictures or intermediaries situated between the mind and the real, are alone knowable.[5] Against the position that ideas, as representations of reality, are all that we know, Bergson's notion of "intuition" brought the mind into a *direct* encounter with the real itself.

Naturally, Bergson was not reacting to Descartes's ideas alone. From Kant, Maritain says, Bergson received the notion of the mind's constructive activity in the knowing process, though now, through Kant's critique of metaphysics, the mind is precluded from the possibility of knowing suprasensible reality; its sole access is to the phenomena of sense experience as presented through the schemata of the imagination. On this accounting, retaining as it does the fundamental Cartesian starting point, "the concept is only an empty form imposed upon the matter of sensibility . . . by the *a priori* functions of judgment, and its sole role is to unify and synthesize the matter—to organize it—under universal and necessary laws."[6] And even though Kant does use the term "intuition," it is only a purely sensible intuition "whose empirical content has from the beginning a mathematical character resulting from the *a priori* forms of space and time. It is the content of this sensible intuition that fills the concept."[7] Thus, all

5. Jacques Maritain, *Bergsonian Philosophy and Thomism,* 23.
6. Ibid., 26–27.                    7. Ibid., 27.

genuine knowledge is limited to sense experience structured by the categories of the mind.

Maritain observes that certain scientists reinforced this Kantian constructing activity of the mind: "Bergson got from Taine the idea of a naturally mechanistic intellect, [and] from Spencer the idea of an intellect engendered according to certain needs and certain demands of evolution."[8] Through an expansion of Darwin's account of the evolution of nature, Bergson understood that the principle of natural selection may be extended beyond the physiological adaptability conducive to the organism's self-preservation to include the evolving development of the intelligence as well. From this perspective, the intellect develops its powers in terms of its capacity for transforming the world into a vast instrumental system or network of constructs which increases the organism's chances of survival. Thus, the individual employs the mind in a purely practical way, adapting itself to, and proceeding to its best advantage in, its environment.[9]

Bergson's understanding of the nature of the mind is thus an obvious heir of the modern philosophical tradition since he viewed mind as the means by which the knower constructs certain limited, inadequate representations of reality that do not provide the knower with any genuine contact with reality itself. The influence of evolutionary theory confirms this epistemology by assigning the constructing power of the mind to the purpose of human survival, which is only the most recent stage in our evolutionary development. As a result, the world is apprehended by the mind in an entirely external fashion, transforming the real into representations that are static, discreet, and immobile quantifications, useful "units" capable of measurement, analysis, and manipulation.[10] It is an interesting account, though for Bergson it is not a complete epistemological picture.

In *Creative Evolution*,[11] Bergson claims that, in the evolution of

8. Ibid., 23.

9. Thomas Goudge, "Introduction," in Henri Bergson, *An Introduction to Metaphysics*, 10.

10. Ibid., 10–11.

11. Henri Bergson, *Creative Evolution* (New York: Random House, 1944), 192–96.

human development, this limited, constructed world that is the result of the mind's activity is complemented by another power that enables us to grasp what concepts fail to give us. Intuition captures the world in all its dynamic dimensions, thus enabling us to have direct contact with the deeper realities of life. For Bergson, intuition puts us in contact with what he calls the *élan vital*—duration, motion, and real change. These are aspects of reality not as statically represented by the concepts of mathematico-physical science, but as they are in themselves. Intuition (what Bergson also refers to as a "divining sympathy"[12]) overcomes the boundaries imposed by conceptual thought, thus allowing the knower direct communion with "absolute reality" itself. This Bergsonian intuition is something quite different from the sensible intuition of Kant. For Bergson, Maritain points out, it is a "supra-intellectual" intuition that "bears upon the spirit"[13] and as such, it should not be confused with emotion, feelings, or some kind of vague inarticulate hunch. Rather, it is an act or series of acts that puts the knower in direct contact with the immediacy of transcendent experience.

The intellectual operation by which we grasp ourselves in becoming, and through which we make contact with the essence of things by transporting ourselves within them, Bergson calls *intuition*. Intuition does not reason, does not discourse, does not compose nor does it divide. Because it is consciousness itself folding back upon duration, and because duration is the living basis wherein all things communicate, it makes us actually coincide with the object known, or rather felt, or ever better, lived; it assimilates us to its most intimate reality in a transcendent and inexpressible experience: "This intuition attains the absolute."[14]

Beyond the philosophical, Bergson also influenced Maritain personally as well. Maritain's lasting appreciation and affection for his first great teacher, liberator, mentor, and friend testifies to "all the respect and gratitude he never ceased to pay to Bergson."[15] Philosophi-

12. Ibid., 193.
13. Jacques Maritain, *Bergsonian Philosophy and Thomism*, 27, n. 1.
14. Ibid., 68.
15. "Preface to the Second Edition," 1929, *Bergsonian Philosophy and Thomism*, 12.

cally, Bergson liberated Maritain's metaphysical eros and cultivated his desire for the Absolute; he also influenced Maritain's philosophical vocabulary. This will be apparent when we explore Maritain's own developed notion of intuition in the next chapter. He also adopts Bergson's expressions "divining sympathy" and "intellectual sympathy"[16] in his theory of Poetry and Poetic Knowledge.

Although Maritain's personal and philosophical indebtedness to Bergson was certainly significant, it pales, however in comparison to the influence of St. Thomas Aquinas. Bergson inspired Maritain through essential insights that fanned his desire and pointed the way out of his philosophical confusion and metaphysical anguish. But it is Aquinas who led Maritain to the light and spirit of truth for which his heart longed and his intelligence thirsted.

## AQUINAS'S PHILOSOPHICAL INFLUENCE:
### THE HUMAN INTELLECT

Shortly after the Maritains were inspired by Bergson, Jacques and Raïssa made the acquaintance of Léon Bloy. In the process of their conversion to Catholicism, Jacques became aware that the secular humanist effort by which one might aspire to bring oneself into the truth was, in the final analysis, essentially futile. In the celebrated passage from the "Preface to the Second Edition" of *Bergsonian Philosophy and Thomism,*[17] Maritain tells us that he initially attempted to reconcile

---

Bergson died on January 14, 1941. In her memoirs, *Adventures in Grace* (being the second half of *We Have Been Friends Together*), Raïssa gives us additional testimony when she quotes an article of her own, published in *The Commonweal,* January 17, 1941, titled "Henri Bergson." In it she writes: "Bergson spoke of Jacques, and of Jacques' work. He said to me: 'You know, when your husband set up my philosophy "of fact" against my philosophy "of intention" as containing certain virtualities which were not developed, he was right.' And he continued, while my heart filled with gratitude and admiration: 'Since then we have moved toward each other, and we have met in the middle of the way.' And I thought to myself that they had met in Christ, who is the Way, as He is also the Truth" (338).

16. Cf. Henri Bergson, *An Introduction to Metaphysics,* 23, where Bergson refers to intuition as "intellectual sympathy."

17. Jacques Maritain, *Bergsonian Philosophy and Thomism,* 16–17.

Bergsonism with those truths which he was at that time (1908) acquiring through the dynamic influence and instruction of his godfather (Bloy) and the Catholic Faith. That effort, he concedes, ended abruptly when he realized that, if there were an incompatibility between the truths of faith and an opposing claim made by reason, a choice had to be made and "obviously this choice could only be in favor of the Infallible." Though not yet confirmed or supported by reason, his embrace of the truths of faith caused him to reassess his philosophical ideas and required, at the conclusion, that he confess "that all the philosophical toil which had been my delight was to be begun again." Thus we see that a clear direction had been given to his intellectual speculations *prior* to his encounter with the thought of Aquinas. This primal spring of intellectual honesty is a significant quality of Maritain's character. He understood that truth cannot be divided against itself, and for him, "it was upon the indestructible verity of the objects of faith that philosophical reflection rested." With his firm conviction of faith, Maritain subsequently came to discover the Angelic Doctor,[18] the one who spoke so simply and powerfully about the seamless continuity and the necessary compatibility between the truths of faith and the truths of reason.

Inspired by the truths of faith and finding their eloquent articulation in the writing of St. Thomas Aquinas, Maritain's first book was a critical study of the philosophical ideas of Bergson (1914). In it, he contrasted the views of Bergson with those of Aquinas concerning human intelligence and the role of concepts in intellectual knowledge. Although the Bergsonian distinction between scientific (or mathematical) time and "real" time reinforced Bergson's claim that there really are dimensions of reality incapable of conceptualization, it was nonetheless from his study of Aquinas (and the whole school of commentators), integrated in a life of prayer, that Maritain learned of the spiritual and privileged nature of human intelligence.

In order to comprehend the mysteries of metaphysics, one must

18. September 15, 1910: "Finally! Thanks to Raïssa, I begin to read the *Summa Theologiae*. As it was for her, it is a deliverance, an inundation of light. The intellect finds its home"; Jacques Maritain, *Notebooks*, 65.

use analogical thinking. This is especially true for the metaphysical analysis of human intelligence. For example, by predicating the verb "to see" to both the powers of sensual sight ("Do you *see* the clock on the wall?") and the intellect ("Do you *see* what I mean?"), Maritain understood in a fundamental way the absolutely unique nature of human intelligence. "If I . . . am a Thomist," he wrote, "it is in the last analysis because I have understood that the intellect sees."[19]

For Maritain, following Aquinas, it is the intellect's capacity for "seeing" which is the faculty or power for the immediate "connivance" with the real itself. This ability differentiates Thomas's idea of intellect from Bergson and the history of modern philosophy since Descartes, since that tradition holds that the mind has access to or immediate contact only with its own contents and representations. What it knows of reality it knows only representatively from its own ideas. Reality in itself, the *ding an sich,* becomes some noumenal reality that is ultimately unknowable because it is inaccessible to the gaze (and for Kant, activity) of the mind. For Maritain, following Aquinas, the intellect is not an inferior and limited knowing power (Bergson), nor is it an active knowing power that has legitimate access only to the phenomenal representations of things, where "anything that is suprasensible in the knowing mind is exclusively its own structure"[20] (Kant), nor is it an isolated knowing power turned in solely upon the contents (ideas) of its own mind (Descartes). No! According to Maritain (and Aquinas), the intellect is a superior, intuitive, immaterial knowing power that operates together with the instrumentality of the senses in a diversity of ways, and, having being itself as its proper object, it puts us in direct and immediate contact with reality itself.[21] This "direct and immediate contact" is possible because of the intuitive nature of human intelligence.

The role of concepts (or ideas) is also important since, in the

19. Jacques Maritain, *The Range of Reason* (New York: Charles Scribner's Sons, 1952), 9.

20. Jacques Maritain, *Bergsonian Philosophy and Thomism,* 26.

21. See Jacques Maritain, *Bergsonian Philosophy and Thomism,* 145; see also Jacques Maritain, *Range of Reason,* 8–16.

Thomist account, the concept is not a confining, limiting, artificially dissecting, and reifying product of an inferior intellect (Bergson), nor is it "an empty form imposed upon the matter of sensibility . . . by the *a priori* functions of judgment"[22] (Kant), nor is it an innate idea that is the direct object of the mind alone (Descartes). No! According to Maritain, the concept is first and foremost an inner "word" (a *verbum mentis,* or *species expressa*) by means of which the intellect "becomes" the object in an intentional mode of existence that directly (immediately—without any *objective* intermediary) attains the real. It is not *that which* the mind knows (idealism). Rather, it is a "formal sign,"[23] a means or *that by which* the mind grasps, directly and immediately,[24] the reality of an object through the process of abstraction (realism). The unique "seeing" activity of the intellect and the interrelation and interdependency of intellect and concept lead Maritain to conclude that the "intellect sees by conceiving, and conceives only to see."[25]

As should now be evident, the Thomist meaning of "concept" or "idea" contrasts sharply with the use of these same terms by modern philosophers. For Thomists, the modern notion of a concept or idea occurs only when the mind directs the focus of its attention back upon its operations and contents secondarily. This difference on the role of concepts in knowledge is at the foundation of the "critical problem," and it sharply divides Thomist epistemology from the modern tradition. Maritain highlights this difference as follows:

22. Jacques Maritain, *Bergsonian Philosophy and Thomism*, 26–27.

23. "[A] formal sign is a sign whose whole essence is to signify . . . it is anything that *makes known*, before being itself a known object. More exactly, let us say it is something that, before being known as object by a reflective act, is known only by the very knowledge that brings the mind to the object through its mediation"; Jacques Maritain, *Distinguish to Unite or The Degrees of Knowledge*, trans. Gerald B. Phelan (New York: Charles Scribner's Sons, 1959), 119. (Hereafter referred to as *The Degrees of Knowledge*.)

24. It is in this sense and for this reason that Maritain calls the intellect "intuitive." He not only justifies this but argues that it is obligatory ever since modern epistemology's "fundamental misconception of the true role of the idea," brought about by the "errors which did not come upon the scene before Descartes and Kant." See Jacques Maritain, *Bergsonian Philosophy and Thomism*, 150–52.

25. Ibid., 30.

[T]he idea is not *that which* the intellect knows (the idea itself is known only by reflection), it is only *that by which* the intellect knows, that by which the intellect communicates with reality, that by which it grasps "intuitively," immediately, natures, objects of thought which are in things and which it brings forth from things by abstraction.[26]

Moreover, intuition in the primary sense for Maritain is not some "supra-intellectual" intuition which is beyond concepts and all of the other inferior rational activities (Bergson), nor is it confined to a sense intuition alone (Kant), nor is it an immediate perception of one's own clear and distinct ideas (Descartes). No! Intuition in the sense that contrasts with modern epistemology is an intellectual intuition that is the direct and immediate knowledge of the "object," through the presence to the intellect of the concept or *verbum mentis*.[27] In another place, Maritain also calls this an "abstractive intuition:"

[T]he activity of the intellect which extricates from sense experience—and raises to the white heat of immaterial visibility *in actu*—objects which the senses cannot uncover in things and which the intellect sees: being and its properties, and the essential structures and the intelligible principles seizable in the light of being. That is the mystery of abstractive intuition.[28]

The above discussion, however, pertains to the exclusively rational, conceptual activity of the intellect. Maritain also is aware that the life and activity of the intellect is much broader than the technical confines of these purely *philosophical* or rational activities or operations. And so Maritain also calls attention to further dimensions of the intellect's life which go beyond what the "philosophers generally think of it."[29] Philosophers often pass "over all that the mind, brought back upon itself by reflection on its acts, can learn of itself." He calls attention to the fact that, in addition to the *overt* philosophical or rational functions, the life of the intelligence also involves many *covert* philosophical activities, other "more deep-seated energies . . . and vital

26. Ibid., 151.
27. Ibid., 151f.
28. Jacques Maritain, *Range of Reason*, 9.
29. Jacques Maritain, *Bergsonian Philosophy and Thomism*, 34.

tendencies which, developing in it, dynamically regulate it with regard to this or that object and which we call *habitus.*"[30]

The overt, ordinary philosophical use of such terms as "intellect," "reason," and "the order of concepts" applies to what in logic is known as the order of verification (*via judicii*). Beyond that, there is also the order of discovery (*via inventionis*) which "depends on laws more hidden, and more individualized as well, and more incommunicable." And although "nothing shows with greater evidence the vitality, the intuitive energies of the power of abstracting," what is operating here (in the *via inventionis*) is the calling forth of "a brand new Word, never yet conceived, from the dark yet fecund waters which have poured into the soul through the sluice-gates of the senses," thus requiring that the "intellect gropes its way, strives, waits; it seeks a gift which will come to it from its nature."[31] And yet, through all of this, it is the "rational" or "philosophical" order that is still under consideration though acting covertly. Maritain reminds us that this type of knowing also involves "an intellectual intuition which proceeds from the power of abstraction," and "is accomplished through and in a concept, and comes to fruition in a definition." "Any important progress in the sciences of nature," Maritain contends, "depends on *intellectual discoveries*" of this kind.[32]

Beyond these overt and covert *philosophical* intellectual operations, however, Maritain tells us that the Thomist notion of intellect also accounts for "vast regions of knowledge" which are outside the parameters of properly *philosophical* knowledge, and yet are to "the immense majority of men" the source of "their opinions, their certitudes, and [for] some a wisdom that philosophy envies."[33] Maritain is here referring to *nonphilosophical* modes of knowledge, also referred to as knowledge by way of "divination."[34] Some of these various kinds of *nonphilosophical* or divinatory types of knowledge "depend upon the

---

30. Ibid., 34–35.                   31. Ibid.
32. Ibid, 35.                        33. Ibid., 36.
34. The ground for these distinctions is ibid., 149, and 36–37; a detailed discussion of this distinction and of the terms "intuition" and "connaturality" follows in the next chapter.

rectifications of the acting subject and on an affective and practical connaturality," and they are of an "order inferior to philosophy" or inferior to *philosophical* knowledge proper. They are "the philosophy of those who do not philosophize at all."[35] On the other hand, and this time "above philosophy," there is also that mode of *nonphilosophical* or divinatory knowledge that is "the wisdom of the saints"—it is a supernatural, mystical mode of knowledge that "experiences divine things in the darkness of faith."[36]

As late as 1929 (the date of the "Preface to the Second Edition" of *Bergsonian Philosophy and Thomism*"), Maritain reaffirms that the internal word or concept is present in all of these forms of *philosophical* and *nonphilosophical* knowledge. This is a position about which he will change his mind in the future. Later, he will develop his notion of Poetic Knowledge and he will refer to it as *nonconceptual*.[37] Nevertheless, up to this point in time, he continues to assert that concepts are present in any of the divinatory types of knowledge, albeit they are functioning in a different way.[38]

This whole discussion highlights the fact that different philosophers understand the term "concept" in different senses. Nothing could be a greater error, Maritain claims, than to reduce all senses of this term to the "technically formulated concept" of modern philosophy. Philosophers frequently succumb to that temptation, and as a result they lose sight of the full richness of the knowing process. By focusing all attention on the "learned concept" (the "idea" of modern philosophy), one is apt to forget that it is primarily a point of completion or termination that we come to know only through reflection. First, it would have had to undergo a "series of determinations and

35. Jacques Maritain, *Bergsonian Philosophy and Thomism*, 37.

36. Ibid., 37. Of these divinatory, *nonphilosophical* modes of knowledge, Maritain remarks: "All of this is what rationalism and a certain philosophical idolatry of learned notions fail to recognize."

37. See chapters 3 and 4 for a further discussion of this problem of nonconceptual knowledge. For the present, suffice it to say that in Poetic Knowledge, Maritain will maintain that the work itself is the *terminus* of the practical intellect's activity, just as the concept or *verbum mentis* is the *terminus* of the speculative intellect's activity.

38. Jacques Maritain, *Bergsonian Philosophy and Thomism*, 37.

differentiations," as the intellect is "formed" by the intentional existence of the object.[39]

As we shall see, Maritain's greatest innovation in his philosophy of art concerns his notions of Poetry and Poetic Knowledge and in the fact that he applied in a new way the integral relation of these intuitive activities of the intellect—a powerful, creative, spiritual notion of human intelligence received from St. Thomas. Maritain's ideas seem to encompass that distinction of powers which Bergson attempted to indicate through his opposition of intellect and intuition.[40] Moreover, when Maritain develops his notions of a "Bergsonism of Fact" and a "Bergsonism of Intention," it is of the former, which pertains entirely to what Bergson in fact said, that Maritain is uncompromisingly critical. In his discussion of "Bergsonism of Intention," however, Maritain seeks to situate Bergson's ideas historically, and he offers an accounting that reconciles the intention of the author of *Creative Evolution* with the truth of the author of the *Summa Theologica*. In the final analysis, while Maritain was inspired in his longing for the Absolute from the encouragement and personal witness of Bergson, it is nonetheless from Aquinas that Maritain was instructed in that truth for which he thirsted—the truth about human intelligence and its life, and the way in which, through that life, one may come to participate in the mystery of the Creator of Life.

---

39. Ibid., 38.

40. Observe that Maritain's criticism of the Bergsonian notion of intuition, while analyzing it as a mélange of four different types of knowing, refers these to an operation of intellect, Thomistically understood: "In reality, it seems clear that the intuition Bergson describes is composed of quite diverse elements artificially gathered together; analyzing it, we should doubtless discover, joined to intellectual perception properly so-called, the activity of that sensible faculty the scholastics call . . . *cogitative* . . . ; then a sort of experimental knowledge, which proceeds by conformity to the inner inclinations of the subject and which is 'a manner of judging that is affective or instinctive, or by inclination,' . . . ; then again the kind of *sensible sympathy* which, for the artist, takes the place of the impossible intellection of the singular and which he needs in order to express in matter his model or his idea . . . ; finally, a share of natural mysticism which would make this intuition akin to the ecstasy of Plotinus"; Jacques Maritain, *Bergsonian Philosophy and Thomism*, 109–10.

# THE FOUNDATION OF MARITAIN'S EPISTEMOLOGICAL UNIQUENESS

⌒

*Before sewing one must cut.*
*A philosopher who is in search of the nature of things*
*is obliged to begin with sharp distinctions.*

—Jacques Maritain

## MARITAIN AND INTUITION

Maritain's published writings on art span some forty years, from the original publication of *Art and Scholasticism* in 1920 to *The Responsibility of the Artist*[1] in 1960. Although the expectation of Yves Simon—that Maritain would continue "to write papers on art and beauty until his last day"[2]—was not fulfilled, his writings on epistemology, many of which contain specific references to the knowledge of the artist, do extend beyond the more than half century that makes up his philosophical life.[3] While there is surely a good deal of change and growth in his ideas over the years, developments that include both the manner of expression and the terms used, there is nonetheless a certain traceable continuity and consistency. To those otherwise

1. Jacques Maritain, *The Responsibility of the Artist* (New York: Charles Scribner's Sons, 1960).

2. Griffin and Simon, *Jacques Maritain: Homage in Words and Pictures*, 7.

3. See his first book, Jacques Maritain, *Bergsonian Philosophy and Thomism*, 162–68. For examples in his later writings, see Jacques Maritain, *The Peasant of the Garonne* (New York: Holt, Rinehart, and Winston, 1968; original French edition, 1966), 11, 85, 110, 125–26, and 220–21; see also Jacques Maritain, *Untrammeled Approaches*, (South Bend, Ind.: University of Notre Dame Press, 1997; original French edition, *Approaches sans entraves* [Paris: Librairie Arthem Fayard, 1973]), 310–49. The pertinent essay, "No Knowledge without Intuitivity," originally appeared as an article in *Revue Thomiste* 70, no. 1 (1970): 30–71.

unfamiliar with the historical range of Maritain's writings on art, the initial encounter may be somewhat puzzling. Not only is his writing frequently graced with poetic flashes (necessary, one might say, in speaking about Poetry), but in addition, sometimes Maritain can be inconsistent in his terminology, while on other occasions he will take great pains to systematically explore and explain essential terms.

An early and important example of the latter concerns his use of the term "intuition." Initially inherited from Bergson, Maritain subsequently used this notion in a radically different way on account of his study of St. Thomas Aquinas. In his critical study of Bergsonism, Maritain explains what he calls the "Thomist doctrine," and points out the *philosophical* and *nonphilosophical* uses of this term. This preliminary distinction lays an extremely important foundation for Maritain's aesthetics.[4]

For Maritain, there are three *general* kinds of philosophical "intuition" that all concern an "immediate or direct perception." (1) The first sense is that upon which the whole of human knowledge depends: it is "the intuition of the external world, sense perception."[5] (2) The second sense of intuition is "that of the active self, which intellectual consciousness does not know through the self's essence, but which it perceives in the self's operations."[6] (3) The third sense, "intellectual perception,"[7] Maritain says, is of particular importance.

After assuming that all will agree that the words "immediate, without intermediary, direct" are precisely the *general* characteristics which distinguish philosophical intuition, Maritain goes on, in a lengthy but important footnote, to give a more detailed elucidation of the *technical* characteristics of philosophical intuition.

First, there is the *absolutely restricted sense*. Maritain refers to it as "that kind of knowledge in which the intellect is informed *immediately* by the essence or the substance of the thing known, *without the means of a subjective similitude of the thing.*" In this sense, he says, we

---

4. See figure 3.1 toward the end of the chapter for a systematic view of all of Maritain's various uses of the term "intuition."

5. Jacques Maritain, *Bergsonian Philosophy and Thomism*, 149.

6. Ibid., 150.                                    7. Ibid.

"reserve the word 'intuition' in this very special sense to . . . a) the knowledge that God has of Himself; b) the knowledge that the angel has of himself; c) the beatific vision."[8]

Secondly, there is *the less restricted but still strict sense* (the "proper sense" for the ancients). Maritain refers to this as that kind of knowledge which, "procured by means of a psychic similitude (*species impressa,* received from things in the case of the senses, infused by God in the case of the angels), attains . . . things . . . as *physically present,* as given in actual existence and therefore also in [their] very singularity."[9] (Note: this second technical sense corresponds to sense (1) of the general division.)

The third technical philosophical sense of the word "intuition" is the *broader sense.* This is the kind of knowledge that is an "introspective perception of the self. Here the intellect, informed immaterially by some psychic similitude (*species*) and determined thus to knowing directly some object other than the soul, perceives by a spontaneous reflection on its concrete and singular act the very existence of the soul that knows."[10] Maritain notes that since this type of intuition apprehends the existence and action of the soul, and not its nature, it is for this reason that the ancients refused to call this obscure type of knowing an "intuition" in the proper sense. (Note: this third technical sense corresponds to sense [2] of the *general* division.)

Finally, the fourth technical philosophical sense is the *very broad sense.* It refers to that type of knowledge which "does not attain the object as present, as actually existing, but as enveloping in itself only a possible or an ideal experience. Since the abstract nature thus attained is, however, attained directly thanks to the idea (*species expressa*) . . . human intellectual perception indeed deserves the name of 'intuition' in the broader sense."[11] (Note: this last technical sense corresponds to sense [3] of the general division.)

In the last two of these four senses, Maritain remarks that he is parting company with "the ancients," and he explains that it is modern epistemology since Descartes, whose method is responsible for creating the "critical problem" that requires this deviation, especially if

8. Ibid., n. 2, 150–51.    9. Ibid.
10. Ibid.    11. Ibid.

its errors are to be refuted.[12] This position gives clear evidence of Maritain's epistemological originality and his advance beyond St. Thomas.

Maritain's precisions concerning "intuition" can be difficult for several reasons. First, the various distinctions are subtle and their context is clearly in a Thomist hermeneutic. Second, many philosophers use this term in a variety of imprecise ways, frequently giving the impression that its use is little more than an epistemological deus ex machina which they summon to save the day when a peculiar kind of knowing cannot be explained in any other way. And finally, modern epistemology uses the term in a fashion that compounds the confusion.[13] For this reason, this text that we have been considering from Maritain's first book provides essential definitions and distinctions concerning the ways that Maritain will use this term in his future writings.[14] Students of Maritain will be well served by turning to these preliminary distinctions in their attempt to understand his discussions about (1) the relation between intuition and the various operations of the mind (apprehension, abstraction, etc.),[15] (2) the "intuition of being,"[16] and (3) the "intuition of subjectivity."[17]

12. Ibid.

13. "[T]he word 'intuition' is one of those which have provoked in the philosophers, by the laws of a bitter destiny, the most misunderstandings and obscurities"; Jacques Maritain, *Bergsonian Philosophy and Thomism*, 148.

14. The fact that Maritain did not come to deny the positions expressed in this early writing on the subject is clearly indicated in his 1929 "Preface to the Second Edition" written sixteen years after the book first appeared: "I maintain every one of [the doctrinal positions which the book defends] whether they concern the criticism of Bergsonian philosophy or the doctrines of Saint Thomas"; Jacques Maritain, *Bergsonian Philosophy and Thomism*, 11.

15. For a random sampling of Maritain's writings on this subject, see "No Knowledge without Intuitivity," chap. 14, in *Untrammeled Approaches*, 1997; "*Intuition et conceptualization*," Annexe II, *Quatre essais sur l'esprit dans sa condition charnelle* (Paris: Alsatia, 1956; originally published 1939); "*Sur l'expression 'intuition abstractive*,'" Appendice II, *Réflexions sur l'intelligence et sur sa vie propre*, (Paris: Desclée de Brouwer, 1929; originally published 1924).

16. On this subject, see Jacques Maritain, *Existence and the Existent* (New York: Pantheon Books, 1948; original French publication, *Court traité de l'existence et de l'existant* [Paris: Paul Hartman, 1947]), chap. 1; *A Preface to Metaphysics* (New York: Sheed & Ward, 1958; original French publication, *Sept leçons sur l'Être et les premiers principes de la raison spéculative* [Paris: Pierre Téqui, 1934]), chap. 3; *The Peasant of the Garonne*, chap. 6.

17. On this subject, see Jacques Maritain, *Existence and the Existent*, chap. 3; "The

The principal reason why many readers may be so nonplussed by Maritain's liberal use of the term "intuition" is that they generally do not understand the distinction between the *philosophical* and the *nonphilosophical* senses of this term. The latter usage is not properly philosophical or scholarly, Maritain says, but is rather a common or ordinary-language usage. The nonphilosophical sense "is that of *divination*; this is the way one usually speaks of 'intuitions of the heart. . . .' It is [in this case] no longer [simply] a question of the *immediacy* of the act of cognition [as with philosophical intuition], but [rather] of the *spontaneity* with which the subject arrives in certain cases at that act of cognition."[18] To have "an intuition in [the *nonphilosophical*] sense means to divine, to know without reasoning, to form a just idea or correct judgment without any discursive preparation."[19]

While insisting that intuition in the nonphilosophical sense is also an act of the intelligence,[20] Maritain goes on to say that "over and above intelligence it is the activity of the whole soul which . . . takes part in the process of knowledge, and especially of that knowledge which divines before demonstrating."[21] This integrity or unity of the operations of the faculties of the knowing subject, the integral relation of sense, memory, imagination, the cogitative power, together with the intellect itself, is all under the influence of the affective powers—the "heart" or the will. Thus it is that love not only influences, but also aids, fortifies, and directs the whole soul toward the good that it seeks. To the extent that this may come to occasion a kind of resonance with Divine Goodness, the intellect is pulled along, together with the whole soul, toward truth, thus causing "many secrets to be divined."[22]

---

Natural Mystical Experience and the Void," *Ransoming the Time*, 255f. (This essay was originally published in *Études Carmélitaines* [Paris] 23 [October 1938]: 116–39.)

18. Ibid., 149.                    19. Ibid., 162.

20. "All that we maintain is that in order to *divine*, to know or judge without discourse, we do not have recourse to a special cognitive power, distinct from the intellect"; Jacques Maritain, *Bergsonian Philosophy and Thomism*, 163. This remark is particularly pertinent because Maritain makes it within the context of his critical study of Bergson's philosophy, which sees intuition as a power distinct from intelligence.

21. Ibid.

22. Ibid., 167. In the 1929 "Preface," Maritain indicates some examples of this divinatory knowledge: "How many naturally vigorous intellects go more directly to the truth with a rudimentary rational equipment than many a doctor with his logic! What

These early insights are especially important since they will reappear in Maritain's later, more fully developed aesthetics.

The discussion of a divinatory or nonphilosophical intuition leads to a closely related notion. Characterized by spontaneity, the nonphilosophical types of intuitive knowledge occur by means of what is traditionally called "connaturality," or a knowledge by inclination, instinct, or congeniality. Following Aquinas, the classic example of connatural knowledge distinguishes between the knowledge of the moral theologian and the knowledge that may be found in a simple, uneducated person of true moral goodness as they each may be called upon to answer a particular moral question. On the one hand, the moral theologian may answer by drawing upon his intellectual knowledge. By doing so, he may give the correct answer to the question even though he himself may not be a particularly moral or virtuous person. On the other hand, the truly morally good or virtuous person may similarly give the correct answer but he does so by drawing upon what he is, his innate moral goodness, even though he may be ignorant of moral science. There are only four different occasions in Maritain's writing where he provides a listing or enumeration of the several different senses or uses of the term "connaturality." The listing in each of these four texts varies slightly. Interestingly, in the book central for the discussion of intuition, *Bergsonian Philosophy and Thomism*, Maritain does refer to connaturality,[23] though there is no detailed discussion of

---

they know they have divined. The poet divines by an instinct of the mind. The prudent man is instructed in another way,—he judges by consulting his virtue. The great common wisdom of the people, like the experience of old men, abounds in undemonstrable [*sic*] certitudes due to an immediate practical perception. . . . The man accustomed to live in himself is capable of metaphysical experiences which enable him to grasp in their concrete application certain transcendent verities. . . . Great faithfulness in seeking in everything one's own human truth, familiarizing the soul with what is spiritual, finally imposes upon it the practical confession of the true God . . . . [F]inally, the wisdom of the saints, which is supernatural, experiences divine things in the darkness of faith"; Jacques Maritain, *Bergsonian Philosophy and Thomism*, 36–37.

23. Ibid., 167.

it. In the 1929 "Preface to the Second Edition," however, a listing of sorts does appear, though it is loosely indicated and imprecise.

The first clear enumeration of the various types of connatural knowledge appears in an essay first published in 1937, "De la Connaissance Poétique," and which later forms chapter 3 of a book which Jacques and Raïssa published together, *The Situation of Poetry*.[24] The essay makes two very significant distinctions. The first concerns the mode of connaturality itself: there is *intellectual* connaturality and *affective* connaturality. Second, there is a distinction concerning the reality that is grasped connaturally. Maritain calls these "reality as conceptualizable," and "reality as non-conceptualizable." In this first listing,[25] Maritain leaves out of consideration that "knowledge by . . . *affective* connaturality . . . , which is at the heart of *prudential* knowledge." He is referring here to the classic example of the good person ignorant of moral science. The listing does identify, however, several other forms of connaturality that employ the two distinctions above: (1) "*intellectual intuition* which is an *intellectual* connaturality with reality as conceptualizable;" (2A) natural contemplation which is an "*intellectual* connaturality with reality as non-conceptualizable and at the same time contemplated;" (2B) supernatural contemplation which is an "*affective* connaturality with reality as non-conceptualizable and at the same time contemplated;" and (3) Poetic Knowledge which is an "*affective* connaturality with reality as non-conceptualizable because awakening to themselves the creative depths of the subject."[26]

A year after this first essay appeared, Maritain delivered a lecture to the fourth Congress of Religious Psychology in September 1938. It appeared in *Études Carmélitaines* in October of that year and became chapter 10 of his book *Ransoming the Time*. Entitled "The Natural Mystical Experience and The Void," the essay begins with a section called "A Classification of Knowings by Connaturality" and in it, the

24. Jacques and Raïssa Maritain, *The Situation of Poetry* (New York: Philosophical Library, 1955; original French publication 1938).

25. See figure 3.2 toward the end of the chapter for a systematic view of all of Maritain's various uses of the term "connaturality."

26. Jacques and Raïssa Maritain, *The Situation of Poetry*, 64–66 (emphases added). See also "De la connaissance poétique," *Deuxième Congrès International d'Esthétique et de Science de l'Art* 2 (1937): 168–70.

following listing occurs: (1) prudential knowledge—an "*affective* and tendential connaturality *with the ends of human action*" (note that this listing of prudential knowledge incorporates what had been left out in the previous listing); (2) intellectual connaturality—an "*intellectual* connaturality with reality *as possible of conceptualization* and made proportionate in act to the human intellect"; (3) Poetic Knowledge— "an *affective* connaturality with reality as non-conceptualizable, because awakening to themselves the creative depths of the subject"; and (4) there is "connaturality with reality as non-conceptualizable" which may be of two kinds: either (4A) supernatural contemplation or supernatural mystical experience—an "*affective* connaturality . . . by means of the union of love and of a specific resonance in the subject itself . . . [that] attains as its object the divine reality of itself inexpressible in any created word," or (4B) natural contemplation or natural mystical experience—an *intellectual* connaturality [with reality as nonconceptualizable] . . . by means of a supra- or para-conceptual intellection [that] attains a transcendent reality of itself inexpressible in any human mental word."[27]

In both of the above divisions, the distinction between affective and intellectual connaturality remains constant, as does the basic types of connaturality enumerated. The next listing appears in *Existence and the Existent*, and it shows something interesting. While there is another threefold division, this time there are no subdivisions and all of the modes listed are of the affective type; the modes of intellectual connaturality do not appear. This restrictive listing makes sense because in all of these instances, Maritain is using the term "connaturality" to focus on the knowledge of subjectivity. Accordingly, each of these is affective and reveals a relation between a subject and some object: (1) practical or prudential knowledge—"which judges both moral matters and the subject itself"; (2) Poetic Knowledge—"in which subjectivity and the things of this world are known together"; and (3) mystical knowledge—"which is not directed towards the subject but . . . in which God is known by union and by connaturality of love."[28]

27. Jacques Maritain, *Ransoming the Time*, 256–64 (emphases added).
28. Jacques Maritain, *Existence and the Existent*, 70–71.

In the same year that *Existence and the Existent* appeared in French (1947), Maritain published another book, *Raison et raisons: Essais détachés*. This book appeared in English in 1952 under the title of *The Range of Reason* and the content was slightly altered compared to the 1947 French edition. Six essays were deleted while seven others were added. One of those additions to the English edition was an essay, "On Knowledge through Connaturality,"[29] a paper which Maritain had read at the Second Annual Meeting of the Metaphysical Society of America in February 1951. In it Maritain once again takes up the treatment of connaturality and a division of the types of connatural knowledge. In addition to the usual breakdown, and while altering his language slightly, Maritain nonetheless provides two very important insights concerning his two main distinctions: affective and intellectual connaturality, and "reality as conceptualizable" and "reality as nonconceptualizable." With regard to the first of these, Maritain writes:

In this knowledge through union or inclination, connaturality or congeniality, the intellect is at play not alone, but together with affective inclinations and the dispositions of the will, and is guided and directed by them. It is not rational knowledge, knowledge through the conceptual, logical and discursive exercise of Reason. But it is really and genuinely knowledge, though obscure and perhaps incapable of giving account of itself, or of being translated into words.[30]

With this as a preliminary remark concerning connatural knowledge in general, this listing includes, with one parenthetical exception, only those affective forms of connaturality which he had listed previously: (1) mystical experience or supernatural contemplation, (2) Poetic Knowledge, and (3) moral experience or prudential knowledge. Maritain's parenthetical exception contrasts supernatural mystical experience and natural mystical experience or natural contemplation. As stated in the *Ransoming the Time* listing (and in contrast to *The Range of Reason* passage that pertains to affective connaturality exclusively), in natural mystical experience, the intellect operates alone ("but the connatural-

---

29. Jacques Maritain, *The Range of Reason*, 22–29.
30. Ibid., 23.

ity in question here is merely intellectual"). If the will or the affections do play any part, it is not in their capacity for loving but in their capacity for directing ("the essential part played by the will consists in forcing the intellect inwards, against the grain of nature"). Thus while acknowledging that there is such a thing as intellectual connaturality, Maritain's later thought emphasizes that the more fitting context for a discussion on connaturality is within the domain of affectivity or affective inclination. The "intellectual intuition" of the early treatments does not appear in the latter two listings; Maritain retains only natural mystical experience.[31]

Finally, some also may find the expressions "reality as conceptualizable" and "reality as non-conceptualizable" troubling. In the case of the former expression, it is possible for the reality that is grasped connaturally to be understood conceptually and expressed linguistically. The latter expression, however, is also a "reality" grasped connaturally, but in this case it is incapable of being understood conceptually and it cannot be expressed linguistically. This limitation does not make the reality grasped any less real. In *The Range of Reason,* and in reference to moral experience specifically, Maritain says: "It is through connaturality that moral consciousness attains a kind of knowing—inexpressible in words and notions—of the deepest dispositions—longings, fears, hopes or despairs, primeval loves and options—involved in the night of the subjectivity."[32] It is legitimate to extend this claim to the other types of affective connatural knowledge, especially since the knowing subject is an unfathomable and inexhaustible mystery in the depths of his or her own subjectivity. By this insight, Maritain is clearly indicating that the "reality" that escapes the penetrating and conceptualizing eye of the intellect may be grasped obscurely and in a fashion that is "incapable of giving account of itself" through these diverse forms of affective connaturality.

Figures 3-1 and 3-2 summarize Maritain's various distinctions con-

31. It is perhaps further interesting to note that in Maritain's major epistemological opus, *The Degrees of Knowledge,* the only discussion of connatural knowledge occurs within a chapter entitled "Mystical Experience and Philosophy." After passing the usual general remark about connaturality, his discussion turns exclusively to supernatural contemplation or supernatural mystical experience; see 260f.

32. Jacques Maritain, *The Range of Reason,* 26.

FIGURE 3-1. Maritain's Uses of Intuition

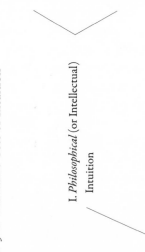

**MARITAIN'S USES OF INTUITION**

**I. *Philosophical* (or Intellectual) Intuition**

A. *Intellect immediately informed by essence:*
  1. Knowledge God has of Himself
  2. Knowledge an angel has of himself
  3. Beatific Vision

B. *Intellect immediately informed by a psychic similitude or species impressa:*
  Sense intuition

C. *Intellect immediately informed by existence and action (but not the essence) of the soul:*
  Intuition of the self

D. *Intellect immediately informed by a psychic similitude or species expressa:*
  Intellectual or abstractive intuition

E. *Intellect immediately informed by the act of existing of something:*
  Intuition of being

**II. *Nonphilosophical* (or Divinatory) Intuition**

A. *Intellect spontaneously divines the moral or natural law concerning an action to be done:*
  Moral or prudential intuition

B. *Intellect spontaneously divines beauty or rules of art:*
  1. Poetic intuition
  2. Creative intuition

C. *Intellect spontaneously divines its created dependency upon a Supreme Being:*
  Natural intuition of God's Existence[a]

D. *Intellect spontaneously divines God's infused love:*
  Supernatural intuition of God

a. For Maritain's discussion of this type of intuition, see Jacques Maritain, *Approaches to God* (New York: Macmillan, 1965), chap. 3

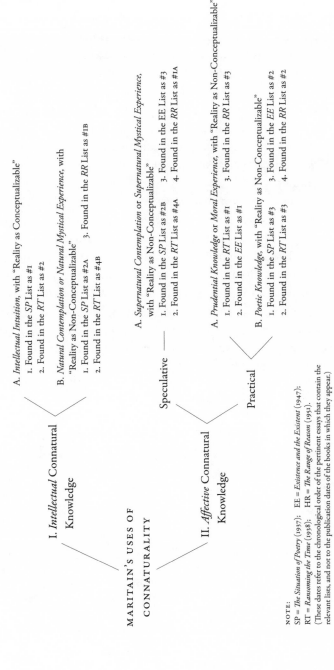

FIGURE 3-2. Maritain's Uses of Connaturality

MARITAIN'S USES OF
CONNATURALITY

I. *Intellectual* Connatural
Knowledge

A. *Intellectual Intuition*, with "Reality as Conceptualizable"
  1. Found in the *SP* List as #1
  2. Found in the *RT* List as #2

B. *Natural Contemplation or Natural Mystical Experience*, with "Reality as Non-Conceptualizable"
  1. Found in the *SP* List as #2A    3. Found in the *RR* List as #1B
  2. Found in the *RT* List as #4B

Speculative

A. *Supernatural Contemplation or Supernatural Mystical Experience*, with "Reality as Non-Conceptualizable"
  1. Found in the *SP* List as #2B    3. Found in the EE List as #3
  2. Found in the *RT* List as #4A    4. Found in the *RR* List as #1A

II. *Affective* Connatural
Knowledge

Practical

A. *Prudential Knowledge or Moral Experience*, with "Reality as Non-Conceptualizable"
  1. Found in the *RT* List as #1    3. Found in the *RR* List as #3
  2. Found in the EE List as #1

B. *Poetic Knowledge*, with "Reality as Non-Conceptualizable"
  1. Found in the *SP* List as #3    3. Found in the EE List as #2
  2. Found in the *RT* List as #3    4. Found in the *RR* List as #2

NOTE:
SP = *The Situation of Poetry* (1937);    EE = *Existence and the Existent* (1947);
RT = *Ransoming the Time* (1938);    HR = *The Range of Reason* (1951).
(These dates refer to the chronological order of the pertinent essays that contain the relevant lists, and not to the publication dates of the books in which they appear.)

cerning intuition and connaturality. These figures suggest several conclusions. First, in the overwhelming number of instances, connatural knowledge is of the affective type. Second, the distinction between *intellectual* and *affective* connaturality corresponds to the distinction between *philosophical* and *nonphilosophical* intuition. Third, connaturality is a type of knowledge that comes about through a type of immediate and/or spontaneous experience. In other words, connaturality comes about through a type of intuition. For example, Poetic Knowledge as a specific type of affective connatural knowledge involves a poetic or creative intuition which is a type of nonphilosophical intuition.

And finally, Maritain uses these two terms, intuition and connaturality, to designate different aspects of one integrated knowing experience. "Intuition" designates its immediate and/or spontaneous character, while "connaturality" calls attention to the fact that this type of knowledge is "lived," nondiscursive, nonconceptual, and an integrated experience. Maritain uses the expression "experience/knowledge" to designate this unique type of knowing. It is, he says, "a knowledge that is different enough from what we commonly call knowledge, a knowledge which is not expressible in ideas and in judgments, but which is rather experience than knowledge."[33]

33. Jacques Maritain, *The Situation of Poetry*, 44–51; see also 44–51.

# THE FUNDAMENTALS OF
# MARITAIN'S AESTHETICS

⌒

*Things are not only what they are. . . .*
*They are better and worse than themselves, because being superabounds.*

—Jacques Maritain

## "AESTHETIC EXPERIENCE"

Although the discipline of aesthetics covers a multitude of experiences and problems, there are within it many issues that are specifically metaphysical and/or epistemological in nature.[1] For this reason, any theory of aesthetics must include a critical examination of the theory's metaphysical and epistemological principles; a theory that omits this runs the risk of being foundationally deficient. Moreover, just as in the philosophy of science, where constructive progress is best made by those who are firmly grounded in both philosophy and science, so too in aesthetics, the philosopher of art should have not only a knowledge of the basic problems and solutions of a consistent tradition of metaphysics and epistemology, he or she also will profit from having

---

1. "If we would accurately describe this branch of philosophy, we should term it the *philosophy of making,* but we shall call it simply the *philosophy of art*"; Jacques Maritain, *An Introduction to Philosophy,* 195. In a footnote, Maritain makes a specific comment on the limitations of the use of the term *aesthetics:* "The term *aesthetics,* which has now become current would be doubly incorrect here. Modern writers understand by the word *the theory of beauty and art,* as though the philosophy of art were the place in which to treat questions concerning beauty considered in itself (such questions belong to ontology), and as though art were confined to the fine arts (a mistake which vitiates the entire theory of art). Moreover, the word *aesthetics* is derived etymologically from sensibility (*aisthanomai* = feel), whereas art, and beauty also, are matters of the intellect, quite as much as of feeling."

some lived experience with creative activity and art appreciation as well.

The logic of comparison between the philosophy of science and the philosophy of art appears rather tidy. However, since both science and philosophy are speculative activities, one is more likely to find their concurrence in one thinker than is the case with philosophy (a speculative activity) and art (an activity of practical intelligence). While it is true that these activities are all intellectual in nature, it is also true that in the case of philosophy and art, the intellect is exercising its activity in two diverse ways.[2]

These remarks are especially true for that artistic activity that is creative or a specifically work-producing activity. However, the term "art" in its strict and proper signification does not encompass the entire range of "aesthetic experience"[3] which includes the emotional response to and appreciation of some art form.[4] Thus the problem concerning the intellect's role in the philosophy of art is more complex since the field of aesthetics, in its broadest application, includes both artistic creativity and art appreciation/art criticism.[5]

2. "Aristotle has shown . . . that the absolutely first and primordial division to be recognized with respect to the activity of the intellect is the division between the speculative or theoretical intellect and the practical intellect. This does not mean a distinction between two separate powers but a distinction between two basically different ways in which the same power of the soul—the intellect or reason—exercises its activity"; Jacques Maritain, *Creative Intuition,* 45–46.

3. Maritain uses the expression "aesthetic emotion." Both of these expressions, "aesthetic experience" and "aesthetic emotion," designate the broadest range of felt or lived experience concerning the human encounter with, emotional response to, and appreciation of some art form. They should not be confused with Maritain's notion of "*Poetic* Experience" which is a term he uses to designate a specific experience proper to the *creative* artist alone. For Maritain's remarks concerning "aesthetic emotion," see his note 56, *Art and Scholasticism,* 162–67; for Maritain's treatment of "Poetic Experience," see *Creative Intuition,* 238f.

4. The term "art form," in its broadest sense, covers virtually *any* work of a particular creative genre: music, painting, film, novels, poems, plays, sculpture, dance, etc., without any consideration given to, or any judgments about, their qualitative merits.

5. See, e.g., the classic text of Melvin Rader, ed., *A Modern Book of Aesthetics* (New York: Holt, Rinehart and Winston, 1965). Rader divides the anthology into three parts: (1) Art and the Creative Process; (2) The Work of Art; and (3) Appreciation and Criticism.

But these matters are more complicated still, since most people feel that "beauty is in the eye of the beholder." In other words, in artistic taste and aesthetic appreciation, *opinio aut de gustibus non est disputandem,* that is, opinions or tastes are subjective and therefore not disputable. People see themselves as their own judges and critics of what pleases them, and, in the bargain, believe that they participate or share in that great human enrichment, "aesthetic experience."

Fortunately, in the face of the complete subjective relativism of taste, opinion, and emotions, Maritain comes to our aid. "Aesthetic experience," which may produce some form of emotional response (tears, a warm glow, a feeling of pride, etc.), may be little more than what Maritain calls "subjective emotion." He distinguishes this type of emotion from "intentional or spiritualized emotion."[6] In this way, Maritain establishes a general distinction between two fundamentally different types of emotion of which we are all capable. Maritain speaks of subjective emotion as "the inexhaustible flux of superficial feelings in which the sentimental reader recognizes his own cheap longings, and with which the songs to the Darling and Faithless One of generations of poets have desperately fed us."[7] By contrast, intentional or spiritualized emotion is not a subjective emotion stimulated by a work of art which moves the one who encounters the work. Rather, Maritain says, intentional or spiritualized emotion is "an emotion as *form,* which . . . gives form to the poem, and which is *intentional,* as an idea is, or carries within itself infinitely more than itself."[8] Permeating the fiber of the artist's being, this kind of emotion emanates through the creative act, and radiates the significance that characterizes a genuine work of art. "[F]alling into the living springs, [this emotion] is received in the vitality of intelligence, I mean intelligence . . . virtually turned toward all the harvests of experience and memory preserved in the soul, all the universe of fluid images, recollections, associations, feelings and desires latent, under pressure, in the subjectivity."[9]

In his study *Maritain's Theory of Poetic Intuition,* Sean M. Sullivan,

6. Jacques Maritain, *Creative Intuition,* 118–25.
7. Ibid., 113.     8. Ibid., 119–20.
9. Ibid., 122.

T.O.R., helps us to understand Maritain's distinction between subjective and spiritualized emotion as he uses the language of psychology and the distinction between "sentiment" and "sentimentality."[10] Fr. Sullivan suggests that "sentiment" refers to or is consonant with true, authentic emotion, while "sentimentality" refers to the inauthentic. Sentiment is a "spontaneous . . . affective response to a valued situation or object,"[11] though this spontaneity is not necessarily about bodily or physiological responses. Rather, it presupposes the operation of reason or the intelligence as a preconditioning factor that disposes the subject's response in a specific way based upon that person's consciously affirmed values. "Sentiment, as a manifestation of genuine affectivity, is at its inception an instinctive judgment of value primarily rooted in the specific nature of any one individual as he [or she] is qualified tendentially."[12]

Sentimentality, on the other hand, is "the manifestation of non-genuine affectivity which finds its basis either in conventionality or in ego-centricity—or in both."[13] The term "conventionality" refers to a feigned emotional response which one learns through the requirements of a given social situation, and hence is inauthentic. When it comes to "ego-centricity," however, the question of values reappears. Sullivan distinguishes between concrete value (that which dispassionate reason determines as value) and subjective value (that which is of value to and for an individual), and he goes on to note that an attitude of egocentricity, "leads to an artificially exaggerated concern for the subjective factor to the extent that the necessary relationship which genuine affectivity has to objects initiating affective response becomes disjointed."[14] As a consequence, all genuine appreciation for concrete values may be lost, since value itself "cannot exist in the absence of concrete reality."[15] Ultimately, the affective life of the self-centered ego, by shifting one's focus from concrete objectivity to one's own subjectivity, becomes superficial and inauthentic.

10. Sean M. Sullivan, T.O.R., "Maritain's Theory of Poetic Intuition," unpublished doctoral dissertation, University of Fribourg, Switzerland, 1963.

11. Ibid., 59.                    12. Ibid.
13. Ibid., 60.                    14. Ibid., 61.
15. Ibid.

Thus the person who comes to participate in *genuine or authentic* "aesthetic experience" (and who subsequently may come to reflect upon it) does not do so simply by virtue of his or her subjective tastes or some feeling of "sentimentality" in either its conventional or egocentric forms. Rather, it is through significant emotion, that is, through the intentional or "spiritualized emotion,"[16] that *genuine* aesthetic experience is born. This emotion "carries the reality which the soul suffers—a world in a grain of sand—into the depth of subjectivity, and of the spiritual unconscious[17] of the intellect."[18] In this fashion, we come to distinguish genuine or significant "aesthetic experience" from subjective sentimentality. Perhaps an example will be helpful: for some people, sad lyrics or a really "sweet" melody might evoke tears of melancholy, while for others, the adagio movement from Beethoven's *9th Symphony* or Mahler's *5th Symphony* might do the same. These emotions, though outwardly similar, are not the same. Even though *subjectively* the experience in either case is real for the person having the respective emotion, *objectively,* or in the sphere of concrete values, these two contrasting emotions and their corresponding experiences are not the same at all. Thus one may distinguish genuine from superficial aesthetic experience. Moreover, to the extent to which a person participates in genuine aesthetic experience, he or she may qualify as an able and suitable commentator on it.

Spiritualized emotion is thus entirely natural, and each of us is potentially capable of it. As such, it is ontologically prior to any creative or Poetic intuition and makes the latter possible. As a corollary, "aesthetic experience" is also more comprehensive than "Poetic experience" or creative intuition. Thus, "aesthetic experience" encompasses both the "creative" aspect and the genuine emotional experience found in any encounter with aesthetic beauty, whether in nature or in works of art. In both cases, regardless of whether the creative aspect or the appreciative aspect predominates, the presence of spiritualized or

16. For a more detailed discussion of spiritualized emotion, see chapter 5.

17. Maritain distinguishes the notion of a spiritual unconscious from the animal or Freudian unconscious; see Jacques Maritain, *Creative Intuition,* 90–92.

18. Ibid., 122.

intentional emotion is the essential underlying ingredient of any form of *genuine* aesthetic experience.

Moreover, we can now see clearly that the field of aesthetics is actually constituted by these two aforementioned distinguishable "moments." On the one hand, there is the creative activity of the artist which ends in the production of a work. The other moment presupposes the existence of the work of art, and concerns the experience of the "audience"—all those persons with varying degrees of aesthetic sophistication, knowledge, and emotional maturity, who come upon the art object and experience it. The professional whose role it is to view and judge these works of art may be called a "critic."

While modern studies in aesthetics may be concerned with one or the other aspects of "aesthetic experience," Maritain is not. Although there are passing footnotes concerning criticism in both *Art and Scholasticism* and *Creative Intuition in Art and Poetry,* in the main, the central focus of his writing in the philosophy of art, from *Art and Scholasticism* (1920) to *The Responsibility of the Artist* (1960), concerns creative activity or "art" in its fundamental sense, "the creative or producing, work-making activity of the human mind."[19]

Moreover, while there are also pages that concern art and morality (and prudence), these are generally used to distinguish the former from the latter, and thereby indicate the proper sphere or domain of each, especially since they are closely related as virtues of the practical intellect. Furthermore, Maritain generally is not concerned with the specific philosophical problems relating to the audience (aesthetic appreciation), with the possible exception of his discussions on the perception of beauty. These discussions are rooted in the ontological nature of beauty primarily, though he does discuss the perception of the beautiful as well. These matters will be the subject of chapter 8.

For the present, we should keep in mind that regardless of whether one is referring to the connatural experience/knowledge[20] of the artist leading to the production of a work, or the connatural expe-

19. Ibid., 3.
20. This expression, "experience/knowledge," is Maritain's; see *The Situation of Poetry,* 51..

rience/knowledge of the person who encounters and delights in the work, in both cases it is always the *human person* who is the subject about whom the experience is predicated. And this subject or person does not appear or exist in some theoretical abstraction, but in the concrete, flesh-and-blood reality of his or her individuation, that is, a dynamic, learning, experiencing, feeling, spirit-incarnate reality of a person who brings *to* the work (again, either in making it or in appreciating it) a complex tangle of his or her own unique life experiences. And it is this infinitely complex reality of the human *person,* together with his or her intimate and experiential relationship to the inexhaustibly rich *universe,* which make both forms of experience/knowledge possible. In *Creative Intuition in Art and Poetry,* Maritain uses the two simple words "Self" and "Things" to designate these profound and complex realities.

## THE "SELF" AND "THINGS"

Maritain's remarks concerning "the Self" in *Creative Intuition* are indeed sparse. To understand those limited remarks in their depth and within their proper philosophical context, we must look elsewhere. His discussion in his book *Existence and the Existent,* however, is especially germane. In the chapter entitled "The Existent," Maritain begins his rather technical philosophical discussion with what in traditional Thomist language is known as the supposit or *suppositum.* This term refers to any of a particular class of existent beings, namely, those that "subsist" and are designated as subsistent beings. This distinction between existence and subsistence is an important though often obscured and frequently overlooked precision, especially in modern and contemporary philosophy. "Existence" is a term that refers to anything at all that may be said "to be"—it encompasses the entire analogical range of the verb "is" and as such designates not only material and spiritual beings (or substances), but accidental, imaginary, and purely rational or logical beings as well.

While it is true that all subsisting beings exist, the converse is not also true. Thus subsistence refers to a special class of existing beings,

namely, those that have their own substantive existence. The word "substance" is perhaps the most frequent translation of what Aristotle termed *ousia* and Aquinas called *suppositum*; Maritain employs the word "subject." Having their being in themselves and not in another, these supposits or subjects have two distinguishable aspects, their essence (*essentia*) and their act-of-existing (*esse*). Maritain says: "Essence is *that which* a thing is; suppositum is *that which* has an essence, *that which* exercises existence and action—*actiones sunt suppositorum*—*that which* subsists."[21]

Traditionally, the term *esse* is used to refer to the act-of-existing whereby a possible or conceivable essence is actualized in the concrete or existential order, while *essentia* refers to the "what-ness" or essence of a particular substance; it is that which makes a thing *what* it is without qualification. For Maritain, following St. Thomas, the relation of *essentia* and *esse* is not the same as the relation of form and matter in the philosophy of Aristotle. Aquinas understood that the essential definition or nature of a material being is ultimately *signified* by both the substantial form and the prime matter—these two together define the essence of a being, which in turn requires an act-of-existing (*esse*) in order that the essence (possible or conceivable) may be particularized and made actual, *hic et nunc*.

But there is more. In material substances, gold, for example, "the essence" is a universal. Regardless of whether a particular piece of gold exists or not, the essence, the "what-ness," is the same. The variables that "modify" a particular piece of gold do so only through its concrete existence—for just as *esse* is related to *essentia* as act is related to potency (i.e., *esse* is the act-of-existing of the essence, which is, at least theoretically, in potency to being made actual), so are the *accidents* (i.e., the concrete variables or individuating characteristics) related to *substance* as act to potency (i.e., the accidents actually modify the existing substance in some particular way rather than another).

There is another important point concerning these two relationships, however. On the one hand, the distinction concerning the re-

lation of accidents and substance is a real *distinction*—by definition, accidents have their being "in" another, while the substance, although actually modified by the accidents in a specific way, does not, for all that, receive its unqualified act-of-existing from these modifications. For example, while the yellow color of the gold is "in" the gold, it is not "the yellow" that makes this piece of gold exist. On the other hand, the relation of *esse* and *essentia* is not only a real distinction but a real *separation* as well—the contingency of a created existent makes clear that it is possible for all things *not* to exist. And yet we can still *understand* or comprehend the meaning of the essence of something. For example, the *essence* of the dodo bird remains entirely unchanged by the fact that none actually exist any longer.

These various distinctions and precisions provide the background against which we can best understand Maritain's language of "individual" and "person." The concrete existence of any supposit is referred to as an individual. Maritain says: "Outside of the mind, only individual realities [or supposits] exist. Only they are capable of exercising the act-of-existing. Individuality is opposed to the state of universality which things [when considered *essentially*] have in the mind."[22] In material beings, "matter" gives them their individuation. Although this is rooted in the "prime matter" of Aristotle (which is only *conceptually* or logically distinct from the substantial form), the matter that gives individuation Aquinas calls "signate or designated matter" (also sometimes referred to as second matter). Signate or designated matter is that matter which can only be pointed to.[23] It is the direct "result" of the actuation of some essence by an act-of-existing, and as

22. Jacques Maritain, *The Person and the Common Good* (South Bend, Ind.: University of Notre Dame Press, 1966; original French edition, 1947), 34.

23. Thomas Aquinas, *On Being and Essence,* trans. Armand Maurer (Toronto, Canada: Pontifical Institute of Mediaeval Studies, 1949), 32: "the matter which is the principle of individuation is not any matter whatsoever, but only designated matter (*materia signata*). By designated matter I mean matter considered under determined dimensions." In his note on the use of the term *materia signata*, Fr. Maurer comments: "A thing is said to be designated (*designatum, signatum*) when it can be shown or pointed to with the finger. This is true of the individual thing, but not of the abstract nature. The latter can be defined; the former can only be pointed to. In this sense, *designated* is equivalent to the demonstrative article *this.*"

such gives to the material being not only its existence but, through the matter, its individuality as well.

[I]ndividuality is rooted in matter in as much as matter requires the occupation in space of a position distinct from every other position. . . . By the fact that it is ordained to inform matter, the form finds itself particularized in such and such a being which shares the same specific nature with other beings equally immersed in spatiality.[24]

The relation of form and matter constitutes a unity in the order of substance. Aquinas's unique and penetrating metaphysical insight is precisely this: beyond the unity (in the *essential* order) of substantial form and prime matter, the unity in the order of existence (or *existential* order) requires the added relation of essence and act-of-existing. This observation is as true for animate as for inanimate beings. And since the word "soul" (*psyche, anima*) is the name assigned to the substantial form of living beings, and "body" (*soma, corpus*) is the name assigned to the prime matter of living beings,[25] we can understand that just as form and matter are distinguishable coprinciples of a substantial unity, in a like manner, so too are soul and body. Drawing upon Aquinas's insight, and focusing our attention specifically upon human persons, we find the following conclusion: the essence of human persons (when articulated in terms of substantial form and prime matter equals "besouled-body") enters into a substantial and existential unity only insofar as these coprinciples are actualized through their participation in the *Ipsum Esse Subsistens,* the Self-Subsisting Act-of-Existing (God). Thus, the unity of soul and body, when made actual in concrete existence, is not some extremely close and intimate relation of two independent substances (soul *and* body), as the dualism of Plato and Descartes presumed. No! Rather, a human person, in his or her concrete existence, comprises one single subsisting being or supposit. Soul and body are two substances that function as co-

---

24. Jacques Maritain, *The Person,* 35–36.
25. *Psyche* and *soma* are the names Aristotle gave to the substantial form and prime matter of *animate* beings; *inanimate* beings have no special names for their substantial form and prime matter.

principles of the one existent reality, the human person.[26] Moreover, "because each soul is intended to animate a particular body, which receives its matter from the germinal cells, with all their hereditary content, from which it develops, and because, further, each soul has or *is* a substantial relation to a particular body, it has within its very substance the individual characteristics which differentiate it from every other human soul."[27]

On this reckoning, individuality in human beings is radically more than the individuation that is transmitted through matter alone. The act-of-existing not only makes one's "matter" intimately and uniquely one's own, but, since the distinctive nature of the human soul specifies it as a substance, the act-of-existing also gives to one's soul the same intimacy and originality which distinguishes it as one's own. Thus a person's individuality is communicated not only by the "mineness" of the matter, but by the unique "mineness" of one's soul as well.

In this way, Maritain sets up the distinction between individuality and personality. "We have sketched briefly the theory of individuality. Personality is a much deeper mystery,"[28] though the reason for that mystery, rightly understood, is quite simple. When we consider the whole of material creation, the whole existent universe, the uniqueness of human nature stands out sharply. While it is true that, for Maritain, the whole of creation participates in the causal power and majesty of the Divine, and thereby offers to the enlightened observer a universe inexhaustible in its intelligible mystery manifesting God's goodness and beauty, there is also, nonetheless, a certain mode of participation in the Divine that is distinctive of the human person by virtue of which he or she is in a privileged position when contrasted with the rest of God's creation. Fashioned in God's own image and likeness, "it is the spirit which is the root of personality."[29]

This spiritual dimension of human existence specifies our nature and makes us capable of the unique activities that are in accordance

---

26. Jacques Maritain, *The Person*, 36.   27. Ibid.

28. Ibid., 38.

29. Jacques Maritain, *Education at the Crossroads* (New Haven, Conn.: Yale University Press, 1943), 8.

with, or follow from, that nature. *"Operatio sequitur esse."* For this reason, Aquinas says simply that the term *"person* signifies . . . a subsistent individual of a rational nature."[30] Surprisingly, perhaps, Maritain's discussion of this mystery of the human person does not proceed from human intellectual *knowledge,* but rather from the exercise of the spiritual or intellectual *appetite,* generally called the will: "Perhaps the most apposite approach to the philosophical discovery of personality is the study of the relation between personality and love."[31] Aquinas's own definition of persons designates them as individuals of a rational nature who have control over their own actions.[32] Maritain is following that designation and building upon it when he focuses attention on the way in which a person's capacity for selfless love is rooted ultimately in freedom and spirituality. To bestow one's self in love requires that the person exist "in self-possession, holding itself in hand, master of itself. In short, it must be endowed with a spiritual existence, capable of containing itself thanks to the operations of the intellect and freedom, capable of super-existing by way of knowledge and of love."[33]

These distinctive features of human personality, the capacity for intellectual knowledge and selfless love, situate man in a mode of being that is naturally communicative: "By the very fact that each of us is a person and expresses himself to himself, each of us requires communication with *other* and *the others* in the order of knowledge and love. Personality, of its essence, requires a dialogue in which souls really communicate."[34] This desire for genuine or intimate communication is, however, seldom achieved. All rational substances or supposits exist in reality as the infinite and "inexhaustible well of knowability" which they are in themselves. On the horizontal plane,[35] persons will

30. St. Thomas Aquinas, *Summa Theologica,* trans. Fathers of the English Dominican Province (New York: Benziger Brothers, 1947), I. 29.3.

31. Jacques Maritain, *The Person,* 38.

32. St. Thomas Aquinas, *Summa Theologica,* I. 29.1.

33. Jacques Maritain, *The Person,* 40.

34. Ibid., 41–42.

35. While the spatial imagery in the expressions "horizontal plane" and "vertical plane" is admittedly less than desirable, it does provide a useful metaphor in this instance.

never truly know another person nor will they ever be known completely because of the limitations of conceptual knowledge. We acquire what we know of others primarily by "objectising" them. This is Maritain's somewhat awkward expression. We do not know subjects as subjects since our knowledge is attained "by achieving objective insights" of subjects—that is, by "making them our objects; for the object is nothing other than something of the subject transferred into the state of immaterial existence of intellection in act."[36] Since this concept formation holds equally true for the knowledge that we possess of persons as well as all other beings, our natural objectising inclination through conceptual knowledge restricts our ability for achieving genuine communication.

Although we do have an obscure knowledge of our own subjectivity as subjectivity,[37] the possibility of overcoming this objectising operation of the intellect and of genuinely knowing another person in the depth of his or her subjectivity is possible only through authentic love. In this case, God's love, of course, is the supreme or primary analogate. Since a person's understanding of his or her own subjectivity is obscure even to him- or herself, it is only in the knowledge and love that God has for us that we are known in the depths of our own subjectivity. To understand what this love of God for every person truly means is also to have some understanding of God's justice and mercy, Maritain says.[38] In any case, the innate longing for overcoming the experience of separateness is accomplished through God's love for persons. (To be sure, this is not always *experienced* in the psychological order even though it does occur in the metaphysical order.) Thus,

36. Jacques Maritain, *Existence and the Existent,* 67.

37. Maritain cites four examples of our knowledge of our own subjectivity as subjectivity, all of which were mentioned in the preceding chapter. The first is "the intuition of the self, the soul, or of one's own subjectivity," where one comes to an intuition of the soul's existence though not of its essence. The other three senses concern the *nonphilosophical* knowing or divination which comes through connaturality. These are (1) prudential knowledge, (2) Poetic Knowledge, and (3) mystical knowledge. In each of these cases, though it is not *philosophical* or rational knowledge proper, Maritain does claim that the subject does gain some insight of its own subjectivity.

38. See Jacques Maritain, *Existence and the Existent,* 77–79.

what is impossible on the horizontal plane, God makes actual on the vertical plane.

But enter authentic love in human experience also and all the rules are broken, for love makes the impossible possible, even on the horizontal plane. To the extent to which one participates in the Divine Selfless Generosity and comes to understand "that love is not a passing pleasure or emotion, but the very meaning of . . . being alive," to that same extent one has the means of being able to enter into the sacred subjectivity of the other which love transforms into another "ourself," thus permitting the communion of two subjectivities, and the overcoming of the prison of separateness.

By love, finally, is shattered the impossibility of knowing another except as object. . . . To say that union in love makes the being we love another *ourself* for us is to say that it makes that being another subjectivity for us, another subjectivity that is ours. To the degree that we truly love (which is to say, not for ourselves but for the beloved; and when—which is not always the case—the intellect within us becomes passive as regards love, and, allowing its concepts to slumber, thereby renders love a formal means of knowledge), to this degree we acquire an obscure knowledge of the being we love, similar to that which we possess of ourselves; we know that being in his very subjectivity (at least in a certain measure) by this experience of union. Then he himself is, in a certain degree, cured of his solitude; he can, though still disquieted, rest for a moment in the nest of the knowledge that we possess of him as subject.[39]

This person, this spiritual supposit, is unique in its ability to understand and love—those two powers through which the infinite richness, splendor, and intelligibility of the created universe (objects and persons together, along with the complexity of relations) come to be received within us by knowledge and love. And it is precisely this meaning of the term "person" that Maritain wishes to designate by using the single, simple word "the Self." Then, in the depth of its subjectivity, the Self enters into a "mutual entanglement"[40] with that other vast and inexhaust-

39. Ibid., 84.
40. Jacques Maritain, *Creative Intuition,* 9–10.

ible sea of splendor and intelligibility, the universe of created beings and relations, things that have their own objective, independent existence. It is these that Maritain simply calls "the Self" and "the *Things*."

I need to designate both the singularity and the infinite depths of this flesh-and-blood and spiritual existent, the artist; and I have only an abstract word: the Self. I need to designate the secretive depths and the implacable advance of that infinite host of beings, aspects, events, physical and moral tangles of horror and beauty—of that world, that undecipherable Other—with which Man the artist is faced; and I have no word for that except the poorest and tritest word of the human language; I shall say: the things of the world, the Things.[41]

Just as Maritain's notion of the Self involved the broader discussion of his notion of the person, so too his notion of "the things of the world," presupposes the broader metaphysical discussion of creation. The "Things" are causally sustained in existence through their participation in an act-of-existing as radiated by the *Ipsum Esse Subsistens*. Through this participation, all created beings receive not only their very existence, but their aspect of mirroring and reflecting the inscrutable, unfathomable, and ineffable ocean of Divine Intelligibility. Thus, employing what only appears to be contradictory logic, Maritain rather mystically asserts:

Things are not only what they are. They ceaselessly pass beyond themselves, and give more than they have, because from all sides they are permeated by the activating influx of the Prime Cause. They are better and worse than themselves, because being superabounds.[42]

### THE INTERRELATION OF THE POWERS
### OF HUMAN KNOWING

As we noted in the introduction, the investigation of human nature requires that we employ the broad metaphysical principle called the "principle of operation": *operatio sequitur esse*. This principle says

41. Ibid., 10.
42. Ibid., 127.

that "a being acts in accordance with its nature," or "as a being is, so it acts." Within this principle, there are two orders, the order of nature, and the order of discovery or knowledge. In the order of nature, the nature of a being is the cause of its unique operations or activities (the "effects"). For the order of discovery or knowledge, on the other hand, it is the priority of our knowledge of these effects (operations or activities) that "causes" (so to speak) our knowledge of, or causes our "discovery of," the cause. "By the fruit you know the tree."

For the most part, when Maritain discusses the nature and inter-relation of the powers of human knowing, particularly in *Creative Intuition,* he proceeds from the causal or ontological order of nature.[43] However, when he discusses the relationship of the senses and the intellect, as these powers emanate from the soul, he first introduces a related distinction between temporal or developmental priority and a priority of nature. In developmental priority, Maritain notes that the vegetative powers precede the sensitive powers, which in turn precede the powers of the intellect. In the order of nature, however, the opposite occurs: the lower powers exist for the sake of the higher, thus giving the higher their priority of nature. Since our human nature is generated from one unitive principle (the soul), Maritain notes that not only do the lower sense powers "feed" the higher, but also that the lower powers are permeated by the light and energy of the higher intellectual powers. As a result, the priority of nature recognizes that human sensation is never entirely the same as sensation in animals since our human powers issue from an intellectual source or principle that is different in kind from those of the animal. Ontologically considered, the human person is one being with two dimensions, the lower or material aspect which is in the service of and yet permeated by the higher, spiritual dimension. All human powers are thus at work in our experience of life, and although distinctions of the various powers can be made by virtue of their proper objects, these distinctions are only useful in understanding more fully the integration of our unified lived

43. See his discussion, ibid., 106–9.

experiences. As we will see in the next chapter, Maritain also calls this intelligence-infused sensation, "intelligentiated-sense." And so, while ordinary language may speak of this or that power as performing this or that function ("my eyes see"), in reality, it is always *the person* who performs or acts in this or that way by virtue of a particular power ("I see by means of my eyes").

A corollary of this understanding of the interrelation and permeation of our human knowing powers asserts that our ability for acquiring knowledge is not confined to nor exhausted by the conceptual operations of the intellect alone. In addition, we also have the divinatory senses of knowing (identified in chapter 3), as well as that knowledge gained through the formality of love[44] and through the formality of "spiritualized or intentional emotion,"[45] both of which already have been mentioned. All of these modes of experience/knowledge, together with our sensual and rational operations, constitute the complexity and variability proper to the knowing subject, as Things are grasped by the Self in an intentional union.[46] Thus constituted, the Self may possess a conscious, reflective awareness of the Things of the universe and be capable of expressing this knowledge in concepts and language. However, we also may be united to Things in an affective, experiential, and nonconceptual manner as well, that is, through the

44. "[T]he intellect within us becomes passive as regards love, and, allowing its concepts to slumber, thereby renders love a formal means of knowledge"; Jacques Maritain, *Existence and the Existent*, 84.

45. Spiritualized or intentional emotion "is not an emotion expressed or *depicted* by the poet, an emotion as *thing* which serves as a kind of matter or material in the making of the work. . . . It is an emotion as *form* . . . which is *intentional*, as an idea is, or carries within itself infinitely more than itself"; Jacques Maritain, *Creative Intuition*, 119–20.

46. In the traditional Thomist sense, intentionality is that mode of being which things acquire when they have become objects for the intellect; as such, they are called concepts or "ideas" and refer or point, as it were, to the object's own mode of existence as it is in itself. See Jacques Maritain, *Creative Intuition*, 120: "I use the word 'intentional' in the Thomistic sense . . . which refers to the purely tendential existence through which a thing—for instance, the object known—is present, in an immaterial or suprasubjective manner, in an 'instrument'—an idea, for instance, which, in so far as it determines the act of knowing, is a mere immaterial tendency or *intentio* toward the object."

diverse forms of divinatory knowledge, the formality of love, and/or spiritualized or intentional emotion.

Maritain calls this form of nonconceptual, affective, divinatory knowledge "Poetry" and "Poetic Knowledge," two of Maritain's original insights that are central to his philosophy of art. The next chapter examines these notions abstractly and in a nonhistorical way, while chapter 6 will consider their historical development.

# MARITAIN'S NOTIONS OF POETRY AND POETIC KNOWLEDGE

～⋆

*Poetic Knowledge is as natural to the spirit of man*
*as the return of the bird to his nest.*

—Jacques Maritain

## MARITAIN'S MEANING OF THE TERM "POETRY"

The term Poetry[1] does not appear in the first edition of *Art and Scholasticism* (1920). Maritain first uses it in his essay that he added in the second edition (1927), "The Frontiers of Poetry."[2] Although the meaning of this term developed over a lengthy period, Maritain provides his clearest and perhaps most well-known definition of it in *Creative Intuition in Art and Poetry* (1953): "By Poetry I mean, not the particular art which consists in writing verses, but a process both more general and more primary: that intercommunication between the inner being of things and the inner being of the human Self which is a kind of

1. As we begin the discussion of the terms "Poetry" and "Poetic Knowledge," I remind the reader that throughout this study, *my* spelling of these terms is consistently given with capital letters to make clear that these terms refer to the specialized meaning that Maritain assigns to them. By contrast, I have not capitalized the terms "art" or "beauty," since these terms do not have any specialized meaning exclusive to Maritain's thought. See my introduction.

2. This essay was later revised and omitted from the third and fourth French editions, since Maritain published it in a separate book: *Frontières de la poésie et autres essais* (Paris: Louis Rouart et Fils, 1935). The English translation of this book appeared in 1943 under the title *Art and Poetry,* translated by Elva de Pue Matthews (New York: Philosophical Library, 1943). In it, Maritain wrote a new preface, but he removed the title essay since it had already appeared as a supplement in the second English translation edition of *Art and Scholasticism.* The first English translation was done by John

divination."[3] From this definition, three things stand out: the concepts of Things, Self, and divination. We have already discussed each of these: "Things" and "Self" in chapter 4, and divination, as another word for intuition *nonphilosophically* considered, in the latter part of chapter 3. For Maritain, Poetry is a "spiritual energy,"[4] a mode of nonconceptual, nonphilosophical, intuitive knowledge.[5] The notion of "inner being" refers to the "infinite depths" of the knowing "Self," while the "secretive depths" of the "infinite host of beings" refers to "Things."[6] Since human persons are capable of both a keen *intellectus* through the instrumentality of the senses, and a knowing as well as a responding through love and emotion, Maritain uses the term "intercommunication" to call attention to the fact that the knower "becomes" (intentionally) the things known regardless of whether the knowledge is conceptual or not, or whether the knower is consciously aware or not. The good and charitable person who has acquired his virtue through affective connaturality ("by loving goodness and charity") is no less good or charitable for not being able to conceptualize his moral judgments. Similarly, the skillful artist who has acquired his virtue through affective connaturality (Poetic intuition or divination), by loving the limitless manifestations of beauty radiating through all of God's resplendent creation, expresses his insights through works of art, not conceptual formulations.

---

O'Connor with an introduction by Eric Gill (Ditchling, U.K.: St. Dominic's Press, 1923); the second translation was done by J. F. Scanlon (London: Sheed & Ward, 1930; New York: Charles Scribner's Sons, 1930). "The Frontiers of Poetry" first appears in this second English translation edition, and it is subsequently included in all other English editions, including the definitive translation by Joseph W. Evans (New York: Charles Scribner's Sons, 1962). In his translator's note, Dr. Evans says: "'The Frontiers of Poetry' essay, which was added as a supplement in the second edition (1927), is again included, as in the 1930 translation, but it is now given, as Professor Maritain desired, equal prominence with *Art and Scholasticism*." Before its inclusion in the second French edition of *Art et scolastique,* Maritain first published "*Frontières de la poésie*" in the series Le Roseau d'Or 14, Chroniques No. 3 (Paris: Librairie Plon, 1927), 1–55.

3. Jacques Maritain, *Creative Intuition,* 3.

4. Ibid., 4.

5. "[P]oetry obliges us to consider the intellect both in its secret wellsprings inside the human soul and as functioning in a nonrational . . . or nonlogical way"; Jacques Maritain, *Creative Intuition,* 4.

6. See chapter 4 for a detailed discussion of Self and Things.

Thus, a passing flutter of a butterfly against an auburn meadow, the radiant reds of a setting sun, dew drops on a soft rose petal, the brilliant colors that wash over Rouault's clowns, or the "transient motion of a beloved hand—[all exist for] an instant, and will disappear forever, and only in the memory of angels [and artists' souls] will [they] be preserved, above time."[7] In other words, all of these, and the infinite number of the other inexhaustible riches of the universe of Things, may be captured in a fleeting instant and preserved deep within the heart and soul of any person (Self) whose sensitivities are great and whose "eye [has been] grafted on to his [or her] heart."[8] In addition to forming one's disposition and personality, they also form the "unexpressed significance, unexpressed meanings," which "more or less unconsciously putting pressure on the mind, play an important part in aesthetic feeling and the perception of beauty."[9]

Seen in this way, Poetry is ontologically antecedent to Poetic Knowledge. Since these two terms are so close, Maritain frequently, and somewhat carelessly, uses them interchangeably. But their difference, however slight, remains, and it resides precisely in Poetry's ontological priority. Maritain says:

[B]ut *what is* [*P*]*oetry?*—that [P]oetry which is to art what grace is to the moral virtues, and which is not the peculiar privilege of poets, nor even of other artists—it can also be found in a boy who knows only how to look and to say *ah, ah, ah,* like Jeremiah, or who intoxicates himself with it to the point of frenzy or suicide without ever having said or done anything in his whole life.[10]

Since this passage appears in a relatively early work of Maritain's,[11] someone might reasonably conclude that by the time he comes to write his major work on the subject of creativity in art (*Creative Intu-*

7. Jacques Maritain, *Creative Intuition,* 126.

8. Auguste Rodin, quoted by Maritain, *Creative Intuition,* 132.

9. Ibid., 9.

10. Jacques Maritain, *The Situation of Poetry,* 44.

11. Although the French edition of *Situation de la poésie,* the book that contained this essay, came out in 1938, the essay itself appeared in 1937, in *Deuxième Congrès International d'Esthétique et de Science et l'Art,* 2 (1937), 168–70.

*ition in Art and Poetry*), he rejects this purely cognitive aspect of Poetry in favor of its creative aspect. For the moment, suffice it to respond to this idea by noting that in *Creative Intuition,* Maritain primarily focuses his attention on *creative* intuition or, in its broader expression, Poetic Knowledge. As we will see in the next chapter, Maritain developed his notion of Poetic Knowledge chronologically after his notion of Poetry, and he is consistent throughout his career in referring to it as the knowledge proper to the *creative artist* as such. Because the relation between Poetry and Poetic Knowledge evolves gradually, by the time we get to *Creative Intuition,* Maritain does make clear that Poetry is ontologically prior.

## THE PREPARATION FOR "POETIC KNOWLEDGE"

Maritain's notion of Poetic Knowledge developed during the decade from 1927 to around 1937–1938. A discussion of this historical development appears in the first section of the next chapter. For the present, however, the reader should note the fact that virtually no additional writing or new material concerning this notion appeared during the period from the publication of *The Situation of Poetry* (1938) until the publication of *Creative Intuition* in 1953. While one might identify three possible exceptions to this—the essays "On Artistic Judgment,"[12] "Poetic Experience,"[13] and "On Knowledge through Connaturality"[14]—the fact remains that none of these essays contain any insights concerning the development of Poetic Knowledge. For this reason, Maritain's definitive statement on the subject of Poetic Knowledge is in *Creative Intuition*:

Poetic Knowledge is as natural to the spirit of man as the return of the bird

12. Jacques Maritain, "On Artistic Judgment," *Liturgical Arts,* February 1943, 116–17. This essay also appears as chapter 2 of *The Range of Reason.*

13. Jacques Maritain, "Poetic Experience," *Review of Politics* 6 (1944): 387–402.

14. Jacques Maritain, "On Knowledge through Connaturality," *Review of Metaphysics* 4 (1951): 473–81. This essay was presented at the Second Annual Meeting of the Metaphysical Society of America in February 1951, and forms chapter 3 of *The Range of Reason,* English edition only.

to his nest; and it is the universe which, together with the spirit, makes its way back to the mysterious nest of the soul. For the content of [P]oetic intuition is both the reality of the things of the world and the subjectivity of the [P]oet, both obscurely conveyed through an intentional or spiritualized emotion. The soul is known in the experience of the world and the world is known in the experience of the soul, through a knowledge which does not know itself. For such knowledge knows, not in order to know, but in order to produce. It is toward creation that it tends.[15]

In these few sentences, Maritain indicates and expresses all of the unique elements that characterize Poetic Knowledge: (1) "as natural to the spirit of man"—that Poetic Knowledge is a natural expression of the human person's spiritual/intellectual nature;[16] (2) "the mysterious nest of the *soul*"—that Poetic Knowledge in its cognitive aspect resides in the "Spiritual Unconscious" or the "Preconscious of the Spirit," and creative impulses emerge from there; (3) "the content . . . is both the reality of the things of the world and the subjectivity of the [P]oet"—that the intuitive nature of Poetic Knowledge involves the Poet's obscure grasping of *Things* and his or her own *Self*; (4) "obscurely conveyed through intentional or spiritualized emotion"—that spiritualized emotion is the formal cause of Poetic Knowledge, the means through which the artist's creative intuition is conveyed; (5) "the soul is known in the experience of the world" and vice versa—that this obscure intuitive grasping involves a kind of connaturality or divination such that Things and Self resound together; and finally (6) "such knowledge knows, not in order to know, but in order to produce"—that Poetic Knowledge as such is the knowledge proper to the creative artist. Moreover, it is a mode of practical knowledge ordered to the making and good of a work, and as such it is distinguishable from both specu-

---

15. Jacques Maritain, *Creative Intuition*, 124.

16. The expression "natural" as used here does not concern the opposition of natural (as in "of nature" or "material") vs. spiritual, since for Maritain the spiritual dimension of our human intellective soul is entirely natural to our mode of being as a human person, which implies a participation in the causal action and likeness of the Divine. Rather, the term "supernatural" that would be opposite to the use of the term "natural" in the sense distinguished here, would refer to such things as the supernatural Gifts of the Holy Spirit, Sanctifying Grace, etc.

lative knowledge (ordered to the penetration and understanding of the truth of being) and prudential knowledge (ordered to the attainment and good of human actions or behavior).

Maritain's method for expressing his notion of Poetic Knowledge in *Creative Intuition* follows these three steps:

1. Proceeding from what is most clearly seen or known to us, Maritain transports his readers into "the inner mystery of personality"[17] (i.e., into the interior notion of the Self) by tracing the "extraordinarily diversified evolution" whereby "our Western Art passed from a sense of the human Self first grasped as object, and in the sacred exemplar of Christ's divine Self, to a sense of the human Self finally grasped as subject, or in the creative subjectivity of man himself, man the artist or the [P]oet."[18] Maritain enumerates the stages of this evolution as a process which involves four phases and spans more than sixteen centuries of art history, from early medieval art to impressionism.

Greek and Roman art, especially statuary, presented the human being as a superior and idealized object in a universe of objects. The advent of a sense of a spiritual Self emerges in human consciousness with the historical event of Christ. Human beings, persons, now are seen to possess an innate sanctity that transcends the material physical objects of the natural universe. Thus the first phase of the evolution of the Self in art history focuses on the transcendence of the human person over Things. This phase is represented by early medieval art's focus on the divinity of Christ. In the second phase, represented by the art of the Late Middle Ages, the human person is still depicted as an object transcending Things, though now it is Christ in his suffering humanity that predominates. "This is the age of Duccio, Giotto, Angelico, of French and Spanish *Pietà*'s, and, in its final ardor, of Grünewald."[19]

Renaissance and baroque art ushered in the third phase wherein human subjectivity embarked upon a process of internalization. The human person was no longer an *object* to be depicted but, in the per-

17. Jacques Maritain, *Creative Intuition,* 21.
18. Ibid., 21–22.
19. Ibid., 22.

son of the artist, the focus of attention shifted from the object (to be represented) to the individualism expressed by the artist in his or her unique *mode* of presentation. During this phase, a profound process began "which was to last and develop in subsequent centuries, namely the fact that the unconscious pressure of the artist's individuality upon the very object he was concerned with in Nature came to exercise and manifest itself freely in his work."[20]

Maritain maintained that the fourth and final phase of the evolution of the sense of Self or human subjectivity began in the last half of the nineteenth century, commencing with Cézanne. He describes this stage as follows:

In this phase, the process of internalization through which human consciousness has passed from the concept of the Person to the very experience of subjectivity comes to fulfillment: it reaches the creative act itself. Now subjectivity is revealed, I mean as creative. At the same time and by the same token is also revealed the intuitive, and entirely individualized, way through which subjectivity communes with the world in the creative act. While being set free, the basic need for self-expression quickens and makes specific the new relationship of the artist to Things. The inner meanings of Things are enigmatically grasped through the artist's Self, and both are manifested in the work together. This was the time when [P]oetry became conscious of itself.[21]

In this fashion, Maritain gives initial expression to the relationship between the artist's Self and Things, to the evolution of the creative self as witnessed and disclosed by the history of Western art, while at the same time, reinforcing his meaning of "Poetry."

2. The second thing that Maritain does when developing his notion of Poetic Knowledge requires numerous preliminary distinctions reminiscent of his early work, *Art and Scholasticism*. In chapter 2 of *Creative Intuition*, Maritain discusses the following *epistemological* distinctions: (a) speculative knowledge versus practical knowledge, (b) art versus prudence (as virtues of the practical intellect), and (c) the rela-

---

20. Ibid., 23.
21. Ibid., 27–28.

tionship and role of the intellect and will with regard to both specula-
tive and practical knowledge. The first two of these distinctions are use-
ful and important, though rudimentary for Thomist philosophy. That
is not the case with the third distinction, however, and some analysis of
it will be beneficial.

Concerning speculative knowledge, the will's operation concerns
the movement of the intellect "to the exercise of its own power." But
once the intellect is doing its own work, as it were, the will (or intel-
lectual appetite) " has nothing to do with this work, which depends
only, as far as normal knowledge through concepts is concerned, on
the weapons of reason."[22]

When it comes to practical knowledge, however, the will plays a
very different role. Since practical knowledge concerns an action to be
done or an object to be made, the action or object lies, so to speak,
in the future and as such does not yet exist. Hence, while truth for
speculative knowledge is the correspondence of the intellect with
"what is," truth for the practical intellect will be the conformity of
the intellect with "right desire," that is, desiring what one ought to
desire.[23] Maritain refers to this as the "straight appetite," that is, "with
the appetite as straightly tending to the ends with respect to which the
thing that man is about to create [or do] will exist."[24] In this way, the
appetite, in its inclination or desire for a particular good, determines
the end which, together with the intellect, it pursues.

Concerning truth for the practical intellect, there is another dis-
tinction that considers the way that the conformity of right desire or
the straight appetite is applied differently in art (the sphere of making,
*factibilia*) and in prudence (the sphere of doing, *agibilia*) since the
end pursued by each of these is different. For prudence, the appetite
tends toward a good life, or supernatural beatitude as the ultimate end
of human life, and everything will depend upon right desire or the
straightness of the appetite, as strengthened by the moral virtues, in

22. Ibid., 46–47.
23. See Mortimer Adler, *The Time of Our Lives* (New York: Fordham University
Press, 1996), 131.
24. Jacques Maritain, *Creative Intuition*, 47.

relation to the attainment of that end. In the case of art, however, the good toward which the appetite tends is the good of the work, and the intellect will need to discover the appropriate "rules" to accomplish this in each case. Thus Maritain maintains that "the judgment of the artist is . . . true when it is in conformity with the appetite straightly tending to the production of the work through the appropriate rules born out of the intellect. Thus, in the last analysis, the main part is played by the intellect, and art is much more intellectual than prudence."[25]

The relation between the will and the intellect in artistic knowledge receives still greater refinement and precision when Maritain contrasts the useful and fine arts,[26] since the appetite tends toward the good of the work in both cases. For the useful arts, "the straightness of the appetite means that it tends to the satisfying of [a] particular need by means of the rules discovered by the intellect." By contrast, the fine arts are liberated from any requirement of utility whatsoever and as such, "in the fine arts what the will or appetite demands is the release of the pure creativity of the spirit."[27] In addition to affirming the intellectual nature of the fine arts, Maritain also says that

[T]he pure creativity of spiritual intelligence tends to achieve something in which spiritual intelligence finds its own delight, that is, to produce an object in beauty. Left to the freedom of its spiritual nature, the intellect strives to engender in beauty.

Such is, in its longing for beauty, that pure creativity of the spirit, to the release of which the appetite basically tends, together with the intellect, in the vital dynamism of fine arts.[28]

---

25. Ibid., 52–53.

26. Maritain uses the language "useful" and "fine" in chapter 2 of *Creative Intuition*. However, in a footnote, he expresses his preferred vocabulary in this way: " the stock phrases 'useful arts' and 'fine arts' which I am now using to conform to the accepted vocabulary, are not, in my opinion, philosophically well grounded. I would prefer to say 'subservient arts' and 'free' or 'self-sufficient arts'"; Jacques Maritain, *Creative Intuition*, 61. The subservient arts "serve" the purpose of the utility at which the end of these arts aims, while the "free" or "self-sufficient arts" are free of any useful ends or utility.

27. Jacques Maritain, *Creative Intuition*, 54.

28. Ibid., 55.

Thus, the understanding of the role of the will provides a foundational background to the way in which love, connaturality, and intentional or spiritualized emotion all function epistemologically.[29] It also helps us to understand that, in the case of the fine arts, the will or spiritual appetite tends toward or desires (loves) the release of the pure creativity of spirit which itself longs, through that release, to create an object in beauty. Maritain concludes:

> Thus the very end—transcendent end—intended [by the fine artist] pertains to the realm of the intellect, of its exultation and joy, not to the world of utility, and the intellectuality of art is in the fine arts (though more bound there with the sensitive and emotive powers) at a much higher degree than in the arts of the craftsman. The need of the intellect to manifest externally what is grasped within itself, in creative intuition, and to manifest it in beauty, is simply the essential thing in the fine arts.[30]

3. In the final step, Maritain integrates the insight concerning the "pure creativity of the spirit" (step 2) with the fourth phase of art's evolution of the notion of Self (step 1). In this way, Maritain claims that through modern art, art has been "bitten by Poetry," and therefore longs to be freed from logical reason. Initially, this release on the part of the pure creativity of the spirit seeks a freedom from nature and the forms of nature, then from language or the literal sense or meaning, and finally, modern art longs to be freed from the intelligible or logical sense as well. Only the Poetic sense remains. In this way, Maritain argues *philosophically* for the legitimacy of a "spiritual preconscious or unconscious" which is at the soul's center, and is the source of that creative intuition which longs for expression and freedom. In his dis-

29. The traditional term "the will" is also called "intellectual or spiritual appetite," and the exercise of some of its activities is "love." This reinforces (a) the earlier discussion in chapter 4 concerning love and the way in which it may become "intentional" or a "formal means of knowledge" (Jacques Maritain, *Existence and the Existent*, 84), as well as (b) the previous discussion in chapter 3 about connaturality and the way in which one becomes "co-natured" with what one loves. In this connection, Maritain combines and affirms these notions when he says in *Creative Intuition* that "the love of beauty should make the intellect co-natured with beauty" (58). Recall that spiritualized emotion too may be a formal cause of knowledge (see *Creative Intuition*, 119–23).

30. Jacques Maritain, *Creative Intuition*, 55–56.

cussion, Maritain distinguishes this "spiritual unconscious" from the Freudian unconscious which is the "unconscious of blood and flesh" and contains "instincts, tendencies, complexes, repressed images and desires, [and] traumatic memories."[31]

Although real, and playing a definite part in ordinary as well as creative activity, this Freudian unconscious is neither the most important nor exclusive aspect of unconscious activity in human behavior. Rather, Maritain contends "that everything depends, in the issue we are discussing [i.e., Poetic Intuition], on the recognition of the existence of a *spiritual* unconscious, or rather, preconscious."[32]

Of course, it is one thing to hypothesize or even postulate the existence of some reality which is outside the realm of empirical verification, and it is quite another to construct a valid inferential argument. At the outset, as Maritain commences to do this, he begs his readers to excuse him for a "rather chill irruption of Scholastic lecturing."[33] He begins by establishing the necessary existence of what he calls "the Illuminating Intellect," traditionally referred to as the agent intellect. He next reasons that, if the Illuminating Intellect does indeed exist and yet its activity is closed to our conscious awareness, then we may reasonably infer the existence of a range of pre- or unconscious intellectual (or spiritual) activities that are also closed to our reflective awareness. His reasoning concludes that these activities occur in the region of the soul he calls "the spiritual unconscious."

While the technical details of the argument for the existence of the Illuminating (or agent) Intellect need not concern us here,[34] Maritain's conclusions are very important for what they have to say about his understanding of human nature and Poetry. While philosophical reasoning establishes the existence of the Illuminating Intellect and other preconscious activities, it also affirms the existence of what Thomist epistemology calls the intelligible germ or "impressed intelligible species." This, he says, occurs through the "logical necessities of reasoning" even though they "totally escape experience and conscious-

31. Ibid., 91.          32. Ibid. (emphasis added).
33. Ibid., 98.
34. Maritain's own elaboration is concise enough; see ibid., 95–100.

ness." Both the Illuminating Intellect and the impressed intelligible species are out of the reach of our conscious awareness and reflection. We know concepts (even if only reflectively) but we do not know the intelligible "germs" when we receive them nor do we know the process by which our concepts are formed from them. Moreover, we do not possess any direct access to the activity of the Illuminating Intellect "whose light causes all our ideas to arise in us, and whose energy permeates every operation of our mind. . . . Thus it is that we know . . . what we are thinking, but we don't know *how* we are thinking."[35] Accordingly, Maritain concludes:

[I]f there is in the spiritual unconscious a nonconceptual or preconceptual activity of the intellect even with regard to the birth of the concepts, we can with greater reason assume that such a nonconceptual activity of the intellect, such a nonrational activity of reason, in the spiritual unconscious, plays an essential part in the genesis of [P]oetry and [P]oetic inspiration.[36]

At this juncture, having established the spiritual preconscious at the core of the human soul that is the source of Poetic energy, Maritain integrates this creative impulse of the spirit with the unity of human nature and the way in which the lower sense powers are in the service of, and yet are also permeated by, the higher intellectual powers. On this accounting, Poetic knowing and the totality of human nature and personal experiences are unified. The senses, the imagination, the emotions, the will, the intellect, the Freudian unconscious, *and* the spiritual unconscious—all of these afford persons an intimate (though not always conscious) association and contact with the world of Things. In doing so, the Poet's knowledge is fed through: (a) the intentionality of concepts; (b) the formality or intentionality of the emotions and love; (c) the dark, vigorous waters of the senses, dreams, and imagination; and (d) the host of psychological complexities which, taken together, constitute a person's Self, an intellectual and emotional life that is often obscure to itself. Commingling, they feed and amplify one another, melding with one's genetic constitution, to

35. Ibid., 99 (emphasis added).
36. Ibid., 99–100.

form the distinctive personality of the artist, a personality forged in the white heat of his or her creative disposition and fired in the center of the soul.

Because Poetry is born in this root life where the powers of the soul are active in common, [P]oetry implies an essential requirement of totality or integrity. Poetry is the fruit neither of the intellect alone, nor of imagination alone. Nay more, it proceeds from the totality of man, sense, imagination, intellect, love, desire, instinct, blood and spirit together. And the first obligation imposed on the [P]oet is to consent to be brought back to the hidden place, near the center of the soul, where the totality exists in the state of a creative source.[37]

## MARITAIN'S MEANING OF THE TERM "POETIC KNOWLEDGE"

Maritain's treatment of Poetic Knowledge entails three distinctive characteristics: (1) its creative aspect, (2) its cognitive aspect, and (3) the means through which this knowledge occurs, namely, spiritualized or intentional emotion.

1. The distinctive feature of Poetic Knowledge is its necessary connection with creativity, "the free creativity of the spirit,"[38] which "fructifies only in the work."[39] The work is a sign which signifies both the Self of the Poet and also some "particular flash of reality bursting forth in its unforgettable individuality, but infinite in its meanings."[40]

In this consistent affirmation of the "free creativity of the Spirit," Maritain takes his cue from reflections upon the prime analogate, the "First Poet," in whose nature the artist (as well as all persons) participates. With God, whose Self-Knowledge is perfect through "an act of intellection which is His very Essence and His very Existence,"[41] the works of His creative activity are entirely and purely formed—"that which will be expressed or manifested in the things made is nothing else than their Creator Himself, whose transcendent Essence is enig-

---

37. Ibid., 111.
39. Ibid., 115.
41. Ibid., 113.

38. Ibid., 112.
40. Ibid.

matically signified in a diffused, dispersed, or parceled-out manner, by works which are deficient likenesses of and created participations in it."[42] The artist him- or herself is one of these works or creations, and his or her participation in the being of the Creator mandates the essential orientation of the human spirit toward creative action.

Naturally, since the Poet knows neither his or her own subjectivity nor the world in a clear or simple way, the exercise of Poetic creativity will be a limited expression of the Poet's own limited being. This limitation, however, in no way mitigates the force and essential orientation of the artist's Poetic intuition as a creative intuition. Maritain is certainly consistent on this point.

From the very start [P]oetic intuition is turned toward operation. As soon as it exists, the instant it awakens the substance of the [P]oet to itself and to an echoing secret of the reality, it is, in the depth of the nonconceptual life of the intellect, an incitation to create.[43]

2. As distinguishable from the Divine creative act, which is purely and entirely a formative act, the artist's creative action is both formative and formed. It is formative in that the artist participates in the creative inclination of the Divine, and as such expresses in his or her art the unique personality of the artist's Self in a fashion that is analogous to the Divine creative expression. It is formed in that the artist is not only limited in his or her knowledge and experiences of the world but also that he or she must acquire knowledge slowly and in a manner that is fraught with the contingencies that characterize the ordinary human learning process and the infinite multiplicities of human experience. Thus the artist's very Self, his or her substance as a person, is uniquely formed by the genetic uniqueness of personal inheritance, and the freedom of intellect and will that are characteristic of the human spiritual dimension, as well as by the historical contingencies and significant events of the totality of one's life experiences.

As a moment in the overall process of Poetic Knowledge, what Maritain refers to as "Poetic Knowledge as Creative" is ontologically

---

42. Ibid., 112.
43. Ibid., 134.

posterior to the cognitive moment, "Poetic Knowledge as Cognitive." To speak of Poetic Knowledge as both cognitive and creative is but a more precise way of affirming that Poetic Knowledge is both formed and formative. Maritain is quick to remind his readers that what is grasped by Poetic intuition is not, technically speaking, an "object" of knowledge since things are "objectivized" in concepts, and there are no concepts in Poetic Knowledge.

[P]oetic intuition is not directed toward essences, for essences are disengaged from concrete reality in a concept, a universal idea, and scrutinized by means of reasoning; they are an object for speculative knowledge, they are not the thing grasped by [P]oetic intuition.[44]

How, then, does Maritain answer the question about what *is* grasped by Poetic Knowledge? "Poetic intuition is directed toward *concrete existence as connatural to the soul pierced by a given emotion.*"[45] Concepts by contrast are the means by which the mind represents the dynamism of reality in a static and hence limited way. Fortunately for Poetic Knowledge, and "precisely because it has no conceptualized object, it tends and extends to the infinite, it tends toward all the reality, the infinite reality which is engaged in any singular existing thing, either the secret properties of being involved in its identity and in its existential relations with other things, or the other realities, all the other aspects or fructifications of being, scattered in the entire world."[46]

The expressions "infinite reality" and "secret properties" underscore Maritain's key notion of created dependence upon the causal power of the Divine *Esse* and the way in which we can find a universe of infinite richness in the proverbial "grain of sand," the human person, and the entirety of God's creation. The relation of the artist to the world is one of an infinite openness open to the infinite. To be sure, the penetration of reality's secrets is not something assured or simply given—but to those who have eyes and the "gift"[47] of Poetic intuition,

---

44. Ibid., 125–26.   45. Ibid., 126 (emphasis added).
46. Ibid.

47. "Difficult acrobatics are undoubtedly required of the [P]oet; . . . however, no venture is possible without a primary gift"; Jacques Maritain, *The Degrees of Knowledge*, 2.

all becomes light and radiant brilliance. "For [P]oetic intuition makes things which it grasps diaphanous and alive, and populated with infinite horizons. As grasped by [P]oetic [K]nowledge, things abound in significance, and swarm with meanings."[48]

3. The richness of the meaning of Things is not the only thing that is grasped in Poetic intuition. It is through love, or what Maritain calls "affective resonance,"[49] that Things are grasped at all. This occurs in, and brings about a union of Things with, the subjectivity of the artist. The Poet knows himself and reveals himself in and through his love for Things, which is given in an obscure experience-knowledge. Thus Poetic intuition most *immediately* attains "the experience of the things of the world," and most *principally* attains "the experience of the Self." Maritain refers to "the awakening of subjectivity to itself" as most principal, because it is on that account that emotion, as "received in the translucid night of the free life of the intellect," is rendered an intentional means of knowledge.[50]

Maritain is aware of the fact that the idea of emotion being raised to the level of intelligence and functioning as a determining means through which reality is grasped is a difficult one. He points out that all similar questions "dealing with the application of the general concept of knowledge through connaturality to the various particular fields in which this kind of knowledge is at play,"[51] are hard questions to answer precisely. His own solution is as follows:

The Poet or artist, on account of a "virtual vigilance and vital tension" of an "unemployed reserve of the spirit," is uniquely suited to allow the soul to suffer the reality conveyed to it by some significant emotion. When this occurs two things are notable: first, the connaturality or affective resonance between the subjectivity or Self of the Poet and the Thing loved "spreads into the entire soul, it imbues its very being" through the instrumentality of significant emotion. Second, this emotion, having imbued the whole soul, especially the "living springs" of the preconscious of the intellect, "is received in the vitality

---

48. Ibid., 126–27.          49. Ibid., 127.
50. Ibid., 127–28.          51. Ibid., 121.

of intelligence, . . . [an] intelligence permeated by the diffuse light of the Illuminating Intellect and virtually turned toward all the harvests of experience and memory preserved in the soul, all the universe of fluid images, recollections, associations, feelings, and desires latent, under pressure, in the subjectivity, and now stirred."[52] The light of the Illuminating Intellect, while allowing emotion to remain emotion, nonetheless transforms it "with respect to the aspects in things which are connatural to, or *like,* the soul it imbues—into an instrument of intelligence judging through connaturality"[53] Given this affective resonance between the Thing(s) loved and the subjectivity of the Poet, emotion plays "the part of a nonconceptual intrinsic determination of intelligence in its preconscious activity."[54] In this way, the significant emotion becomes intentional ("as an idea is") or spiritualized, and as such it becomes a formal means of knowledge, informing the intellect in an obscure and nonconceptual manner and "carries within itself infinitely more than itself."[55]

[Significant or spiritualized emotion] becomes for the intellect a determining means or instrumental vehicle through which the things which have impressed this emotion on the soul, and the deeper, invisible things that are contained in them or connected with them, and which have ineffable correspondence or co-aptation with the soul thus affected, and which resound in it, are grasped and known obscurely.

It is by means of such a spiritualized emotion that [P]oetic intuition, which in itself is an intellective flash, is born in the unconscious of the spirit.[56]

### CONCLUDING PROVOCATIVE QUESTIONS

Thoughtful reflection upon Maritain's insistence that Poetic Knowledge is necessarily ordered to creative action, generates some provocative questions: (1) Since Poetry is the root of Poetic Knowledge, *must it* be considered as ordered *always and necessarily* to creative action alone?

---

52. Jacques Maritain, *Creative Intuition,* 122.
53. Ibid., 122–23.  54. Ibid., 123.
55. Ibid., 119–20.  56. Ibid., 123.

(2) Why isn't it possible to consider the two "moments" of Poetic Knowledge, "Poetic Knowledge as Cognitive" and "Poetic Knowledge as Creative," autonomously? (3) How can the necessarily creative orientation of Poetic Knowledge account for the experience of the lover of the beautiful, who delights in the Poetry of an authentic aesthetic experience but who remains content simply to revel in joy or delight, without having any "incitation to create?" And if it cannot account for that experience of aesthetic savor and delight, what term does Maritain use, if any, to describe epistemologically this "knowing-delighting" experience? And finally, (4) if Maritain does have built in to his epistemology an explanation of the "knowing-delighting" experience, why hasn't he provided us with more information concerning it?

Such questions naturally arise for those who welcome the insights of Maritain's explanation of creative knowledge, but who, reflecting upon their own aesthetic experiences of appreciation and delight, find that they are not bound by the creative requirement that Maritain's strict definition of Poetic Knowledge imposes. One answer is that Maritain's grounding principles allow for the reconstruction of just such an epistemological theory; that he has pointed out this pathway without exploring or developing it himself.

In order to defend this answer, two things are necessary: First, we must show that certain texts of Maritain's epistemology contain the foundation for such a theory. Second, we must show that such a reconstruction can be systematically developed while remaining consistent and compatible with the rest of Maritain's philosophy of art. Satisfying these two requirements is the work of the chapters that follow.

# TWO PATHWAYS DISCERNED

The Priority of Poetry, 1920–1927

⌐✦

*This divination of the spiritual in the things of sense, and which*
*expresses itself in the things of sense, is precisely what we call POETRY.*
—Jacques Maritain

Chapters 2–5 systematically explored certain key concepts of Maritain's epistemology in general and his aesthetics in particular. In addition to the all-important notions of Poetry and Poetic Knowledge, the list of other important terms included intuition, the intellect, connaturality, the Self and Things, as well as a discussion of aesthetic experience. On the evidence of certain decisively clear texts of Maritain, chapter 5 resolved that Maritain uses the term Poetic Knowledge as the exclusive privilege of creative artists alone. Moreover, since Poetic intuition is born of spiritualized emotion and emanates from a "most natural capacity of the human mind," it follows that all persons are "potentially capable of it."[1] And although all instances of Poetic intuition require spiritualized emotion, it does not follow that all instances of spiritualized emotion necessarily result in or terminate in Poetic or creative intuition. The presence of spiritualized emotion in any form of aesthetic experience simply obliges us to characterize that experience as a bona fide aesthetic experience, regardless of whether it is creative or not. And finally, chapter 5 also showed that the question concerning the exclusive/nonexclusive nature of spiritualized emotion is broad in scope, and one about which Maritain himself provides no definitive answer.

1. Jacques Maritain, *Creative Intuition,* 123.

The real issue that emerges from these considerations specifically concerns the type of knowledge proper to the person who has or participates in spiritualized emotion that is not ordered toward creative activity . . . what kind of knowledge is this? Just as spiritualized emotion may fuel the affective, nonconceptual connaturality of Poetic Knowledge, isn't it also possible that spiritualized emotion may terminate in the joy and delight characteristic of a heightened level of aesthetic experience? If so, we are on the edge of a distinction which, although grounded in Maritain's ideas, is a pathway that he himself did not develop.

Since certain passages of Maritain's discussion of Poetry and Poetic Knowledge contain an ambiguity or even inconsistency, this chapter will show that this ambiguity in his terminology occurred because he is primarily and most frequently talking about the artist's creative knowledge (Poetic Knowledge). In certain key but relatively few passages, however, Maritain's same vocabulary points toward a related but different type of knowledge that is contemplative in nature. And while the discussion of the defining characteristics of this knowledge will be reserved for the final chapter, this chapter first must establish *that* this unique mode of contemplative knowing is grounded in, and consistent with, Maritain's epistemology and metaphysics.

Accordingly, this chapter will show that (1) Maritain's notion of Poetic Knowledge grew and developed gradually over a period of several years; (2) the notion of Poetic Knowledge itself emerged from the *ontologically* prior notion of Poetry, a priority which is also reflected *chronologically* in Maritain's writings; and (3) given the foundation of Poetic Knowledge in Poetry, we also will show that Maritain's notion of Poetry permits the discernment of a new avenue of his thought, Poetic Contemplation, that thus supports Maritain's own self-understanding as a "spring-finder."[2]

By treating selected writings in aesthetics in chronological order, we will show that two pathways are discernible during Maritain's early period. To do this, we will explore the philosophical development of

---

2. Jacques Maritain, *Notebooks,* 3.

the concepts Poetry and Poetic Knowledge during the period 1920–1927; the texts and their editions are as follows:

1. 1920: *Art and Scholasticism*—original edition only.[3]
2. 1926: *Art and Faith*
3. 1927: a. "The Frontiers of Poetry"
     b. *Art and Scholasticism*—second French edition

## THE HISTORICAL/THEORETICAL DEVELOPMENT OF MARITAIN'S NOTIONS OF POETRY AND POETIC KNOWLEDGE

### 1. 1920: The First Edition of *Art and Scholasticism*

As mentioned earlier, Maritain's writings on the subject of art span nearly the entire duration of his philosophical life, although this is not the case with the specific notions of Poetry and Poetic Knowledge. Neither of those terms appears in his first book, *Bergsonian Philosophy and Thomism,* nor do they appear in the first edition of *Art and Scholasticism.* The notion of Poetry first appears in the late twenties, while the notion of Poetic Knowledge does not appear until the mid-thirties. There can be little doubt that this term was developing in Maritain's mind during the latter part of the twenties and early thirties, those fruitful years during which the Sunday meetings of the Cerclé Thomiste were at their peak, attracting as they did so many creative artists. The early friendship which Maritain shared with Léon Bloy and Georges Rouault, enriched by the other creative artists who frequented his home, played a strong influencing role in the development of his ideas, both through the interchange of speculative reflec-

3. The English translation of this work is that of Prof. Joseph Evans, and was undertaken at Maritain's suggestion. This 1962 Scribner edition is a translation of the third and final edition of *Art et scolastique.* The original French text (1920) did undergo revisions, and especially additions, in each of its subsequent editions of 1927 and 1935. Since we are presently tracing the development of Maritain's ideas chronologically, I will treat each of these editions separately and chronologically. Moreover, although Evans's translation is used exclusively, the reader should note that I have taken great care to note the textual shifts, modifications, and additions as these appear in the different original French editions.

tions, as well as through the witness and testimony provided by the lives and work of these artists.

Certain passages from the first French edition of *Art and Scholasticism* prefigure Maritain's later notions of Poetry and Poetic Knowledge, particularly when viewed against the backdrop of his mature ideas in *Creative Intuition*. For example, in the opening chapter of *Art and Scholasticism,* Maritain makes plain his intention for this work: "by gathering together and reworking the materials prepared by the Schoolmen, [to] compose from them a rich and complete theory of Art."[4] By situating art as an intellectual virtue of the practical intellect ordered "to the good or to the proper perfection, not of the man making, but of the work produced," Maritain brought the Aristotelian and Scholastic definition of art, *recta ratio factibilium* ("art is the *undeviating determination of works to be made*"), to the contemporary art world.[5] The wisdom of his approach here is not simply in the recognition of the activity and importance of the intellect in artistic productivity, but also in the recognition that the principles that operate and govern creative action in the fine arts are properly grounded in a broader theory of art.

For this reason, Maritain's discussion "Art an Intellectual Virtue" makes no distinction concerning the types of objects to be made . . . a bridge, a boat, a painting, or a song. The Scholastic meaning of art is that it is a *habitus* or operative, qualitative disposition of the *artifex* or maker.[6] To the extent that this *habitus* comes to be "determined to the ultimate of which the power is capable," it is called a virtue. As prudence stands as the virtue of the practical intellect in the sphere of Doing (and is thus ordered to the good of the person or agent himself), so art stands as the virtue of the practical intellect in the sphere of Making (and is thus ordered to the good of the work).

With this comparison in mind, recall that, from our earlier discussion on connaturality, Maritain had clearly indicated as early as 1914 in *Bergsonian Philosophy and Thomism* that knowledge of a moral good

4. Jacques Maritain, *Art and Scholasticism,* 4.
5. Ibid., 8–9.
6. Ibid., 10–12.

could be attained either through rational, conceptual knowledge, or through connaturality, a kind of divination. St. Thomas's classic text in this regard, often referred to by Maritain, specifically pertains to an application of connaturality to the moral order. Since Doing and Making are both situated in the Practical Order, however, it is not surprising that Maritain applies this notion of connaturality to the sphere of Making. Appealing to I-II, q. 55, a. 2, ad. 1 of Thomas's *Summa Theologica*, Maritain says:

> The existence of such a virtue in the workman is necessary for the good of the work, for *the manner of action follows the disposition of the agent, and, as a man is, so are his works.* To the work-to-be-made, if it is to turn out well, there must correspond in the soul of the workman a disposition which creates between the one and the other that kind of conformity and intimate proportion which the Schoolmen called "connaturality." . . . Through the virtue of Art present in [artists], they in some way are their work before making it; are conformed to it, so as to be able to form it.[7]

This passage provides a faint prefiguration of Poetic Knowledge and is the only one of its kind in the first edition of *Art and Scholasticism.* However, this connatural aspect of Poetic Knowledge is not the only key notion from *Creative Intuition* to be prefigured in *Art and Scholasticism.* The ideas of Self, Thing, and spiritualized emotion—the first being made one with the second through the vehicle of the third—are also forecast by certain sections of *Art and Scholasticism.* The idea that the artist is a person who reads deeply into Things, grasping their hidden secrets and meanings which are subsequently revealed, along with some aspect of the artist's Self in the work produced, is found in germinal form in the following three passages, each given here with brief comment:

The human artist or [P]oet, whose intellect is not the cause of things, as is the Divine Intellect, cannot draw this form [the manifestation of which

---

7. Ibid., 12. St. Thomas says: "Mode of action follows on the disposition of the agent; for such as a thing is, such is its acts. And therefore, since virtue is the principle of some kind of operation, there must pre-exist in the operator in respect of virtue some corresponding disposition"; *Summa Theologic,* I-II, 55, a. 2, ad. 1.

makes an object beautiful] entirely from his creative spirit: he goes and im-
bibes it first and above all in the immense treasure-house of created things,
of sensible nature as also of the world of souls, and of the interior world of
his own soul.[8]

Notice the "ingredients" that are present in this passage: the artist's
"creative spirit" which seeks to reveal "a form" in matter must first be
nourished by the "immense treasure-house of created things" and es-
pecially of the "interior world of his own soul," particularly, since the
knower is one who becomes "the other" through an intentional mode
of being. How is this made possible? The passage continues:

From this point of view he is first and foremost a man who sees more deep-
ly than other men, and who discloses in the real spiritual radiances which
others cannot discern. But to make these radiances shine in his work, and
therefore to be truly docile and faithful to the invisible spirit that plays in
things, he can, and he even must, distort in some measure, reconstruct,
transfigure the material appearances of nature. . . . [T]he work always ex-
presses a form engendered in the spirit of the artist.[9]

The Poet or artist "sees more deeply," "divines," or "discloses" hid-
den significations or "spiritual radiances," and in the creation of a
work transforms some matter (the medium of art) in order to reveal
both the invisible "spirit" in things and in the artist him- or herself.

Some pages later, Maritain stresses an aspect of the Self. This di-
vining process is not something that occurs in some aesthetic vacuum.
Rather, it is something which, although presupposing some innate
disposition or gift, nonetheless requires cultivation, education, and
reinforcement.

But art does not reside in an angelic mind; it resides in a soul which ani-
mates a living body, and which, by the natural necessity in which it finds
itself of learning, and progressing little by little and with the assistance of
others, makes the rational animal a naturally social animal. Art is therefore
basically dependent upon everything which the human community, spiri-

---

8. Ibid., 59.
9. Ibid., 59–60.

tual tradition and history transmit to the body and mind of man. By its human subject and its human roots, art belongs to a time and a country.[10]

In yet another passage, Maritain expresses the idea that a work of art proceeds from the totality of the artist, only this time he calls attention to the part played by the appetites, the passions, the will, the emotions, and love:

[I]n the painter, poet, and musician, the virtue of art, which resides in the intellect, must not only overflow into the sense faculties and the imagination, but it requires also that the whole appetitive power of the artist, his passions and will, tend straightly to the end of his art. If all of the artist's powers of desire and emotion are not fundamentally straight and exalted in the line of beauty . . . then human life and the humdrum of the senses, and the routine of art itself, will degrade his conception. The artist has to love, he has to love *what he is making* . . . so that beauty may become connatural to him and inviscerate itself in him through affection, and so that his work may come forth from his heart and his bowels as well as from his lucid spirit. This undeviating love is the supreme rule.[11]

The references in this passage provide a good indication that as early as 1920, Maritain's understanding of the appetites, the passions, the will, the emotions, and love had not as yet gone beyond the application of the traditional Thomist doctrine concerning them, nor had it as yet developed any of the rich insights that would come later. And in spite of the many other valuable things which he has to say about art in this 1920 edition of *Art and Scholasticism,* particularly in relation to the perception of beauty and the analogy between the poet and the contemplative, the passages just quoted are the limits of the prefiguration of Poetry and Poetic Knowledge. Although we will consider the substantial additions in the 1927 second edition and the essay "The Frontiers of Poetry" shortly, we first should consider the insights found in the chronologically prior correspondence between Maritain and Jean Cocteau.

But first, let us consider one final but important note concerning

10. Ibid., 74.
11. Ibid., 46–47.

*Art and Scholasticism*. In his chapter "Art and Beauty," Maritain fo-
cuses almost entirely on the analysis of the "beautiful" as an aesthetic
object of knowledge and delight. As such, this kind of knowledge is
not proper to the artist per se. Regardless of whether the perception
of beauty occurs through an object in nature or in a work of art, the
knower is not engaged in a practical knowledge ordered to the making
of a work, but in a mode of speculative knowledge whose sole end is
delectation or delight for its own sake.[12] "Saint Thomas, who was as
simple as he was wise, defined the beautiful as that which, being seen,
pleases: *id quod visum placet*. These four words say all that is necessary:
a vision, that is to say, an *intuitive knowledge*, and a *delight*."[13]

The creative artist participates in this knowing/delighting but he
or she does so as a member of the "audience," and not on account of
his or her practical virtue of art. Accordingly, we are presented here, in
Maritain's earliest writing on art, with a treatment of a type of aesthetic
knowledge that is not ordered toward creativity. We will discuss this
later; for the moment, however, the most important point concerns the
fact that, although Maritain's discussion of the artist's creative knowl-
edge does increase, surprisingly, his treatment of the perception of beau-
ty (with the exception of a few added and lengthy footnotes in the 1927
edition of *Art and Scholasticism*) virtually ceases until the publication of
*Creative Intuition* in 1953. In point of historical fact, his attention turns
more and more exclusively toward the exploration and articulation of
creative knowledge while the other field, the perception of beauty and
any form of aesthetic or Poetic Contemplation, lies dormant.

### 2. 1926: *Art and Faith*

In June 1925, the Maritains held a meeting at their home in
Meudon for the purpose of launching a series of books to be called
"Le Roseau d'Or" for the publishing firm, Plon.[14] Maritain was to be
one of the editors of the series, and a small group of prominent writ-

---

12. Ibid., 34.

13. Ibid., 23.

14. The initial publication of Maritain's essay "Frontières de la poésie" appeared
in this series.

ers were invited to give advice. One of the guests was Jean Cocteau, at once an avant-garde poet, novelist, filmmaker, playwright, and painter. It was at that gathering that Cocteau also met Fr. Charles Henrion, a French priest living as a hermit in Africa, who came periodically to visit the Maritains. That meeting of Fr. Charles and Cocteau led to Cocteau's return to the religion of his youth.[15] Despite the brevity of this conversion, one result of it was Cocteau's book, *Lettres à Jacques Maritain,*[16] which was followed shortly thereafter by Maritain's *Réponse à Jean Cocteau.*[17] These two books were later combined to form the 1948 English translation edition, published under Maritain's name alone and titled *Art and Faith.*

This book is well titled since it concentrates on Cocteau's return to the Catholic Faith, with particular attention focused on the analogy that exists between "the world of [P]oetry and that of sainthood." In making this and related comparisons, Maritain introduces his use of the word "Poetry" for the first time. Although he does not provide a definition at this time, Maritain does sketch out in his letters to Cocteau some of his basic ideas of Poetry that he will develop later. Speaking of the "Poet" rather than of the nature of "Poetry" itself, Maritain offers a passage that is quite similar to the definition of Poetry that will appear in his 1927 essay "The Frontiers of Poetry." In this 1926 work, he refers to the Poet as one who

sees into things and brings forth a sign . . . of the spirituality they contain; . . . [he] completes the work of creation; he co-operates in divine balancings, he moves mysteries about; he is in natural sympathy with the secret powers that play about in the universe.[18]

The above passage, and the few others that are similar, provide little else concerning Maritain's developing understanding of the term Poetry. Accordingly, *Art and Faith* is perhaps noteworthy for the sole reason that it is in this work that the term Poetry first appears.[19]

15. See Julie Kernan, *Our Friend, Jacques Maritain,* 64–65.

16. Jean Cocteau, *Lettres à Jacques Maritain* (Paris: Librairie Stock, 1926).

17. Jacques Maritain, *Réponse à Jean Cocteau* (Paris: Librairie Stock, 1926).

18. Jacques Maritain, *Art and Faith,* 90.

19. Although the second edition of *Art and Scholasticism* included three appendi-

3. 1927: "The Frontiers of Poetry" and the Second Edition
of *Art and Scholasticism*

In the essay "The Frontiers of Poetry," Maritain articulates his understanding of "pure [P]oetry." He tells us in its opening pages that he is going to "intermingle," with some of the ideas expounded in *Art and Scholasticism,* "some new considerations" that he develops by means of an analogy with the theory of the Divine Ideas. After discussing how the "making or operative idea" is different from the "speculative concept" or "conceptual idea,"[20] Maritain goes on to contrast the difference between God's and human's creative intelligence. "In us," he says, "the creative idea is not a pure intellectual form . . . " as it is with God.

[The] independence with regard to things, essential to art as such and to the operative idea, is thwarted in us by our condition—minds created in a body, placed in the world after things had been made, and obliged to draw first from things the forms they use.

In God only does this independence with regard to things appear in a perfect manner.[21]

Since man's being is a bodily participation in spirit, Maritain explains the contemporary "search for *pure music, pure painting, pure theatre, pure poetry*" as an inclination of the human spirit to free itself from the conditions of its existence and, without realizing it, to wish for itself that it usurp what in essence belongs solely to the Divine.[22]

This tension, between the essence of creative intelligence considered in its pure state (i.e., in God), and the conditions of existence in which this essence is "realized here on earth" in us, contextualizes the meaning of the adjective "pure," and it accounts for our natural inclination to aspire to it. But what of the word "Poetry" itself? Mari-

---

ces that were written prior to 1926, none of them contain any reference to poetry as something other than the art of verse writing.

20. The making or operative idea "is *formative* of things and not *formed* by them [and is] far from being measured by them, as is the speculative concept"; Jacques Maritain, "The Frontiers of Poetry," 121.

21. Ibid.

22. Ibid., 122–23.

tain answers this question by first considering another closely related problem. For not only does God's creative act occur in a way that is entirely *formative* (and in no way *formed*), so, too, we can observe that the works of Divine Creative action participate in, and in a certain way also *imitate,* God's Divine Essence. In this way, Maritain introduces the frequently misunderstood problem of "imitation." Reflection upon the theology of God's creative idea reveals to us the correct meaning of this notion. "Just as God makes created participations of His essence to exist outside Himself, so the artist puts himself—not what he sees, but what he is—into what he makes."[23]

Thus the expression "art imitates nature" does not imply some form of servile imitation or copy of the appearances of things in the natural world (nature). Rather, the nature which the artist imitates is his own nature. For Aristotle, "art imitates nature" originally meant that art as a virtue (*habitus*) of the practical intellect, in its inner workings and the ordering of its operations, is similar to the inner dynamism of the natural forces of nature. The term *imitation* indicates an analogy between the dynamics of the activity of art and the dynamics of the activity of nature. The common misunderstanding of this term is "to copy or to reproduce," and mistakenly, it is taken to mean that the art work is a "copy" of what is found in nature. This erroneous and superficial understanding of the whole expression is a derivative of the original or foundational meaning. "Imitation" in that sense is not only the dynamism of nature in general, but the dynamism of the *habitus* of the human nature of the artist specifically. As observed earlier, and in contrast to the Divine, human nature is both *formed* and *formative.* Maritain indicates this point clearly: "The truth is . . . that we have nothing which we have not received."[24]

The knowledge received by the artist, however, is neither rational knowledge about the world, nor is it simply the privileged skill of the artistic *habitus.* Rather, Maritain now points out for the first time that the artist "divines" a "secret" in things and that it is precisely these

23. Ibid., 126.
24. Ibid.

"hidden meanings" that characterize the personal uniqueness of the art work, as well as to enable him or her to "transform the universe" in a "spiritual resemblance" of his or her own created and creative mind.[25]

And so it is, after reflection on the contrast between Divine Creativity and human creativity and the way in which this analogy provides new and valuable insight into the notion of "imitation," that Maritain finally presents his definition of Poetry:

> This divination of the spiritual in the things of sense, and which expresses itself in the things of sense, is precisely what we call POETRY. Metaphysics too pursues a spiritual prey, but in a very different manner, and with a very different formal object. Whereas metaphysics stands in the line of *knowledge*[26] and of the contemplation of truth, [P]oetry stands in the line of *making* and of the delight procured by beauty.[27]

This earliest definition of Poetry is especially important, since it encompasses and prefigures the two distinct aspects of this divinatory experience/knowledge. The opening clause of the first sentence ("the divination of the spiritual in the things of sense") is clearly similar to the definition of Poetry Maritain gives later in *Creative Intuition* ("That intercommunication between the inner being of Things and the inner being of the Human Self"), while the second clause ("which expresses itself in the things of sense") is a forecast of the notion of Poetic Knowledge, soon to appear in Maritain's writings.

Maritain reinforces these dual aspects of Poetry when he contrasts metaphysics and Poetry. On the one hand, Poetry involves the order of making (an aspect later designated by the language of "Poetic Knowledge"), while on the other hand, he points out that it also pertains to "the delight procured by beauty." Thus, the "divination of the spiritual in the things of sense" leads to both the making of a work

25. Ibid., 127–28.

26. It is clear from both the context of the usage as well as from the related terms employed in the remainder of the paragraph that Maritain is using the word "knowledge" here in a quite restricted sense, designating it as that conceptual, rational knowledge that terminates in concepts or ideas. He is not intending here any of the other analogical senses, particularly those that refer to divinatory or connatural knowledge.

27. Jacques Maritain, "The Frontiers of Poetry," 128.

*and* "the delight procured by beauty." This early expression of the notion of Poetry is extremely important since it indicates two pathways: (1) *The Pathway Developed* leads to the development of the notions of Poetry and Poetic Knowledge, culminating in the distinction between "Poetic Intuition as Cognitive" and "Poetic Intuition as Creative."[28] (2) *The Pathway Undeveloped* concerns the relation between Poetry and the aesthetic delight that results from the perception of beauty, and leads from Poetry to Poetic Contemplation. Since this pathway is without systematic development in Maritain's writings, we will reconstruct it in the final chapter.

Although systematically undeveloped, Maritain does attend to that type of contemplation which is connected with aesthetic experience in his discussion of beauty. These insights occur in the considerable emendations and additions to the 1927 second edition of *Art and Scholasticism*. Although this edition does not provide any significant changes in the basic text, the numerous and lengthy endnotes which amend this edition are very important, particularly for their advance on the discussion of the perception of beauty. And even though his later writings progressively turn more in the direction of the development of Poetic Knowledge only, the fact remains that up to this point in 1927, both Poetic Knowledge and Poetic Contemplation, grounded as they both are in Poetry, are only inchoately indicated.

By way of a final summation, here are the noteworthy conclusions from the years 1920–1927 concerning Poetry and Poetic Knowledge: (1) The term Poetry, which did not appear in the first edition of *Art and Scholasticism* (1920) and which received only passing reference in *Art and Faith* (1926), appears in "The Frontiers of Poetry" (1927), where it receives its earliest formulation; (2) this early definition of Poetry suggests two distinguishable aspects, both of which are open to independent lines of development; (3) by way of historical fact, only one of these lines (the line of Poetry-Making), *the Pathway Developed* (Poetic Knowledge), received Maritain's attention in his subsequent writings, and it is that development that we will trace in the next

28. See Jacques Maritain, *Creative Intuition*, 125f. and 134f.

chapter, Chapter 7. And (4) the other line of Poetry's two distinguishable aspects, *The Pathway Undeveloped* (Poetic Contemplation), is in the line of Poetry-Delight. Chapter 8 concerns Maritain's treatment of the perception of beauty and the important endnotes from the 1927 second edition to *Art and Scholasticism*. It is in that chapter, as we again consider Maritain's writings chronologically, that we will explore the point where these two pathways first begin to diverge.

# TWO PATHWAYS CLARIFIED

## Maritain's Turn to Poetic Knowledge, 1927–1938

*Art, while it is productive in its essence,*
*always supposes a moment of contemplation.*

—Jacques Maritain

The previous chapter traced the early developments in Maritain's aesthetics from 1920 to 1927. Specifically, we noted that the notion of "Poetry," central to Maritain's philosophy of art, did not appear in his first book on art. While the notion does appear in 1927, its close relative, "Poetic Knowledge," does not. With Maritain's epistemological interests shifting to a greater focus on the knowledge proper to the creative artist, we will see Maritain's progressive development of his notion of Poetic Knowledge. This relationship between Poetry and Poetic Knowledge is not always clear and precise, however, and so this chapter will trace the development of their relationship chronologically during the period 1927–1938 by examining the following texts:

1. 1932: *The Degrees of Knowledge*[1]
2. 1935: *Art and Poetry* and the third edition of *Art and Scholasticism*
3. 1938: *The Situation of Poetry*

---

1. This work is being considered as a whole chronologically according to its original publication date, 1932, even though sections of this book appeared from 1925 to 1932. No substantial alterations occurred between their original publication and their appearance in this book and its subsequent editions. The preface to the second edition notes that "[t]he text of the second edition conforms to that of the first in practically every detail. A few alterations and additions have been made in the notes"; Jacques Maritain, *The Degrees of Knowledge*, xv.

## THE HISTORICAL/THEORETICAL DEVELOPMENT OF MARITAIN'S NOTIONS OF POETRY AND POETIC KNOWLEDGE

### 1. 1932: *The Degrees of Knowledge*

Although the definitive English language translation of *The Degrees of Knowledge*, Maritain's major opus in epistemology, was not published until 1959,[2] the original French publication date was 1932. The book is comprised of nine chapters, eight of which were published, in whole or part, as separate articles spanning the years 1925 to early 1932.[3] And although we now are considering *The Degrees of Knowledge* chronologically according to its original publication date, the reader will do well to recall that some of the ideas reflected in it were written over the years from just prior to the publication of "The Frontiers of Poetry" through to 1932. In this discussion of *The Degrees of Knowledge*, we will consider all of the minor chronological developments of the several editions as one.

As noted in the previous chapter, Maritain's early ideas in aesthetics contained two independent and discernible lines of possible development. In the essay that comprises chapter 1 of *The Degree of Knowledge*, "The Majesty and Poverty of Metaphysics," Matitain indicates the cognitive aspects of Poetry and he contrasts the Poet and the metaphysician. Notice the rather cognitive tone of the text and the way that the reference to the Poet shows no necessary connection with creative action. The Poet, Maritain says, "thrusts his heart into things like a dart or rocket and, by divination, sees, within the very sensible itself and inseparable from it, the flash of a spiritual light in which a glimpse of God is revealed to him."[4]

---

2. The first English translation, by Bernard Wall and Margot Adamson (London: G. Bles/Centenary Press, 1937), does not contain all of the appendices. The definitive and complete English translation was made from the fourth French edition under the supervision of Rev. Gerald B. Phelan with a forward by Maritain himself.

3. Chapter 1 was originally published in 1925; chapters 2 and 6 in 1926; chapters 7 and 9 in 1930; chapters 8 and 5 in 1931; and part of chapter 3 in early 1932. For publication information, consult the cross-reference information provided by Donald and Idella Gallagher, *The Achievements of Jacques and Raïssa Maritain*, 54–55.

4. Jacques Maritain, *The Degrees of Knowledge*, 2.

A page later, however, Maritain does refer to the artist as one who "pours out his creative spirit into a work." This duality between the cognition and the creativity of the Poet appears again in the following important passage from chapter 6, a text the composition of which precedes "The Frontiers of Poetry" by one year, and is roughly cotemporaneous with his correspondence with Jean Cocteau.

Matters having to do with moral action are not, however, the only ones that have to be considered in the realm of the practical intellect. Knowledge by connaturality has its place among the activities of the artist, too, in matters of art and [P]oetry.

Nor do we mean aesthetic contemplation alone—that contemplation which places us in immediate connivance with the object and in which, on a lower level, a distant image of mystical contemplation has often been, quite rightly, discerned.

We mean the virtue of art itself. If in the natural order anyone has entered into a sort of agreement and . . . a kind of metaphysical conspiracy with God as cause of beings, it is not the philosopher but the [P]oet. . . . The [P]oet is, therefore, much better prepared than anyone else to understand things that are from on high. . . . His proper task is to create an object that brings joy to the spirit in which the brilliance of a form shines forth. He perceives in things and brings forth a sign, weak though it may be, of the spirituality within them; he is connaturalized . . . with the mystery that is scattered in things.

Prayer, holiness, mystical experience—[P]oetry, even *pure* [P]oetry, is none of these things. . . . Because it detects allusions scattered throughout nature, and because nature is an allusion to grace, [P]oetry unwittingly gives us a foretaste, a hidden desire for supernatural life. A man who has never written a poem, but who is truly a [P]oet, said to us one day: "I do not believe it is possible to be a [P]oet and an atheist."[5]

After distinguishing between the moral order and the order of art, both of which are activities of the practical intellect and may involve connatural knowledge, Maritain goes on to observe that the connaturality (divination or "immediate connivance") of "aesthetic contemplation" is distinguished from that connaturality which functions in

5. Ibid., 281–82.

the exercise of the virtue of art, with all its creative force. Since the artist has a nature both formed and formative, we can see the cognitive aspect of the Poet's activities ("He perceives in things . . . ; he is connaturalized . . . with the mystery that is scattered in things") as well as the Poet's creative orientation ("His proper task is to create an object . . . ; he . . . brings forth a sign").

But, given the chapter's subject (mystical contemplation), what is most significant about this early passage is that there is compelling evidence for "aesthetic contemplation" as the cognitive dimension of Poetry. Moreover, when Maritain says "aesthetic contemplation *alone,*" this clearly shows that, at this early point in his thinking, he considers this notion as possessing epistemological autonomy. Maritain dispels any possible objections against this interpretation of Poetry's autonomy when he tells us of the man "who has never written a poem, but who is truly a [P]oet." Moreover, this autonomy also reflects an early epistemological equality with the creative dimension of Poetry.

We should note in passing that this passage is not Maritain's only use of the expression "aesthetic contemplation." In his additional notes added to the 1927 edition of *Art and Scholasticism* concerning the perception of beauty, Maritain mentions a contemplation that is associated with the perception of the beautiful, although interestingly, he does not refer to it as "aesthetic contemplation," but rather as "artistic contemplation." The great likelihood is that this difference simply results from imprecise language and that Maritain is really talking about the same thing.

Surprisingly, for all of its wide range of epistemological ideas, as well as for the range of years covered by the dates of composition of the essays found in the 1932 first edition, *The Degrees of Knowledge* does not contain any additional material pertinent to Poetry or Poetic Knowledge. This is also true of the 1935 second edition which contains, in addition to very minor revisions to the text and some additional footnotes, nine new appendices. Despite the fact that Maritain does not use the terms "Poetry" and "Poetic Knowledge," the first appendix, "The Concept," once again compares the divine, creative idea and the human artistic, operative idea. This discussion is an advance

over the earlier similar discussion both in terms of its technicality and the depth of its insight, a depth that advances the notion of Poetic Knowledge without using that name to designate it.

Maritain begins with a consideration of the Divine creative ideas. Technically, he says, the expression "creative idea" really has the Divine Ideas for its sole and proper reference; other uses occur improperly through an analogy of relation to the primary analogate. "[A]t the lowest possible level," one finds "the human artist's working idea" that imitates the Divine "with the maximum of imperfection." The creative idea, when spoken of in relation to the human artist, is more properly referred to as the artistic or operative idea and he discerns two "moments of reason." "First, in its common function as concept or presentative form informing the intellect, the artist's concept is the specifier of his knowledge" in that it shares a similarity with the "ordinary function" of concepts, namely, that they are "the *medium in quo* of knowledge. Second, the artist's concept as an operative concept, forms in his mind, contains and expresses, as object known, the thing to be made even before it exists in its own nature (it is thus that it is a *quod*)."[6] Maritain concludes this distinction of the two "moments of reason" with an expression of the twofold function of the artistic idea: "Thus, it is the privilege of operative knowledge and, in a unique way, of creative knowledge, for the idea to be at once a means *in quo,* and an object *quod,* by reason of a content that precedes the thing."[7]

A couple of things are especially noteworthy about this passage. First, in the last sentence quoted, notice that Maritain inserts a distinction between operative knowledge and creative knowledge, a type of knowledge not defined but which, Maritain says, operates in a "unique way." Second, since the term "Poetic Knowledge" is not employed here, this leads us to conclude that, despite its 1935 publication date, this particular essay is an earlier composition, probably penned somewhere between 1932 and 1934, that is, after 1932, the publication date of the first edition of *The Degrees of Knowledge,* and, as we will see in the forthcoming section, before 1935, the publication date of the es-

---

6. Ibid., 397.                    7. Ibid.

say "The Freedom of Song" (from his book *Art and Poetry*), the essay in which the term "Poetic Knowledge" first appears.

And lastly, in making this distinction of the two "moments of reason," Maritain, while still remaining within the analysis of the concept, introduces the notion that the artistic idea of concept functions as a *quod*—as an object known, "even before it exists in its own nature." By the time we come to the articulation of Poetic Knowledge in his 1937 essay "Concerning Poetic Knowledge," we will observe that Maritain modifies this position. There, Maritain will claim that the term of this mode of intellectual activity will only be completed *in the work,* and in no way is it a finished or completed object (*quod*) in the mind. This is especially true of properly Poetic Knowledge, and it is this uniqueness which is likely taking shape in Maritain's mind at this time, thus accounting for his expression that "creative knowledge" functions in a "unique way."

### 2. 1935: *Art and Poetry* and the Third Edition of *Art and Scholasticism*

In 1935, Maritain published his book *Frontières de la poésie et autres essais.* This book appeared in English in 1943 as *Art and Poetry.* The English version does not have the French original's main essay since it had already been published in 1927 as a supplement to the second edition of *Art and Scholasticism.* The English edition of *Art and Poetry* contains: (1) brief essays on the painters Marc Chagall, Georges Rouault, and Gino Severini; (2) an essay entitled "Dialogues" which, Maritain says, are "but the continuation, in written form, of some Parisian conversations and controversies"; and (3) the essay "The Freedom of Song." The dates of composition of these essays are different in each case,[8] and they vary in terms of their philosophical significance as well. As a matter of fact, concerning the development of the no-

---

8. The essay on Rouault was partially written in 1924, with additional remarks added in 1935; the essay on Severini was written in 1930; the essay on Chagall was written in 1929 and supplemented in 1934; the essay "Dialogues" dates from 1928; and "The Freedom of Song" dates from 1935. See Donald and Idella Gallagher, *The Achievements of Jacques and Raïssa Maritain,* 57.

tions of Poetry and Poetic Knowledge, it is the last essay alone, "The Freedom of Song," that holds any real significance, forming as it does a sequential relationship with its predecessor, "The Frontiers of Poetry." If we recall that the French edition contains both of these essays in the same volume, their continuity may be more easily appreciated. For English readers, Maritain's remarks in his preface to the English translation make their connection clear:

The subject of this book is art and [P]oetry, and the intermingling of the human and [P]oetic demands in man. . . . In my book *Art and Scholasticism* I intended to consider the essentials of art rather than the nature of [P]oetry. Later on it was this mysterious nature that I became more and more eager to scrutinize. . . . To tell the truth, [the essay in the present volume] presupposes in some way this essay, "The Frontiers of Poetry."[9]

In his 1943 preface, Maritain also makes clear that his "positions on [P]oetry and [P]oetic [K]nowledge are not explicitly stated in this book, but in another."[10] Nonetheless, two things from "The Freedom of Song" are worth mentioning. First, just as the term "Poetry" first appeared in "The Frontiers of Poetry," so the term "Poetic Knowledge" first appears in this related essay, "The Freedom of Song." Second, when contrasted with the mature expression of his thought in *Creative Intuition,* this essay clearly reflects many germinal insights. For example, Maritain articulates with unprecedented clarity and precision the analogy that exists between the mental word (or concept) as the term of the "speculative intuition of the philosopher" and the artwork as the term of the creative intuition or "creative idea" of the artist: "And it is only when the symphony is made and finished that, in the mind of the composer, its creative idea itself is achieved." And later: "And in truth these are analogous: to perform the inner word in the mind, and the work of art in matter."[11]

Here we see that this notion of a "creative idea" is once again drawn

9. Jacques Maritain, *Art and Poetry,* 9–10.

10. Ibid., 12. Maritain is referring to *The Situation of Poetry,* published in French in 1938.

11. Jacques Maritain, "The Freedom of Song," *Art and Poetry,* 80–81.

from the "astonishing correspondence of divine things,"[12] from whence he concludes that "the movement of operative spirituality which is the essential of the creative idea, *as such* is free of all, and receives nothing from anything nor from anyone (save from the first Poet)."[13] This of course refers to the very purity of the creative intuition considered *in itself*. It does not take into account the nature of the being in which it resides. In this pure state, the creative idea par excellence "is all liberty with regard to the object—formative and not formed"[14]—and as such, it is properly predicated only of God.

About this creative intuition in the human artist, with all of its "movement of operative spirituality," Maritain says two things: the first concerns the substance of the creative intuition, while the second concerns the vehicle for its communication. Concerning the first point, Maritain is consistent with his position in "The Frontiers:" "it is indeed himself and his own essence . . . that [the artist] expresses in his work; here is the hidden substance of his creative intuition."[15] Now, however, and for the first time, Maritain refers to this creative knowledge as Poetic Knowledge; it contains the reality of things co-natured with the artist's very Self and which together become the substance of that creative intuition that finds its full expression only in a work.

If [the artist] hears the passwords and the secrets that are stammering in things, if he perceives reality, correspondences, figures of horror or of beauty of a very certain objectivity, if he captures like a spring-finder, the springs of the transcendentals, it is not by disengaging this objectivity for itself, but by receiving all this into the recesses of his sentiment and of his passion—not as something other than he . . . but on the contrary as inseparable from himself, and in truth as part of himself; and it is thus to seize obscurely his own being with a knowledge which will not come to anything save in being creative . . . in a work made by his hands. . . . [T]hus knowledge by affective connaturality, knowledge by resonance in subjectivity, is by nature a [*P*]*oetic* [*K*]*nowledge*, tending of itself to a work of sounds or colors, of forms or words.[16]

---

12. Ibid.  
14. Ibid., 86.  
16. Ibid., 89–90 (emphasis added).  

13. Ibid., 87.  
15. Ibid., 88.

Note that this passage contains a reference to "affective connaturality," an expression which now is also appearing for the first time. This is also true in regard to the unique kind of emotion that is the vehicle through which the creative intuition is manifested. We can discern this early expression of emotion as the instrumental cause of Poetic Knowledge because of the advantage that hindsight affords, particularly in relation to the full articulation of this idea in *Creative Intuition*. The notion of "affectivity" is but a tidy and technical expression for the range of human passions or emotions, and Maritain is here indicating an interrelation between creative intuition and emotion. The reference, however, is not just to any emotion (or brute emotion); in the passage just quoted, he refers to it as "sentiment," that emotion referred to in *Creative Intuition* as "spiritualized emotion." It is an emotion that has been "transverberated by intelligence" and as such, he says, is "full of eyes."[17] He indicates that this emotion, as "charged with will," is also creative and "avid to give existence," since it is an "intelligenced emotion" which is "the invisible and intentional dart of intuition."[18] As the "dart" however, Maritain is clear right from the start that this "creative emotion" is not the *matter* of the creative intuition "but the *form* of the work"; "it is not a thing-emotion" but rather "an intuitive and *intentional* emotion, which bears within it much more than itself. It is the self of the artist insofar as it is a secret substance and person in the act of spiritual communication that is the content of this formative emotion."[19]

At this time, we can see that Maritain's predominate focus is the creative or operative idea (Poetic Knowledge), the creative, work-making activity of the spirit. In the third and final edition of *Art and Scholasticism* (1935), published around the same time as "The Freedom of Song," we find the only uses of the term "Poetic Knowledge." They appear in three footnote references, two of which merely use the term in passing.[20] The third use covers ground that is now familiar as it displays the sense of its operative orientation:

17. Ibid., 81.                    18. Ibid.
19. Ibid., 88.
20. Jacques Maritain, *Art and Scholasticism*, 187, n. 116, and 204, n. 138.

It is proper to insist here on the altogether particular knowledge by which the poet, the painter and the musician perceive in things forms and secrets that are hidden to others and which are expressible only in the work—a knowledge which may be called [P]oetic [K]nowledge.[21]

It is important that we note that, during this period, with his focus on this properly creative aspect of aesthetic experience, Maritain does not discuss the perception of beauty and the resulting delight. And so, while the expression "Poetic Knowledge" assumes the meaning that Maritain had formerly bestowed upon the creative aspect of Poetry, it is legitimate for us to inquire after the cognitive dimension of Poetry: What has become of it?

To answer this question, we should note that Maritain alters his manner of expression along with his shift in emphasis. The cognitive dimension of Poetry is now being expressed as "the transcendence" of Poetry, while the creative dimension becomes Poetic Knowledge. By 1935, in the historical development of Maritain's thinking, we see his first use of the term "Poetic Knowledge," while the transcendence of Poetry is equal to, and yet, somehow also above it. All future references to Poetic Knowledge will retain this de jure orientation toward a work-to-be-made; references to Poetry ambiguously sometimes will do the same, while on other occasions, they may not.

### 3. 1938: *The Situation of Poetry*

Maritain's most fully developed ideas concerning Poetic Knowledge from this middle period (1935–1938) are in his essay "Concerning Poetic Knowledge," originally delivered as an address before the Deuxième Congres International d'Esthétique et de Science de l'Art in 1937. This essay was subsequently incorporated along with another essay of his, and two of Raïssa's, to form their book *The Situation of Poetry* (1938). If "The Freedom of Song" introduced the terminology of Poetic Knowledge, the essay "Concerning Poetic Knowledge" focuses entirely on the meaning of this notion in its normal as well as its

---

21. Ibid., 195, n. 130. In that note, Maritain in fact refers the reader to his essay "The Freedom of Song" from *Art and Poetry* for additional explanation.

aberrant forms. At the outset, Maritain distinguishes three aspects of "[P]oetry's taking consciousness of itself as [P]oetry."[22] Maritain refers to this progressive move to the self-consciousness of Poetry as a natural result of the progress of the spirit. Since Poetry is of the spirit and spirit is naturally reflexive, it is only fitting that, in the evolution of artistic consciousness, Poetry would eventually come to be fascinated with itself and seek to penetrate its own secrets.[23]

In the final analysis, Poetry's evolving self-consciousness concerns the fascination it has with its own capacity for knowledge. "The more deeply [P]oetry becomes conscious of itself, the more deeply it becomes conscious of its power of *knowing*."[24] Essentially, however, Poetry is ordered toward productive activity; and so, while ringing the changes on an old theme—that Poetry is both cognitive and creative—Maritain now points out the fact that this fascination with its own power for knowledge can, like the insect drawn inexorably to the flame, be the source of an intoxication that ultimately leads to its own destruction.

In addition to this aberrant form, however, Poetry also can manifest itself in a purely contemplative form, as indicated by the following passage: "[P]oetry . . . is not the peculiar privilege of poets, nor even of other artists—it can also be found in a boy who knows only how to look and to say *ah, ah, ah*, like Jeremiah, or who intoxicates himself with it to the point of frenzy or suicide without ever having said or done anything in his whole life."[25]

All totaled, there are then three different modes of Poetry's life: First and foremost, there is Poetry's most natural, creative mode; it "lives" in the artist, quickening his or her creative pulse and sharpening the intuitive eye. Second, there are also those who, like Jeremiah, know "only how to look and say *ah, ah, ah!*" This is also natural though the contemplative-delight form. And finally, Maritain also claims that Poetry can become despotic and vampiric in its desire for knowledge. Poetry in this case is no longer connected with its natural

---

22. Jacques Maritain, "Concerning Poetic Knowledge," *The Situation of Poetry*, 44.
23. Ibid., 37–39.          24. Ibid., 47.
25. Ibid., 44.

flow toward either creativity or cognitive delight, but rather, turned against its natural orientation, it can exist for knowledge and knowledge alone. This desire leads not only to the destruction of Poetry itself, but also may lead to the demise of the Poet's very being as well, the destruction of the one who "intoxicates himself . . . to the point of frenzy or suicide." Maritain symbolizes this by the life examples of Rimbaud and the surrealists:

If [P]oetry loses its footing, there it is, detached from its operative ends. It becomes a means of knowing; it no longer wants to create, but to know.

The experience of Rimbaud is decisive here. Whereas later, while appealing to Rimbaud, the surrealists were to try to use [P]oetry as an instrument for their quasi-"scientific" curiosity, Rimbaud himself obeyed, he consciously and voluntarily obeyed the ultimate tyrannical exigencies of [P]oetic [K]nowledge let loose in its full state of savagery. . . .[26]

Wresting [P]oetry almost completely from its natural finalities, [the surrealists] wanted to make of it a means of speculative knowledge, an instrument of science, a method of metaphysical discovery.[27]

In this essay, Maritain develops his notion of genuine Poetic Knowledge against the backdrop of this perversion. And although Maritain occasionally uses the terms Poetry and Poetic Knowledge interchangeably, in the main, Poetry retains the transcendent, cognitive dimension of its ontological priority, while Poetic Knowledge permeates the artist's creative activity. It is "a knowledge which is . . . creative experience, for it wants to be expressed, and is expressible only in a work;" it is "neither previous to nor presupposed by the creative activity, but inviscerated in it, consubstantial with the movement toward the work."[28]

And yet, as always, Poetic Knowledge presupposes Poetry: "art, while it is productive in its essence, always supposes a moment of contemplation, and the work of art a melody, that is to say, a sense animating a form."[29] In referring to Poetry as "the melody of every authentic work of art," Maritain confirms again the cognitive or contemplative dimension of Poetry, which is ontologically prior to the creative force

26. Ibid., 53–54.
28. Ibid., 51.

27. Ibid., 57.
29. Ibid., 50.

of Poetic Knowledge, and as such represents that divination which "seizes the secret *meaning* of things." This intuitive knowing or

divining plunge *is* [P]oetry itself, it is the spirit which, in the sensible and through the sensible, in passion and through passion, in and through the density of experience, seizes the secret *meaning* of things and of itself in order to embody them in matter; the same meaning constituting at the same time the meaning thus perceived in being and the meaning which animates the work produced, or what I called a moment ago the melody of every authentic work of art.[30]

Up to this point, we have discussed the usual inclination of Poetry as a cognitive moment of Poetic Knowledge ordered toward the production of a work of art, and the aberrant, deviant form of Poetic Knowledge, whose demonic appetite turns Poetry into an instrument of *science* and *knowledge*. But what of Jeremiah, the prophet-boy "who knows only how to look and to say *ah, ah, ah*?" How might we incorporate this third mode into either of these?

The answer, I think, is simple—we can't. For we find here neither creativity nor the intoxication with Poetry's magical charm for procuring speculative knowledge. The example of Jeremiah suggests something of an entirely different nature—this is not some form of cognition ordered to artistic creation, nor is it a knowledge for science. Rather, it is a knowledge ordered simply to *delight*; the divining plunge which in and through the sensible, in and through passion and the density of experience, seizes the secret meaning of things simply for the pure delight which this moment of contemplation brings. It looks only to say "ah, ah, ah!"

### SUMMARY: THE SIX CONCLUSIONS
### FROM CHAPTERS 6 AND 7

We conclude this chapter with a systematic summary of the various conclusions from the research discussed in chapters 6 and 7.

---

30. Ibid., 52.

### 1. 1920: *Art and Scholasticism*

In 1920, neither of the terms "Poetry" and "Poetic Knowledge" appears in Maritain's writings though there is sufficient evidence to suggest that these terms are in a certain sense prefigured. By contrast, there is a lengthy and important discussion on the perception of beauty, a subject he does not discuss again until *Creative Intuition* in 1953. On this account, our *first conclusion* is: in the beginning of Maritain's reflections on aesthetics, both aspects of the aesthetic experience are represented, though in the development of his thought, Maritain's major concentration will be upon the creative or work-producing activity of the artist. This major concentration remains unchanged throughout his life.

### 2. 1926: *Art and Faith*

Our *second conclusion* is that, in this work, the term "Poetry" first appears, although without definition. Maritain uses it clearly to mean something other than "the art of verse writing." Poetry, as an aesthetic term, precedes the notion of Poetic Knowledge chronologically.

### 3. 1927: "The Frontiers of Poetry" and the Second Edition of *Art and Scholasticism*

With the essay "The Frontiers of Poetry," the definition of the term "Poetry" reveals the two distinguishable aspects of aesthetic experience: creative activity and the delight that results from the perception of beauty. Our *third conclusion* thus identifies these two subject areas as inherent in Maritain's connotation of Poetry and both are open to the possibilities of future development.

### 4. 1932: *The Degrees of Knowledge*

In this section, we observed that, since the dates of composition of the essays that comprise this work vary, these relatively early essays retain Poetry's duality. Although the work does reflect some prefiguration of Poetic Knowledge, the term itself does not appear in this work and accordingly, from the perspective of tracing the development of

Maritain's philosophy of art, this book is transitional. With no significant advances, there is no noteworthy conclusion concerning Maritain's aesthestics.

### 5. 1935: "The Freedom of Song": *Art and Poetry*

From "The Freedom of Song" (the sequel to "The Frontiers of Poetry"), we draw two additional conclusions. The first concerns the relationship between Poetry and Poetic Knowledge, and the second concerns the relation between Poetry and the perception of beauty. Thus our *fourth conclusion* is: in this essay, the term "Poetic Knowledge" appears for the first time, and it takes on the meaning of what Maritain formerly referred to as the creative dimension of Poetry. Meanwhile, our *fifth conclusion* is that the term "Poetry" itself assumes a transcendence and ontological priority over Poetic Knowledge, and reflects what previously was Poetry's cognitive dimension. Used in this way, Poetry has a kinship with his early discussions on the delight produced in the perception of beauty, a discussion which, from 1927–1938, has dropped out of Maritain's consideration.

### 6. 1938: *The Situation of Poetry*

In the essay "Concerning Poetic Knowledge," from *The Situation of Poetry,* Maritain calls attention to Poetry's three different expressions; the articulation of these constitutes our *sixth conclusion*. First, in the relation of Poetry to Poetic Knowledge, Poetry functions cognitively in the creative activity of Poetic Knowledge. In *Creative Intuition,* Maritain will refer to this aspect of Poetry's contemplative nature as "Poetic Intuition as Cognitive."[31] This is one of Poetry's natural functions. Second, Maritain also calls attention to a perversion of Poetry that results when it is used solely as an instrument for knowledge. Maritain rejects this use as something that is against the true nature of Poetry. And finally, Maritain also designates another natural function of Poetry which results solely in aesthetic joy and delight through an encounter with beauty.

---

31. See Jacques Maritain, *Creative Intuition,* 125–34.

From 1938 to 1953, Maritain published a limited number of articles on the subject of art, Poetry, and/or Poetic Knowledge. In all cases except one, these writings drew from preexisting material. The one possible exception is an article titled "Poetic Experience," in the *Review of Politics*.[32] Since many passages of this essay reflect similar ones from either *The Situation of Poetry* or *Creative Intuition,* we find no real advances in this essay. The essay is perhaps noteworthy, however, for the fact that in it Maritain does employ the expression "Poetic Contemplation" in the following sentence: "Poetic Contemplation is as natural to the spirit as is the return of the bird to its nest."[33] Unfortunately, he gives no further elucidation or development of the meaning of this term. Moreover, since virtually the same sentence, beginning with the term "Poetic Knowledge" instead, appears in *Creative Intuition,* this diminishes any real significance which we might wish to attach to the appearance and use of this term. While this study seeks to develop a notion of Poetic Contemplation as a legitimate extension of Maritain's ideas, for the present, suffice it to say that we can conclude little else from this essay beyond the fact that he does use this expression Poetic Contemplation.

### CONCLUDING REMARKS

We have now reached an important turning point in our investigation of the development of Maritain's aesthetics. While chapter 1 provided the biographical background concerning Maritain's unique suitability as a philosophical commentator on the totality of aesthetic experience, chapters 2 and 3 focused upon the theoretical background and key terminology that he employs. Chapters 4 and 5 systematically investigated the creative dimension of Poetry and Poetic Knowledge since those notions are central to the originality of his philosophy of art. These terms represent a fresh insight into the understanding of that intuitive nonconceptual connatural knowledge that characterizes

32. Jacques Maritain, "Poetic Experience," *Review of Politics* 6 (1944): 387–402.
33. Ibid., 396.

the creative aspect of aesthetic experience. They also give Maritain's aesthetics its true innovation.

In chapters 6 and 7, we have traced the development of Poetry and Poetic Knowledge, noting that, in addition to the experience and knowledge proper to the creative artist, it is possible to discern and trace the development of another closely related yet altogether different type of experience/knowledge—one that reveals a surprisingly fertile foundation for a legitimate extension of Maritain's epistemology and that rightly deserves to be called Poetic Contemplation. Before reconstructing that notion, however, we must first explore Maritain's ideas concerning the perception of beauty since they play a significant part in that reconstruction.

EIGHT

# THE PERCEPTION OF BEAUTY

The Key to Resolution

⌒

*The beautiful goes straight to the heart.*

—Jacques Maritain

The conclusions from chapters 6 and 7 indicated clearly that, although Maritain used the term Poetic Knowledge to refer exclusively to creative knowledge, Poetry's history reveals a duality. Poetry serves as the foundation for that creative knowledge which reaches its term only in a work (i.e., Poetic Knowledge), yet it also serves as the foundation for an alternative form of knowledge, one which, although sharing in the *cognitive* dimension of Poetic Knowledge, nonetheless bears no *necessary* orientation toward creativity. But what is this possible alternative use of Poetry that Maritain left undeveloped? This chapter will show that Maritain's discussion of beauty holds the key to the answer of that question. His detailed discussion of this topic first appeared in the 1920 first edition of *Art and Scholasticism,* and as such, it predates his specialized use of the term Poetry by nearly seven years. In this early work, Maritain provides a thoroughgoing and substantial explanation of the ontological nature of beauty and our epistemological perception of it.

Maritain's analysis of beauty involves a reflection upon basically the same human experience as its equivalent in the thirteenth century of Aquinas. Maritain would have had no reason to think that the human encounter with beauty, either in nature or in a work of art, would have been significantly different in either time period. Hence his 1920 analysis stands as a rather complete and conclusive treatment

of this subject articulated in twentieth-century Scholastic language. From Aquinas to Maritain, the basic substance is unchanged; only the form of expression is contemporary.

A sharp contrast to this exists, however, in the case of his theory of art. While it is true, as Maritain says, that *Art and Scholasticism* only indicates "some of the features" of a "rich and complete theory of Art" which are reworked from "the materials prepared by the Schoolman," it is also true that these materials serve only as principles or "maxims" for reconstructing a theory that will avoid the errors "of the 'Aesthetics' of modern philosophers."[1] At every turn, we should measure this newly expressed theory against the witness of modern and contemporary art and artists. Maritain's personal life, from his relationship with his poet-wife to his friendships with many artists and musicians, certainly afforded him ample firsthand contacts of this kind. And although *Art and Scholasticism* provided a sound primer of Thomist principles concerning a philosophy of art, when we think about the centuries of change that had occurred in creative expression from the thirteenth to the twentieth century, there can be little doubt that *Art and Scholasticism* represented only a beginning. As Maritain's own discussion of the human creative process attests, and as he traces the stages of growth of artistic consciousness in *Creative Intuition*,[2] the understanding of creativity had changed and grown significantly.

It should come as little surprise therefore that Maritain's writings concerning creative knowledge and the creative process display a long history of progressively deepening insight. Conversely, it also should come as no surprise that Maritain's discussion of the nature and human appreciation of beauty does not reflect a lot of innovation during his early years. However, after many years of continued philosophical reflection, and with the formation of a cohesive theory of creativity behind him, Maritain returns in his mature work to reflect upon the relationship between Poetry and beauty.[3] In this way, he provides

1. Jacques Maritain, *Art and Scholasticism*, 3–4.
2. See Jacques Maritain, *Creative Intuition*, 21–34.
3. Jacques Maritain, *Creative Intuition*, chap. 5, "Poetry and Beauty."

some late but valuable insights into that undeveloped aspect of his thought. We will revisit these considerations in our final chapter.

For the moment, our investigations into Maritain's ideas about beauty will take us from the 1920 text of *Art and Scholasticism* to the very few but extremely important additions to the later editions of this work. In the 1927 second and 1935 third editions, Maritain places these new insights concerning beauty and the perception of beauty in either new explanatory endnotes or as emendations to original ones. With the appearance of his opus magnus *Creative Intuition* in 1953, Maritain revisits the subject of beauty and the perception of beauty. In this chapter, we will trace the development of his ideas on beauty and its eventual relation to Poetry in order to discover those foundational insights that will pave the way for the reconstruction of his undeveloped pathway, Poetic Contemplation.

## THE HISTORICAL/THEORETICAL DEVELOPMENT OF MARITAIN'S THEORY OF BEAUTY AND THE PERCEPTION OF BEAUTY

### 1. 1920: The First Edition of *Art and Scholasticism*

*Id quod visum placet.* With this phrase, Maritain introduces the simple wisdom of Aquinas: "These four words say all that is necessary: a vision, that is to say, an *intuitive knowledge,* and a delight."[4] Since this phrase has been interpreted incorrectly so often—as if beauty were an object of ocular vision only—Maritain hastens to assert that beauty is "essentially an object of *intelligence.*" And yet, although the discussion is clearly on the side of the intellect, Maritain's full commentary also affirms the role of human *affectivity* in the perception of beauty. This delight, he says, is "not just any delight, but delight in knowing; not the delight peculiar to the act of knowing, but a delight which superabounds and overflows from this act because of the object known."[5]

In this first edition of *Art and Scholasticism,* Maritain does not

4. Jacques Maritain, *Art and Scholasticism,* 23.
5. Ibid.

make clear what he means by saying "not the delight peculiar to the act of knowing, but a delight which superabounds and overflows from this act because of the object known." The footnote that closes the section simply quotes the following passage from Aquinas, a passage which itself does much for reinforcement and little for elucidation: "It is of the nature of the beautiful that by the sight or knowledge of it the appetite is allayed," says St. Thomas,[6] though he too does not explain the relationship between the intellect and the will in the perception of beauty. In the 1927 second edition, Maritain will provide a full, technical discussion of this relationship in an emendation to a footnote. Accordingly, we will consider this relationship in the next section of this chapter.

But first, Maritain discusses the relationship between the intellect and the senses (or sensual appetites). This is particularly appropriate since, especially concerning aesthetic beauty, this relationship is prior both in time and in nature. When we consider the ontology of human nature, the senses serve the intellect and they alone possess that "intuitiveness required for the perception of the beautiful." Thus, after acknowledging that it is certainly possible for humans to enjoy purely intelligible beauty, Maritain emphasizes that the unique type of beauty which is "connatural to man is the beautiful that delights the intellect through the senses and through their intuition."[7]

As he develops this insight, Maritain once again follows St. Thomas. Maritain begins by discussing the three classical components of the perception of beauty: *integrity or perfection,* which describes the intellect's delight in the wholeness or fullness proper to a thing's nature; *proportion or harmony,* which describes the intellect's delight in order, balance, unity, and proper relation; and *clarity or radiance,* which describes the intellect's delight in "light and intelligibility." Maritain holds that this third factor is the most significant since all beauty requires some type of splendor. Naturally, this splendor will impart a certain delight in the senses, but sensual delight is only an accompanying good—the

6. Ibid., 161, n. 48 (Thomas Aquinas, *Summa Theologica,* I-II, 27, 1, ad 3).
7. Ibid., 24.

real splendor is the splendor of intelligibility. Maritain refers to this as the "splendor of the form" and he describes it as the proper principle of a thing's intelligibility: "every form is a vestige or a ray of the creative Intelligence imprinted at the heart of created being."[8] Thus, when an intellect discerns integrity, proportion, and clarity in some natural or humanly made object, it is actually discerning in the object some manifestation of intelligible activity—it is a "flashing of intelligence on a matter intelligibly arranged." For this reason, the "intelligence delights in the beautiful because in the beautiful it finds itself again and recognizes itself, and makes contact with its own light."[9] At the heart of all creation, whether human or divine, there shines the splendor or radiance of a form that has "an infinity of diverse ways of shining on matter." It is important to note that Maritain refers to three kinds of radiance: sensible radiance, intelligible radiance, and spiritual radiance, each of which permits many varieties and degrees.[10]

Maritain is wise to observe that we need to think according to the analogy of proper proportionality if we are to think rightly about all of these characteristics of beauty. "The good proportion of a man is not the good proportion of a child. Figures constructed according to the Greek or the Egyptian canons are perfectly proportioned in their genre; but Rouault's clowns are also perfectly proportioned, in their genre."[11] There are no absolute or fixed meanings concerning any of the three characteristics of beauty; all must be applied analogously in relation to a specific work. From this insight, we may conclude that beauty certainly is "relative," but not in the way in which this expression is usually understood: it is not relative to the subjective tastes of the "beholder." Rather, Maritain observes, it is relative "to the proper nature and end of the thing."[12] By understanding beauty in this way, we can account more adequately for the relativism of "subjective" taste: "however beautiful a created thing may be, it can appear beautiful to some and not to others, because it is beautiful only under certain aspects, which some discern and others do not."[13]

8. Ibid., 25.
9. Ibid.
10. Ibid., 28–29.
11. Ibid., 27.
12. Ibid., 29.
13. Ibid., 29–30.

The reason for this extreme diversity, both in terms of the varying degrees of perfection or in terms of the analogous modes of predication, is the fact that beauty is a transcendental. As such, it is convertible with the One, the True, and the Good; it is a certain "property of being" and, like all of the other transcendentals, "it is predicated for diverse reasons, . . . of the diverse subjects of which it is predicated." This accounts for its *analogous* nature—beauty, like being, is said of each kind of being, each in its own peculiar way. "Thus everything is beautiful, just as everything is good, at least *in a certain relation*. And as being is everywhere present and everywhere varied, the beautiful likewise is diffused everywhere and is everywhere varied."[14]

That beauty deserves to be counted among the traditional list of transcendentals is something which Maritain takes for granted in the original text. Not all Thomist philosophers agree, however, and so, in the 1927 second edition of *Art and Scholasticism*, Maritain adds a note to this passage defending his position. In the first edition, Maritain simply refers to God as the "sovereign analogue" of all of the transcendentals, concluding that "Beauty is one of the divine names." God in fact is "beauty itself, because He gives beauty to all created beings, according to the particular nature of each, and because He is the cause of all consonance and all brightness."[15]

Beauty, then, is primarily a concept of the metaphysical order, not solely of the aesthetic order. For just as something is good insofar as it exists, so in an analogous way (though by virtue of a different relation), it is also beautiful because it is or exists. This type of beauty is, strictly speaking, metaphysical beauty, and as such it frequently may not square with what is generally or commonly thought to be beautiful. The reason for this is actually quite simple: metaphysical beauty is an object for our understanding or intellect alone, while aesthetic beauty is an object that pleases the intellect through the means of sensible experience. This is the type of beauty which Maritain says is connatural to human experience and is proper to human art. Through it, the "brilliance of the form, no matter how purely intelligible it may

14. Ibid., 30 (emphasis added).
15. Ibid., 30–31.

be in itself, is seized *in the sensible and through the sensible,* and not separately from it."[16]

In this regard, beauty holds a special and privileged place in human experience. Just as Plato pointed out in the *Phaedrus,*[17] so Maritain too, following Aquinas yet again, agrees that the beautiful is an intelligible object, apprehended properly and primarily through an intuition of sense. In this apprehension, however, the intellect does not function according to its ordinary operation of abstraction and concept formation leading to judgments of speculative truth. Rather, the intuition of aesthetic beauty is at the opposite extreme of this normal intellectual functioning. Maritain says:

The intelligence in this case, diverted from all effort of abstraction, rejoices without work and without discourse. It is dispensed from its usual labor; it does not have to disengage an intelligible from the matter in which it is buried, in order to go over its attributes step by step; like a stag at the gushing spring, intelligence has nothing to do but drink; it drinks the clarity of being. Caught up in the intuition of sense, it is irradiated by an intelligible light that is suddenly given to it, in the very sensible in which it glitters.[18]

Moreover, this unique operation of the intellect in the perception of beauty accounts for a "curious analogy between the fine arts and wisdom."[19] Both are ordered to a transcendent object, whose ultimate value lies within itself alone. Pursued for their own sake, they are both truly noble since their ends are devoid of utility and desired solely for the delight that they provide. Since they desire this production of intellectual delight, their very activity, Maritain says, is a "kind of contemplation." And so, if the fine arts "aim at producing an intellectual delight, that is to say, a kind of contemplation," then it is equally true to say that *the very experience of this delight itself* is a "kind of contemplation." This realization will be especially valuable to recall when we take up the discussion of contemplation in the next chapter.

16. Ibid., 25.
17. Plato, *Phaedrus* 250D.
18. Jacques Maritain, *Art and Scholasticism,* 26.
19. Ibid., 33–34.

## 2. 1927: The Second Edition of *Art and Scholasticism*

With only two minor exceptions, the body of the original text of Maritain's chapter "Art and Beauty" remains unchanged from the first edition. The several really significant modifications that do appear in the 1927 second edition are found in two entirely new endnotes (one of which is quite lengthy) and seven additions to existing notes (three of which are lengthy and substantive).[20] Even before discussing the content of this new material, we may raise a prior question: Why has Maritain assigned his new material to footnotes rather than to a substantial reworking of the text? The response to this question I think is twofold: first, the material in Maritain's chapter "Art and Beauty" is already fine as it stands; it does not contain any errors or ideas that he needed to change. Second, since Maritain's primary interest concerned the exploration of artistic activity and the creative process, at this time in his life the connection between the knowing/delighting dimension of Poetry and the perception of beauty was of lesser importance. However, in the same year that Maritain first uses the term Poetry in "The Frontiers of Poetry," he connects this new insight to the perception of beauty: "Poetry," he writes, "stands in the line . . . of the delight procured by beauty."[21] Furthermore, just as Poetic Knowledge finds its termination only in a work (and not in a concept), so too, in a similar way, the perception of beauty does not terminate in a concept either:

[I]n the perception of the beautiful the intellect is, *through the means of the sensible intuition itself,* placed in the presence of a radiant intelligibility . . . which insofar as it produces the joy of the beautiful cannot be disengaged or separated from its sense matrix and consequently does not procure an intellectual knowledge expressible in a concept.[22]

20. Using the notation and pagination of the 1962 Evans's translation of *Art and Scholasticism,* the changes to the chapter "Art and Beauty," from the 1920 edition to the 1927 second edition, are as follows: note 50—a small addition; note 54—an addition to the existing note; note 55—a small addition; note 56—lengthy additions; note 57—a lengthy addition; note 62—new note; note 65—an addition; note 66—a lengthy, new note; note 73—an addition. The word "lengthy" designates additions or new notes that are more than a page.

21. Jacques Maritain, "Frontiers of Poetry," *Art and Scholasticism,* 128.

22. Ibid., 163–64.

Although this passage does appear in the 1920 first edition, with the 1927 edition, and in an effort to make clear that his emphasis upon the intuition of sense ought not be confused with the intuitionism of the Italian aesthetician Benedetto Croce, or confounded with faulty Thomistic interpretations, Maritain makes the following very important addition: "To understand this, let us recall that it is intellect and sense as forming but one, or, if one may so speak, *intelligentiated sense*, which gives rise in the heart to aesthetic joy."[23]

It is interesting to note that the 1927 edition of *Art and Scholasticism* contains a number of references to the "heart"—an expression not found in the 1920 edition. In addition to the passage just quoted, Maritain uses this term three times within the span of only two pages. These new additions are:

Thus artistic contemplation affects the heart with a joy that is above all *intellectual.*[24]

This seizure of an intelligible reality immediately "sensible to the heart," . . . creates . . . a distant analogy between aesthetic emotion and the mystical graces.[25]

The beautiful goes straight to the heart. . . .[26]

At first glance, the precise meaning of Maritain's use of this term appears rather ambiguous; closer scrutiny reveals that Maritain uses the notion of the "heart" as a faculty of, or vehicle for, the knowledge that one gains through love serving secondarily as a *form* for the intellect, just as "spiritualized emotion" also may serve as a *form* of knowledge.

That "the beautiful goes straight to the heart," then, is just another way of saying that, as opposed to purely intellectual knowledge that terminates in ideas or concepts, this knowledge or perception of the beautiful through "intelligentiated sense" ends in a joy or delight, it "gives rise in the heart to aesthetic joy" and "affects the heart with . . . joy." In other words, it is a satisfaction of our natural intellectual appetite. Maritain makes this clear when he writes: "The beautiful goes

23. Ibid., 164.    24. Ibid.
25. Ibid., 165.    26. Ibid., 166.

straight to the heart, it is a ray of intelligibility which reaches it direct-
ly and sometimes brings tears to the eyes. And doubtless this delight is
an 'emotion,' a 'feeling' (*gaudium* in the 'intellective appetite' or will,
joy properly so called . . . )."[27]

Acknowledging this relationship between the intuition of the in-
telligible radiance and the joy or delight that it produces, Maritain
adds a note in 1927 that establishes the precise relationship between
the intellect and the will in regard to beauty. The intellect has "be-
ing" as its formal object; its natural orientation, end, and desire is for
"what-is," or being. Of itself, it desires only to know. The appetitive
dimension of human existence does not know but desires as good
what the cognitive faculties present to it. Those things that the senses
perceive as good are objects for our sense appetites, while those things
that the intellect understands as good are objects for our intellectual
or spiritual appetite (the will). Simply and generically expressed, the
definition of the good is that which is desirable. Maritain says that the
good is "generally speaking, . . . an object the possession of which ap-
pears to the subject as good and towards which he directs his desire."[28]
Thus, that which the intellect discerns as good is thereby intellectually
desirable.

The sense and intellectual appetites naturally take pleasure in the
satisfaction of their desire, yet the aspect of pleasure (mentioned in
the definition of beauty—"that which, being seen, *pleases*") is not the
factor that distinguishes the good from the beautiful. Rather, Maritain
follows Aquinas and rightly points out that the pleasure that comes
from the perception of beauty derives from the fact that the beautiful
satisfies the natural orientation of the intellect for integrity, propor-
tion, and radiance. "The beautiful adds to the good a relation to the
cognitive faculty: so that that is called good which simply pleases the
appetite; whereas *that is called beautiful whose mere apprehension gives
pleasure.*"[29]

Maritain notes that certain major texts of Aquinas emphasize ei-

27. Ibid.
28. Ibid., 170.
29. Ibid., 169. See Thomas Aquinas, *Summa Theologica*, I-II, 27, 1, ad 3.

ther of two different ways in which the beautiful may relate to the appetite. The first of these relates an object "X" directly to our appetite—thus we love or desire "X" simply because it is beautiful. In this experience, the question "Why is X beautiful?" is of no importance. This question, however, points the way to the second relation, one that takes account of the part played by the intellect in the love, desire, and pleasure experienced in our contact with X. In this second case, the "sight" of X is the reason first for our pleasure, and consequently for our calling it beautiful. Maritain writes:

[T]here are two ways in which the beautiful can be related to the appetite: either as subsumed under the aspect of the good and as the object of an elicited desire (we love and desire a thing because it is beautiful); or as a special good delighting the appetitive faculty *in the faculty of knowledge* because it satisfies the latter's natural desire (we say that a thing is beautiful because *the sight of it* gives us pleasure). From the first standpoint the beautiful coincides with the good only materially . . . ; from the second, on the contrary, it is of the very notion of the beautiful to be the *special* good in question.[30]

Thus the distinguishing factor that is present in the logical notion of beauty is not the concomitant pleasure given in its apprehension but rather in its relation to the natural desire of the intellect; in this way, the beautiful is a special kind of good.

Maritain ratifies this point in the 1927 second edition by renewing an earlier discussion. This time he defends his position that beauty rightly deserves to be called a transcendental. He argues persuasively that the beautiful is as much a transcendental as any in the classic list of transcendentals (*ens, res, unum, aliquid, verum, bonum*). Maritain defines the transcendentals as "objects of thought which transcend every limit of genus or category, and which do not allow themselves to be enclosed in any class, because they imbue everything and are to be found everywhere."[31] Transcendentals are not distinguished materially, but only according to their formal or logical idea. Maritain says that "like the one, the true and the good, the beautiful is *being* itself

---

30. Ibid., 169–70 (emphasis added).
31. Ibid., 30.

considered from a certain aspect . . . it adds to being only a relation of reason."[32] Why, then, is the beautiful included only occasionally when the transcendentals are named?

In a lengthy note added for the first time in 1927, Maritain responds to this question directly. He says:

The classic table of transcendentals . . . does not exhaust all the transcendental values, and if the beautiful is not included, it is because it can be reduced to one of them (to the good—for the beautiful is that which in things faces the mind as an object of intuitive delight). Saint Thomas constantly affirms that the beautiful and the (metaphysical) good are the same thing in reality and differ only in notion or idea. . . . It is so with all the transcendentals: they are identified in the thing, and they differ in idea. . . . If it is true that *the beautiful is the same thing as the good, differing only in idea* (I-II, 27, 1, ad 3), why should the beautiful not be a transcendental as well as the good? Strictly speaking, Beauty is the radiance of all the transcendentals united.[33]

If the relation to the cognitive faculty is that aspect which distinguishes beauty from the good in idea, it is, on the other hand, the aspect of joy or delight, produced by an intelligentiated-sense intuition, which distinguishes the beautiful from the other intellectual objects of thought. On this account, we cannot discuss the beautiful solely in terms of the intellect. For just as the beautiful itself is a transcendental and hence of an analogous order, so too is "the property of causing joy, of 'giving pleasure,' implicit in the notion of the beautiful itself."[34] And that faculty which pertains to joy, delight, or pleasure is the intellectual appetite or will (the "heart"). The fact that beauties are analogous attests to the varying and diverse ways that human intelligence operates in ordinary experience; the fact that pleasures or joys are analogous attests to the varying and diverse expressions of human appetites that also operate in ordinary experience. Hence, the more pure the intelligibility of beauty, the more pure the spiritual joy of the will.

This relationship of the beautiful to the appetites is not an acci-

32. Ibid.      33. Ibid., 172–73.
34. Ibid., 173.

dental or incidental relationship but one that pertains to the very essence of the beautiful. As references to the "heart" make clear, this relationship reaffirms the important way that the affective or appetitive dimension of human nature may serve as the "form" of human understanding. Thus, to his reflections on the relationship between the beautiful and the will, Maritain adds three important qualifications. First, the essential nature of beauty satisfies the natural desire of the intellect. As such, it is only in an indirect relation with the will. "It is the nature of beauty to gratify desire in the intellect, the faculty of enjoyment in the faculty of knowing."[35] And later, "beauty, while directly facing the faculty of knowing, by its very essence indirectly concerns the appetitive faculty."[36]

Second, Maritain goes further still and says that the delight that is given in the act of knowing is not only "a property of beauty . . . but a formal constituent of it."[37] If we were to imagine, against all possibility, a human being composed solely of intellect, with no appetites, desires, or affectivity, such a being, Maritain tells us, could not possibly have an experience or perception of beauty. Without "heart," the experience or perception of beauty is an impossibility. "It is the fact of stirring desire and awakening love which is a *propria passio* of the beautiful."[38]

Maritain's third addition is perhaps the most significant. For not only is beauty an object that relates to both intellect and will, and not only is the joy and delight which the perception of the beautiful produces, a formal and essential constituent of beauty, Maritain also observes that, while this joy or delight which we experience is certainly an emotion, it is not an emotion in the ordinary, biological sense of the term. Rather, it is properly called a *gaudium* or joy in the intellective appetite or will; it is "an altogether special feeling, one *which depends simply on knowledge* and on the happy fullness which a sensible intuition procures for the intellect."[39] It is this intellective joy which creates, "on an entirely different plane and by an entirely different psy-

---

35. Ibid., 168.      36. Ibid., 170.
37. Ibid., 168.      38. Ibid.
39. Ibid., 167.

chological process, a distant analogy between aesthetic emotion and the mystical graces."[40]

### 3. 1935: Third Edition of *Art and Scholasticism*

Few additions were made in the 1935 third and final edition of *Art and Scholasticism*. In almost every case, however, the new material that does appear reflects that progressive intensification of Maritain's ideas of Poetry and Poetic Knowledge which was taking place during this period. For example, it is in this edition that Maritain first uses the term "Poetic Knowledge," though, as mentioned, this occurs in the notes only.

Following upon the discussion at the conclusion of the previous section, there are also three very important additions in the 1935 notes that further the case for the reconstruction of a notion of Poetic Contemplation. Previously, we observed how "this seizure of an intelligible reality immediately 'sensible to the heart,' without resorting to the concept as formal means, creates, on an entirely different plane and by an entirely different psychological process, a distant analogy between aesthetic emotion and the mystical graces." In the 1935 edition only, Maritain directly inserts the following qualifying remark:

I say "by an entirely different psychological process." In reality, mystical contemplation takes place by virtue of the connaturality of love; here, on the contrary, love and affective connaturality with regard to the beautiful thing are a *consequence* or a *proper effect* of the perception or aesthetic emotion—a proper effect, moreover, which normally reverberates back on this emotion itself to intensify it, to give it content, to enrich it in a thousand ways.[41]

Mystical contemplation, then, depends upon a connaturality with the Holy Spirit (or the gifts of the Holy Spirit or love), while aesthetic contemplation depends upon a connaturality with beauty. In the process of the latter experience, a natural desire of the intellect is satisfied, producing that "special feeling" called *guadium* or joy.

Later on, at the end of that same note, Maritain adds another sen-

40. Ibid., 165.
41. Ibid.

tence that further expands our understanding of this special emotion: "it is a superior emotion, whose essential nucleus is spiritual in nature, although in actual fact, like every emotion in us, it sets in motion the whole domain of affectivity."[42] Here we find the real roots of that "spiritualized emotion" that is at the foundation of every *genuine* aesthetic experience, regardless of whether it is creative or not. Moreover, since it "sets in motion the whole domain of affectivity," it is now easy to understand how, by "reverberating back on itself," this spiritualized emotion, together with love, not only "intensifies" the experience but also, "without resorting to the *concept* as formal means," nonetheless serves as a formal means of nonconceptual knowledge ("to give it content") and in the process enriches it "in a thousand ways."

There is also a passage in the original text where Maritain discusses the fact that art has as "its *effect* . . . to produce emotion"[43] In 1927, he adds a cautionary endnote remark: "It is perfectly true that art has the *effect* of inducing in us affective states, but this is not its [proper] *end* or its *object*."[44] Now, in 1935 only, and characteristic of the ideas just observed, he adds the following new paragraph:

[A]rt has as its *proper effect* to cause the one who enjoys the work to participate in the [P]*oetic* [K]*nowledge* which the artist is privileged to possess. This participation is one of the elements of aesthetic perception or emotion—in the sense that, produced immediately as a proper effect by the perception or emotion of the beautiful (considered in its essential nucleus), it redounds upon this perception or emotion, nourishes it, expands and deepens it.[45]

From this it should be clear that the "audience" does not *have* Poetic Knowledge—that is the exclusive knowledge of the creative artist as such. Yet, in this passage, Maritain tells us that the audience may *participate in it!* In this way, Maritain reinforces the fact that this knowledge is indeed a type of contemplation, one that involves the intellect as dependent upon the intuitions of sense. Moreover, in the

42. Ibid., 167.          43. Ibid., 62.
44. Ibid., 204.          45. Ibid.

following important passage, appearing in the 1935 edition only, notice the clear reference to this type of knowledge as a *speculative* mode of knowing that "pertains to the powers of contemplation":

> The judgment of *taste* is something altogether different from the judgment of *art:* it is of the speculative order. *Taste relates to the power of perception and delight of the one who sees or hears the work*; it does not by itself concern the operative intellect . . . ; *it pertains to the powers of contemplation.*
>
> Taste . . . concerns the sense as much as the intellect and it concerns the intellect, as bound up with the exercise of the sense: no universe of knowledge is more complex and more unstable.[46]

The perception of the beautiful (including "the judgment of taste") is then a speculative knowledge that is not in the order of science but in the order of contemplation. It proceeds by the intuition of intellect and sense ("intelligentiated sense") and has for the *terminus* of its activity that joy and delight in the will which occurs because it satisfies a natural intellectual desire. As a proper effect of this experience/knowledge, a certain resonance or reverberation with spiritualized emotion occurs in the perceiver such that he or she not only participates in the artist's Poetic Knowledge but through this emotion itself, the entire experience receives intensification and nourishment. This is a contemplative knowledge; it shares with Poetic Knowledge its character as an intuitive, nonconceptual, affective connatural form of knowledge. It is differentiated from Poetic Knowledge because the latter is a knowledge of the practical order directed toward the production of a work. By contrast, this type of knowledge is of the speculative order, primarily intellectual (though secondarily affective), and ordered toward joy or delight. Both share in the special emotion called spiritualized emotion, and they both share a foundational participation in Poetry. Were this not the case, we would hardly be in a position to assert in the last chapter that this Poetic Contemplation is a legitimate extension of Maritain's aesthetics, and one that is internally consistent with it.

46. Ibid., 202–3 (emphasis added).

COMPREHENSIVE REVIEW

Since the last three chapters have examined the theoretical ideas of Maritain's aesthetics by tracing their historical development, the following comprehensive review appropriately divides all three of these chapters into two parts, a historical review and a theoretical review.

1. Historical Review

The historical review makes note of the following three periods:

1. From the period circa 1920: (a) the terms "Poetry" and "Poetic Knowledge" are not present in Maritain's writings; (b) Maritain's primary focus is upon art as an activity involving creative knowledge; and (c) Maritain also discusses the perception of beauty (as a form of aesthetic or contemplative knowledge).

2. From the period circa 1927: (a) although the term "Poetic Knowledge" is still not present, Maritain does introduce the term "Poetry"; (b) articulated in both its cognitive and creative aspects, Maritain's discussions of Poetry nonetheless place greater emphasis upon the creative knowledge of the artist; and (c) despite the new and important insights he advances concerning the perception of beauty, that whole discussion now becomes proportionately less prominent.

3. From the period circa 1935–1938: (a) the term "Poetic Knowledge" enters as the term which properly designates the creative dimension of Poetry; (b) although the vocabulary from this period reflects a certain overlap and somewhat careless interchangeability between Poetry and Poetic Knowledge, there are other clear indications which point to Poetry's ontological priority over Poetic Knowledge, thus also indicating its cognitive dimension; and (c) discussions of beauty or the perception of beauty during this period are notes of clarification only. Rev. Joseph J. Sikora, S.J., ratifies this observation with the following comment:

Unfortunately, while insisting that in [P]oetic [K]nowledge both the subjectivity of the self and of things are known, Maritain so emphasizes *creative* [P]oetic intuition as to neglect somewhat the fully adequate disengagement

of simply *receptive* [P]oetic intuition which does not terminate in the production of a work but simply in the joy of the beholder. It is not that Maritain is unaware of simply receptive [P]oetic intuition . . . ; it is simply that he is focusing upon creative intuition, the intuition of the artist and [P]oet as such.[47]

## 2. Theoretical Review

The theoretical review contains four major points. The specific conclusions for this chapter 8 are the six subdivisions of point four:

1. Maritain's early work in aesthetics provides two distinct yet interrelated avenues of thought—one pertaining to creative knowledge, the other to the perception of beauty.

2. The key term that captures these two aspects is the term "Poetry" —it is chronologically and ontologically prior to Poetic Knowledge.

3. In his writings from the thirties, Maritain gives full attention to the exploration of creative knowledge (Poetic Knowledge), while his remarks concerning the perception of beauty (also called Aesthetic or Artistic Contemplation) are pale by comparison.

4. From the early discussions of the perception of beauty, we can see that:

a. Beauty is understood as an analogous term. It is superabundant and legitimately designated as one of the transcendentals.

b. The intellect is that faculty which is principal in the discernment of beauty. The experience of properly *aesthetic* beauty occurs through the intelligentiated sense of the viewer who engages some radiance of the artist's intelligence which shines forth in the work.

c. The perception of beauty, though properly ordered to, or an object for, the intellect, does not terminate in any conceptual knowledge. Rather, it finds its *terminus* in delight or joy. This results because it satisfies a natural intellectual desire and in turn accounts for the resulting *gaudium*.

d. This joy or aesthetic emotion is not directly a connaturality of love (as is the case with supernatural contemplation) but rather, in the

---

47. Joseph J. Sikora, S.J., *The Christian Intellect and the Mystery of Being* (The Hague: Martinus Nijhoff, 1966), 87–88.

perception of beauty, love is a consequence or proper effect of it. In this case, human nature is connatural with beauty, though the resulting love and aesthetic emotion consequently serve as a "reverberation" to intensify the entire experience by constituting the foundation of "spiritualized emotion."

e. As a result, the perception of beauty, though primarily intellectual, is nonetheless secondarily affective. Our connaturality with beauty is therefore at once intellectual and affective, a position which makes the understanding of this unique experience both obscure and fertile.

f. Moreover, the intensification of aesthetic or spiritualized emotion enables the viewer to participate in Poetry. It is a matter of what Maritain called "the judgment of taste" which is speculative in nature and "pertains to the powers of contemplation."

In order to properly integrate the notions of Poetry and the perception of beauty with contemplation, we now turn to Maritain's thinking about contemplation (chapter 9) in order to show the way in which, in chapter 10, a reconstruction of Poetic Contemplation is indeed a legitimate extension of Maritain's aesthetics.

NINE

# MARITAIN ON CONTEMPLATION
# AND BEAUTY

~~~

*Contemplatives and [P]oets understand each other.*

—Jacques Maritain

Having completed our discussion of Poetry and the way that it operates both in creativity and in the perception of beauty, we should note that this type of human knowing represents an overlooked, yet much needed addition to the canon of systematic epistemology, particularly within the Thomist tradition. Of the following classic Thomist epistemology texts,[1] none makes any mention of a knowledge, like Poetry, that is intuitive, connatural, nonconceptual, and pierced by significant or spiritualized emotion: Regis, Brennan, Klubertanz, O'Neill, Donceel, Royce, Gardeil, Van Steenberghen, Phillips, Peifer, and others.[2] Were this insight Maritain's sole contribution to Thomistic episte-

1. L. N. Regis, O.P., *Epistemology* (New York: Macmillan, 1959); Robert Edward Brennan, O.P., *Thomistic Psychology* (New York: Macmillan, 1941); George P. Klubertanz, S.J., *The Philosophy of Human Nature* (New York: Appleton-Century-Crofts, 1953); Reginald F. O'Neill, S.J., *Theories of Knowledge* (Englewood Cliffs, N.J.: Prentice-Hall, 1960); J. F. Donceel, S.J., *Philosophical Anthropology* (New York: Sheed & Ward, 1967); James E. Royce, S.J., *Man and His Nature* (New York: McGraw-Hill, 1961); H. D. Gardeil, O.P., *Introduction to the Philosophy of St. Thomas Aquinas: Vol. 3. Psychology* (St. Louis, Mo.: B. Herder Book Co., 1956); Fernand Van Steenberghen, *Epistemology* (New York: Joseph F. Wagner, 1949); R. P. Phillips, *Modern Thomistic Philosophy*, vol. 1 (Westminster, Md.: Newman Press, 1948); John Frederick Peifer, *The Mystery of Knowledge* (Albany, N.Y.: Magi Books, 1964; originally published as *The Concept in Thomism* [New York: Bookman Associates/Record Press, 1952]).

2. Frederick D. Wilhelmsen, *Man's Knowledge of Reality* (Englewood Cliffs, N.J.: Prentice-Hall, 1965); Peter Hoenen, S.J., *Reality and Judgment According to St. Thomas* (Chicago: Henry Regnery, 1952); Joseph D. Hassett, S.J., Robert A. Mitchell, S.J, and

mology, his contribution would already be significant. And yet, there is more.

For Maritain is not only a great commentator and innovator; he is also an astute pathfinder. In addition to the carefully articulated and brilliantly defended positions of traditional Thomist epistemology, his writings also contain a number of new and original insights. Many of these advances, like Poetry and Poetic Knowledge, were developed by Maritain himself; others await their full development by his students. Since his writings are copious and their topics expansive, we can expect that the full implications to be drawn from them will, like the mining of all great works, be forthcoming for quite some time.

This and the final chapter constitute but one such attempt at extracting some ore of insight from Maritain's writings. For just as with Poetry and beauty, so too we find, scattered throughout Maritain's discussions about contemplation, essential insights that confirm that a reconstructed notion of Poetic Contemplation is a legitimate extension of Maritain's epistemology. In this chapter, we will examine Maritain's understanding of contemplation in general and its relation to beauty in particular.

## ON NATURAL AND SUPERNATURAL
## CONTEMPLATION IN GENERAL

Poetry . . . is spiritual nourishment; but of a savor which has been created and which is insufficient. There is but one eternal nourishment. Unhappy you who think yourselves ambitious, and who whet your appetites for anything less than the three Divine Persons and the humanity of Christ.

It is a mortal error to expect from [P]oetry the supersubstantial nourishment of man.[3]

Although Poetry *is* spiritual nourishment, this passage clearly distinguishes it from that spiritual nourishment which alone provides

---

Donald J. Monan, S.J., *The Philosophy of Human Knowing* (Westminster, Md.: Newman Press, 1953); Cornelius Ryan Fay and Henry F. Tiblier, S.J., *Epistemology* (Milwaukee: Bruce Publishing Company, 1967).

3. Jacques Maritain, *Art and Scholasticism,* 132.

eternal sustenance: the indwelling of the Holy Spirit leading to sanctity and the beatific vision. As it is, Maritain has no developed discussion of aesthetic contemplation, and there is no special treatment of a purely *natural* contemplation either. In the vast majority of cases where Maritain uses the term "contemplation" without adjectival qualification, he uses it as the equivalent of supernatural contemplation. As indicated by the opening quotation, for Maritain, nothing, not Poetry, not metaphysics, not philosophical contemplation, takes the place of that union and beatitude given in supernatural contemplation and divine grace.

Recalling Maritain's biography from chapter 1, this commitment to a sanctified life of prayer and holiness should not surprise us. While it is true that Maritain always referred to himself as a philosopher, it is helpful to remember that the primal source of energy and inspiration that propelled his life's work derived from his burning love for, and unassailable confidence in, the truth of Jesus Christ and His Gospel. Maritain maintained that human personality is by nature an image of, and a participation in, the life of the Trinity, predestined to ultimate beatitude through that unity with God that is the beatific vision. He clearly follows Aquinas in this regard: our ultimate happiness and fulfillment is obtained through the satisfaction of the natural desire of the intellect for beholding the fullness of Being. This is *contemplatio sanctorium.*

The Christian doctors tell us that [*contemplatio sanctorium*] is supernatural, that is to say, it is achieved by the gifts which Sanctifying Grace,—formal participation in us of divine nature,—brings to the soul. . . .

It can be called Christian in [an ontological or metaphysical] sense, since it lives by the grace of Christ. In that sense it can even be found,— substantially the same, whatever the difference of mode, degree, purity, or human setting,—in eras or lands where Christianity is not professed. It is the supernatural contemplation of the Old Testament and the New, of Moses and St. Paul, such as is exercised by the living faith and supernatural gifts. The existence of these divine gifts is taught us by Christian revelation, but they are alive in all who have the grace of Christ, even when not belonging visibly to His Church.[4]

4. Jacques Maritain, "Action and Contemplation," *Scholasticism and Politics,* 170. Although there is no French equivalent of this book, this essay had its original French

In his earliest and rather lengthy discussion of contemplation, *Theonas: Conversations of a Sage,* Maritain distinguishes the Greek and Christian conceptions of contemplation. The former is "set forth by the Philosopher," while the latter is the "contemplation as practiced by the Christian," that is, by one who is a "partaker of the divinity by grace."[5] The Greek notion leads inevitably to a kind of "intellectualism"—it is a contemplation of the intellect alone which is solely for the good of the one contemplating. Maritain cautions that it is possible to misinterpret Aquinas's ideas as consistent with this Greek ideal, since for St. Thomas the intellect is superior to the will, the faculty of human love. Such an interpretation, taken without qualification, is of course a mistake. The truth is that St. Thomas compares the intellect to the will only "according to the absolute hierarchy of the faculties." But that is not the sole consideration. Rather, "above all, [St. Thomas] most definitely affirms the pre-eminence, considered according to the conditions of this world, of love in human life." In the afterlife, the intellect "will enjoy its primacy" as it beholds God face to face; here below, however, "it is better to love God than to know Him," since our present knowledge of God is so limited.[6]

Drawing upon this basic distinction, Maritain contrasts supernatural and philosophic contemplation in the following way: "Christian contemplation then, is distinguished from philosophic contemplation by the three following characteristics: a) Instead of having for its sole end the perfection of him who contemplates, it exists for love of Him Who is contemplated; b) It does not stop short in the intellect as in its term, but passes into the will by love; c) It is not opposed to action in such a way as to exclude it, but rather it permits action to overflow from its own super-abundance."[7]

The discussion of contemplation found in Jacques's and Raïssa's little book, *Prayer and Intelligence,* amplifies the ideas expressed in *Theo-*

publication in *Revue Thomiste* 43 (1937): 18–50. In book form, it first appeared as one of the essays in Jacques Maritain, *Questions de conscience: Essais et allocutions* (Paris: Desclée de Brouwer, 1938).

5. Jacques Maritain, *Theonas: Conversations of a Sage,* 36–37.

6. Ibid., 37–38.

7. Ibid., 38.

*nas*: the term "contemplation" is understood in a very restricted, theological sense. In fact, Maritain even goes so far as to say that contemplation may be considered as roughly synonymous with the mystical life.[8] Moreover, contemplation

depends essentially on the Gifts of the Holy Spirit, and on the divine mode of action which they communicate to man . . . .

Contemplation is thus the domain of the liberty of the Spirit who breathes where he wills and no man knows whence he comes or whither he goes. . . .

Contemplation is the fruit of the indwelling of the Blessed Trinity in the soul and of the invisible mission of the Son and the Holy Spirit. . . .

It raises man to a knowledge and love of God which are all spiritual, . . . stripped of the sensible and the human, transcending the order of images and ideas and therefore incomprehensible and ineffable, and introducing the soul into the luminous cloud of divine things.[9]

This of course is hardly the language of a philosopher strictly or purely considered, though it is perfectly consistent with our understanding of this man, Jacques Maritain, who aspired to holiness and was, yet, one who philosophized. Given that for Maritain the defense of Truth (as an activity of the philosopher) is not of value in "isolation" but rather acquires an infinite value insofar as it is integrated into the quest of human persons for a knowledge and love of God, it is easy to understand that, for Maritain, theoretical abstractions and precisions ultimately gain significance only as an assistance to individuals on their journey toward a union with the Heavenly Father. "*Il n'y a qu'une tristesse, c'est de n'être pas des saints*": "There is but one sadness and that is for us not to be saints."[10]

It is for this reason that the main thrust of Maritain's writings on contemplation center upon its theological character—the gifts of the Spirit, participation in divine grace, the final call to the beatific vision, and the like. This is also true of passages that the reader will find

8. Jacques and Raïssa Maritain, *Prayer and Intelligence,* 19.

9. Ibid., 19–21.

10. Leon Bloy, quoted by Jacques Maritain in his "Introduction" to Leon Bloy, *Pilgrim of the Absolute,* 10. See also Raïssa Maritain, *We Have Been Friends,* 88.

in the following works: (1) *The Things That Are Not Caesar's*; (2) *The Degrees of Knowledge*; (3) *Science and Wisdom*; (4) The essay "Action and Contemplation" from *Scholasticism and Politics*; (5) *Liturgy and Contemplation*; and (6) *Man's Approach To God*.[11]

While there are other briefer sections or references to the supernatural nature of contemplation sprinkled throughout Maritain's writings, this listing, and particularly *The Degrees of Knowledge*, indicate the major sources of his ideas on this topic. There are, nonetheless, other relatively infrequent occasions where Maritain refers to natural modes of contemplative knowledge. In addition to the already mentioned rare references to artistic or aesthetic contemplation, we also may identify three other kinds of contemplation: (1) a natural, philosophic contemplation; (2) a natural form of affective contemplation (no name is given); and (3) a natural, mystical experience (which involves natural contemplation). These modes of natural contemplative knowledge have a direct bearing upon our study.

### ON NATURAL CONTEMPLATION IN PARTICULAR

The three factors by which Maritain contrasted Christian contemplation with Greek contemplation in *Theonas* reappear in a somewhat modified form in his essay, "Action and Contemplation." In the first place and in contrast to philosophical contemplation, Maritain points out that, with Christianity, the notion and practice of contemplation is not reserved to only a chosen, select few; nor is it solely the "business of specialists." Rather, with the Christian idea of contemplation, we find

11. Jacques Maritain, *The Things That Are Not Caesar's* (New York: Charles Scribner's Sons, 1931), chap. 3, sec. 3; original French publication, *Primauté du spirituel* (Paris: Librairie Plon, 1927); Jacques Maritain, *The Degrees of Knowledge*, chaps. 6, 7, 8, and 9—this is an extremely important work concerning Maritain's ideas on *supernatural* contemplation; Jacques Maritain, *Science and Wisdom* (London: Geoffrey Bles/ Centenary Press, 1940), chaps. 1 and 3; original French publication, *Science et sagesse, suivi d'éclaircissements sur la philosophie morale* (Paris: Labergerie, 1935); Jacques Maritain, *Scholasticism and Politics,* 170f; Jacques Maritain, *Liturgy and Contemplation* (New York: P. J. Kenedy & Sons, 1960), part 2 ; original French publication, *Liturgie et contemplation* (Paris: Desclée de Brouwer, 1959); Jacques Maritain, *Man's Approach to God* (Latrobe, Pa.: Archabbey Press, 1960).

an astounding revolution in the spiritual order. Greeks and Jews, masters
and slaves, men and women, poor and rich . . . all are called to the feast of
divine Love and divine wisdom. That wisdom calls them all, it clamours
[*sic*] in the public places and in the roadways. All, without exception, are
called to perfection . . . all are called to the contemplation of the saints, not
the contemplation of the philosophers, but to loving and crucified contem-
plation.[12]

Following these comments, Maritain goes on to discuss the rela-
tionship between contemplation and action, here referred to as "work."
Provocatively, he makes clear that, beyond contemplation, "all are
bound by the law of work."[13] In this way, he establishes a second con-
trast between Christian supernatural and Greek natural contempla-
tion. "Christianity," Maritain had just said, "has also transfigured the
notion of action [or work] and has given it a new meaning."[14] Aris-
totle's distinction between immanent activity and transitive activity[15]
(and the greater nobility of the former) tends to obscure a subtle but
very important factor, namely, that human transitive action exists on a
different plane than that transitive action which material things exert
on one another. This human transitive action is "born in the heart be-
fore being made manifest in the external world; it not only necessarily
proceeds from an immanent act [e.g., contemplation], but, moreover,
it goes beyond the work it serves, and by an instinct of communication
which demands to be perfected in goodness, proceeds to the service of
other men."[16]

These teachings concerning the nobility of work and the law that

12. Jacques Maritain, "Action and Contemplation," *Scholasticism and Politics*, 168.
13. Ibid.
14. Ibid., 166.
15. "Transitive activity is that which one being exercises upon another, the so-
called patient, in order to act upon it, imparting to it movement or energy. . . . Im-
manent activity . . . is the characteristic activity of life and spirit. Here the agent has its
own perfection in itself. . . . The acts of knowing and of loving are not only within the
soul, they are for the soul an active superexistence. . . . It speaks for Aristotle's greatness
to have known and taught that immanent (or vital or interiorizing) action is nobler
and more elevated than transitive (or non-vital or exteriorizing) action"; Jacques Mari-
tain, "Action and Contemplation," *Scholasticism and Politics*, 163–64.
16. Ibid., 166–67.

binds all human beings to it, affirm the greater nobility of the contemplative life. Human action is ennobled in a special way the more that it proceeds from a superabundance of the spirit nourished in contemplation. Since human persons, while not *of* the world, are nonetheless *in* the world, they may be considered both as members of a "terrestrial community and as part of the temporal universe of civilization" and as members of a celestial community, as persons ordered toward their ultimate, "transcendent and superterrestrial end."[17]

On the surface, it might appear as if temporal work, work of the ethico-social order, as Maritain refers to it, may have as its goal or purpose to lead us to some form of relaxation or holiday. It would appear that we work in order to obtain the money we need in order to afford our weekends and vacations. But to understand things in this way, Maritain cautions, is to understand the nobility of work as "directed to something less noble and less generous than itself."[18] We must be careful not to confuse rest or leisure as a kind of "relaxation," which refreshes the body for renewed work, and true rest or leisure, which refreshes and renews the soul. It is clear that leisure does not mean what most people tend to think of it. Leisure is not "relaxing," "chilling out," or "lounging around." Nor is it simply time off from work—a vacation or holiday. Rather, the word reflects the precise and restricted meaning articulated by Josef Pieper in his classic book *Leisure: The Basis of Culture*:

[L]eisure is not necessarily present in . . . things like "breaks," "time off," "weekend," "vacation," and so on—[rather,] it is a condition of the soul. . . . [Leisure is] "non-activity"—an inner absence of preoccupation, a calm, an ability to let things go, to be quiet. [It] is a form of that stillness that is the necessary preparation for accepting reality; only the person who is still can hear. . . . Leisure is the disposition of receptive understanding, of contemplative beholding, and immersion in the real. [It is the] surge of new life that flows out to us when we give ourselves to contemplation.[19]

---

17. Ibid., 171.  18. Ibid., 172.

19. Josef Pieper, *Leisure: The Basis of Culture,* trans. Gerald Malsbury (South Bend, Ind.: St. Augustine's Press, 1998), 30–31; original German publication, *Musse und Kult* (Munich: Kosel-Verlag, 1948).

Maritain understood all too well the application *in terms of work* of the distinction between the "terrestrial" and the "celestial." When we come to consider the ultimate end of human work, we can observe the way in which the two orders come together, such that even socio-temporal work must necessarily be ordered to a higher end. Other-wise, it loses its noble and truly human quality.

The quotation above was originally published by Josef Pieper in 1948. Let us observe similar ideas of Maritain's, penned some ten years earlier:

In reality, human work, even on the plane of social terrestrial life, must be accomplished with a view to an active and self-sufficient rest [i.e., one aspect of leisure or contemplation], to a terminal activity of an immanent and spiritual order, already participating in some measure in contempla-tion's supertemporality and generosity. . . . it is the *active* rest of the cul-ture of the mind and the heart, the joy of knowing, *the spiritual delectations which art and beauty offer us,* the generous enthusiasm supplied by disinter-ested love.[20]

Maritain is reluctant to use the word "contemplation" in a purely natural sense. Rather, he identifies human immanent activities as be-ing a *participation* in "contemplation's supertemporality." Maritain makes this point clear: "There is nothing here that is contemplation, properly speaking." Properly speaking? That's correct, since for Mari-tain, contemplation means supernatural contemplation.[21] And yet, Maritain is, of course, also aware that the world (Things) and works of art all participate in Spirit and stand as so many diverse signs of the Divine. "But if in this kind of leisure, instead of shutting up hu-man concerns in themselves, man remains open to what is higher than himself, and is borne by the natural movement which draws the hu-man soul to the infinite, all this would be contemplation in an incho-ate state or in preparation."[22] In an earlier passage, Maritain gives us

20. Jacques Maritain, "Action and Contemplation," *Scholasticism and Politics,* 172 (emphasis added).

21. "The contemplation of which I have been speaking is Christian contempla-tion,—what Albert the Great . . . called *contemplatio sanctorium*"; ibid., 170.

22. Ibid., 172.

a similar indication of his mind concerning natural contemplation in ordinary, lived, human experience. "There is a vast region of life of the spirit, where [supernatural] contemplation is prepared. . . . In this wider sense, the philosopher and the [P]oet can be said to be already contemplative on the plane of natural activities."[23]

In the same year as the publication of "Action and Contemplation," Maritain delivered his paper "Concerning Poetic Knowledge" at the *Deuxième Congres International d'Esthétique et de Science de l'Art* (1937). Within the text of that essay, Maritain distinguishes three different types of connatural knowledge, one of which is Poetic Knowledge itself. Another is supernatural contemplation which attains "as object the divine reality inexpressible in itself in any created word, by means of the union of love . . . and by a resonance in the subject."[24] The third is natural contemplation; it is not affective, as supernatural contemplation is, but rather an intellectual connaturality which attains "a transcendent reality inexpressible in itself in a human mental word, by means of a supra- or para-conceptual intellection."[25]

Although this statement of natural contemplation reflects an emphatic and conclusive tone, it is not Maritain's last word on the matter. He revisits this topic a year later, in September 1938, in an address to the *Congres de Psychologie Religieuse d'Avon* titled "The Natural Mystical Experience and the Void." While this essay also contains an enumeration of the various kinds of connatural knowledge, its real focus is the exploration of that natural, supra- or para-intellective, connatural experience identified in the 1937 essay. Maritain's treatments of the notion of natural contemplation comes in two forms, technical or casual. His technical discussions center on that intellectual contemplation of the philosophers or that para- or supra-intellectual contemplation produced by certain techniques of Eastern religions. By contrast, his casual remarks refer to leisure, "active rest," "spiritual delections," or "contemplation in an inchoate state"—that "vast region of life of the spirit, where contemplation is prepared." These casual

---

23. Ibid., 171.
24. Jacques Maritain, "Concerning Poetic Knowledge," *The Situation of Poetry,* 66.
25. Ibid.

uses are especially important for us in the development of Poetic Contemplation.

Maritain is aware, however, that the technical discussion of natural contemplation aims at a particular mode of knowledge only and consequently does not do justice to the entire range of possible forms of natural contemplation. There are certainly other dimensions of human experience/knowledge which go beyond his technical definition of natural contemplation. Hence he refers to "a great zone" of natural experience which may be either intellectual or affective, and which include "intuitions, warnings, forebodings, premonitions, divinations . . . whereof the noetic world of practical affectivity supplies us with so many examples."[26] But that is not all. In addition to designating "certain metaphysical intuitions" of "natural illuminations or revelations," "certain exalted states of philosophic contemplation," and the "numerous cases of 'religious experience' of which William James has collected so many examples," Maritain ties this entire discussion together when he reminds us of the whole "province of other states of contemplation which have a strongly affective hue and which, without being [P]oetic experience itself, are very common among [P]oets."[27]

With this one remark, Maritain unites the discussion on the perception of beauty (with all of its intellective/affective, connatural, nonconceptual, joy-producing, speculative characteristics) with the discussion of natural contemplation. This one remark, quiet as snow, carries with it the force of a storm for it refers specifically to a natural contemplation that is clearly affective; it is obviously not creative experience, though it is evidently common among Poets (i.e., "those who have never written a poem" but who, like Jeremiah, "know only how to say, *ah, ah, ah*"). In this way, we see a forecast of the integration of Maritain's discussions on the perception of beauty with this mode of natural contemplative knowledge.

---

26. Jacques Maritain, "The Natural Mystical Experience and the Void," *Ransoming the Time*, 266. (This essay was originally published in *Études Carmélitaines*, 23[1938]: 116–39.)

27. Ibid.

CONTEMPLATION AND BEAUTY

Since Maritain's thinking is rooted in the vast range of metaphysical truths, he is in a unique philosophical position. First, his metaphysics affirms the participation of all creation in the act-of-existing as bestowed by the *Ipsum Esse Subsistens,* God. Second, for him, the transcendentals truly are ubiquitous, and they are objectively real, regardless of whether anyone knows or acknowledges them or not. Third, as a Christian, Maritain's position becomes even more unique: the Prime Mover or "First Act" of the philosophers becomes the loving and compassionate Father who gives the gift of His Son for the love and salvation of humankind. In a special way, we are His children who are heirs by "adoption." Moreover, God's love (and beauty), His causal *esse,* shines forth through all creation, and is distinctively manifest in the lives of all human beings, regardless of whether we return this love in faith or not.

On this accounting, Maritain the Catholic/Christian philosopher necessarily affirms the possibility of a personal relationship between the Father and each person, accomplished through His Son and the Gifts of the Holy Spirit. Many accept this gift and grow in it, while others may not ever come to know of it consciously. Those who enter into this personal relationship open themselves up to the realm of supernatural contemplation in terms of the "ordinary" gifts of Faith, Hope, and Love. In this way, Maritain goes on to tell us that not just those who "know" God through faith are called to the mystical life. Everyone is called to the perfection of love, and everyone is called to the mystical life.

[I]f we define mystical life (or life according to the spirit) as a coming of the soul under the regimen in which the gifts of Grace [the gifts of the Holy Spirit] . . . predominate . . . , then it is clear that every soul is called,—at least in a remote manner,—to mystical life *thus defined.* Why is that so? Because all are called to the perfection of love.[28]

Since Christian mysticism "is, essentially, not esoteric or *reserved to specialists,*"[29] we must transpose the language and message of the mys-

28. Jacques Maritain, "Action and Contemplation," 176.
29. Ibid., 178.

tics in order to make their meaning pertinent to our time: "we who read [them] are expected to hear . . . according to a whole key-board of analogical values, to hear with *universal resonances*, and in a non-specialized sense."[30]

The upshot of this whole discussion indicates that, while there is a distinction between supernatural and natural contemplation, the exact line of demarcation between the two is not always easy to discern, especially in the practical order of ordinary experience. Consider Maritain's statement from *Prayer and Intelligence*, a perfectly "orthodox" statement on supernatural contemplation: "'The contemplative life,' says St. Thomas, 'consists in a sort of leisure, a repose' . . . 'a liberty of spirit' in which man 'burns with a desire of seeing the beauty of God.'"[31]

Consistent with his disavowal of himself as a "theologian," Maritain the metaphysician writes of our "seeing *the beauty* of God." Why is this not the equivalent of seeing God in either the beauty of nature or, through the instrumentality of the artist, in the beauty of works of art? In this way, we enter into that grey area where the demarcation between supernatural and natural contemplation becomes difficult to discern. On the one hand, the perception of beauty is clearly a form of natural contemplation, since it is not an immediate contact with, or presence of, the Divine itself. And yet, on the other hand, beauty is a transcendental, a divine name. Maritain writes:

Analogous concepts are predicated of God pre-eminently; in Him the perfection they designate exists in a "formal-eminent" manner. . . . God is their "sovereign analogue" and they are to be met with again in things only as a dispersed and prismatized reflection of the countenance of God. Thus Beauty is one of the divine names.

God is beautiful. He is the most beautiful of beings. . . . He is beautiful through Himself and in Himself, beautiful absolutely.

He is beauty itself, because He gives beauty to all created beings, according to the particular nature of each, and because He is the cause of all consonance and all brightness.[32]

30. Ibid., 179–80.
31. Jacques and Raïssa Maritain, *Prayer and Intelligence*, 29.
32. Jacques Maritain, *Art and Scholasticism*, 30–1.

Thus, the natural beauty with which we have contact is not truly the divine beauty that the holy will one day see "face to face." Rather, it is manifested darkly, through the veil of nature or works of art. And yet, they are signs nonetheless. They are created participations in nature, or works of art which artists cocreate, as it were, working as associates "of God in the making of beautiful works."[33] While strictly of the natural order, such aesthetic contemplations or perceptions of beauty thus transport us into "the domain of spirit." "The moment one touches a transcendental, one touches being itself, a likeness of God, an absolute, that which ennobles and delights our life; one enters into the domain of the spirit."[34]

Although all of the forms of natural contemplation may be said to encroach upon the "grey zone," there is nonetheless a special place that may be granted to Poetic Contemplation. The reason is that, although it is primarily intellectual (and this firmly establishes it as a mode of natural contemplation), it is also affective. In this regard, it shares something with supernatural contemplation, albeit analogously. We have already seen that supernatural contemplation results from the presence and activity of divine charity and the gifts of grace or the Holy Spirit. And yet, there is a certain real and legitimate analogy possible between supernatural contemplation and Poetic Contemplation—especially since it produces a love that *reverberates back* upon the aesthetic emotion, to enhance and enrich it. Maritain himself tells us about that "distant analogy between aesthetic emotion and the mystical graces."[35] And after all, it is not without reason that "contemplatives and [P]oets understand each other."[36]

In the last analysis all genuine [P]oetry is religious. Even if a [P]oet has no conceptual knowledge of God, even if he is or believes he is an atheist, it is toward the primary source of Beauty that in actual fact his spiritual effort is oriented. And thus . . . he will naturally be led by [P]oetry to some conscious notion and awareness of the existence of that God at Whom he is unconsciously looking, in and through his art and his work.[37]

33. Ibid., 60.                                    34. Ibid., 32.
35. Ibid., 165.                                   36. Jacques Maritain, *Art and Faith,* 83.
37. Jacques Maritain, *Man's Approach to God,* 19.

And again, from another text: "Thus it appears that [P]oetic experience, in its approach to created things, is an unknowing correspondence to the mystical approach to God, a lived analogy of that knowledge (not rational and conceptual, but by union of love) which the contemplative has of God."[38]

While other examples could be supplied from Maritain's writings, the main point is that the phrase "contemplation of beauty" approximates and, in some cases, even is a suitable equivalent for the expression "perception of beauty." Maritain refers to this form of contemplation as "aesthetic contemplation." In this study, we have shown that, given the development of Maritain's thought concerning the term Poetry, there is yet another avenue of thought concerning the perception or contemplation of beauty that he did not formally pursue. For this reason, the task of showing the insufficiency of the term "aesthetic" and the greater desirability of the term "Poetic" rests with his disciples. This is the argument that we will now develop in the final chapter. In this way, we will provide a well-balanced completion of Maritain's aesthetics, as well as enhance and expand that important though generally overlooked type of connatural knowledge that fills a void so frequently found in traditional, systematic Thomist epistemology.

38. Jacques Maritain, *Approaches to God*, 82.

# THE INTEGRATION OF POETRY, BEAUTY, AND CONTEMPLATION

⌒

*It is at once by [P]oetry and through [P]oetry . . .*
*that the soul divines what splendors shine beyond the tomb.*

—Jacques Maritain

## THE FIRST IMPORTANT INSIGHT

In chapter 5 of his *Creative Intuition in Art and Poetry,* Maritain takes up a consideration of the relationship between Poetry and beauty. Although reminiscent of his earlier treatment of the perception of beauty in *Art and Scholasticism,* his mature thought on the nature of Poetry enables him to make many new crucial observations about its relationship with beauty. For our purposes, two of those new insights are especially important.

In our chapter on the perception of beauty, we observed the essentials of Maritain's ideas concerning beauty: following Aquinas, beauty is *id quod visum placet.* The perception of it involves an intuitive knowing and delight that satisfies a natural desire of the intellect for integrity, proportion, and radiance. The intellect perceives aesthetic beauty through the instrumentality of the senses (intelligentiated sense). We should note here, however, that the part played by the senses in the perception of the beautiful may be difficult to understand correctly. It is not simply that certain colors are pleasing to the eye, or that certain sounds are pleasing to the ear, even though admittedly ordinary language does refer to pleasant experiences such as these in this way. What Maritain stresses is that human sensation is permeated by intelligence and does not function in isolation from it. As we have observed, the

senses (or more correctly, the intelligentiated senses) are really delighted by those intelligible rays, the "flashing of intelligence," which shine forth from "matter intelligibly arranged." And thus, while integrity, proportion, and radiance are all "shining" together, and are grasped by the intellect and give delight, Maritain now assigns the element of radiance or clarity to a special place of preeminence. Radiance is "the most important, [and] also the most difficult to explain."[1]

The great Schoolmen, Maritain tells us, referred to this element of radiance as *splendor formae,* the splendor of the form. In order to capture their meaning, Maritain turns to the original Aristotelian notion of form: "[T]he Aristotelian notion of *form* . . . does not mean external form but, on the contrary, the inner ontological principle which determines things in their essences and qualities, and through which they are, and exist, and act."[2] In other words, it is "the splendor of the secrets of being radiating into intelligence."[3] "The Schoolmen, when they defined beauty by the form, in reality defined it by the radiance of a mystery."[4] From these quotations, we can see easily that this "radiance" entails an encounter with the secrets and mystery of being, one that sounds remarkably similar to the object that is grasped by Poetry, "the inner being of things."[5] And not without good reason.

From the distinction between aesthetic beauty and transcendental beauty (where the former is that beauty most immediately proportioned to human experience, while the latter belongs preeminently to God as the primary analogate of all transcendental perfections), we can identify the first of Maritain's important insights: the fine arts struggle "to surmount the distinction between aesthetic beauty and transcendental beauty and to absorb aesthetic beauty in transcendental beauty."[6] This occurs because of the essentially spiritual and intelligible nature of beauty and art. And while there are many modes of creative artistic expression, it is, nonetheless, through the encounter with them that one learns "of the transcendental and analogous nature of beauty."[7]

---

1. Jacques Maritain, *Creative Intuition,* 161.
2. Ibid.                                         3. Ibid.
4. Ibid., 162.                                   5. Ibid., 3.
6. Ibid., 165.                                   7. Ibid., 166.

But that is not all. In its aesthetic beauty, the authentic artwork is a shared or participated sign of the transcendental nature of beauty and leads the receptive person to an appreciation of the spiritual—the Divine—that shines through the work. As evidence that Maritain holds this position in the highest regard, we can point to the fact that the following passage (or a form of it) appears in no less than six of his works, works that pertain to discussions of God as well as art, beauty, and Poetry:

"It is the instinct for beauty," [Baudelaire] said, "which makes us consider the world and its pageants as a glimpse of, a *correspondence* with, Heaven. . . . It is at once by [P]oetry and *through* [P]oetry, by music and *through* music, that the soul divines what splendors shine behind the tomb; and when an exquisite poem brings tears to the eyes, such tears are not the sign of an excess of joy, they are rather a witness to an irritated melancholy, an exigency of nerves, a nature exiled in the imperfect which would possess immediately, on this very earth, a paradise revealed."[8]

How shall we speak of this revered beauty? While it is aesthetic to be sure, it aspires to the transcendental; it brings tears to the eyes and provides us with a glimpse of paradise revealed. Does the term "aesthetic" adequately capture these spiritual overtones? Is the term "aesthetic" sufficient to express Maritain's insights?

Considered in itself, there is a certain measure of legitimacy to the adjective "aesthetic" as descriptive of beauty. This is due to a certain time-honored tradition where the word "aesthetics" refers to anything having to do with art. And yet, as early as 1921, Maritain pointed out that the term "aesthetics" is a technically incorrect designation for the philosophy of art. Modern writers, he says, use that term to encompass the theories of both art and beauty. However, as Maritain correctly points out, the theory of beauty belongs properly to ontology where the other transcendentals are treated also. The theory of art, however, rightly ought to use the term "art" in its broadest sense, and its domain should *not* be confined, as is the practice of modern and

8. Ibid., 166. See also these additional works of Maritain: (1) *Art and Scholasticism*, 32; (2) *Art and Faith*, 91; (3) *The Situation of Poetry*, 43; (4) *Approaches to God*, 80; and (5) *Man's Approach to God*, 18.

contemporary theories of aesthetics, to the fine arts alone. Moreover, Maritain goes on to note that "the word *aesthetics* is derived etymologically from sensibility (*aisthanomai* = feel), whereas art, and beauty also, are matters of the intellect, quite as much as of feeling."[9]

On Maritain's good advice, the spiritual-intelligible nature of beauty and natural contemplation suggest that we limit our use of the adjective "aesthetic." Although it does have popular usage (Maritain himself uses it), it is in the long run a term that is undesirable because it connotes the sensual dimension of the arts and too easily obscures the essentially spiritual-intelligible nature of beauty and art. In its place, we submit that Maritain's meaning of the term "Poetry" (or adjectively, "Poetic") is far more comprehensive and hence technically appropriate.

## THE SECOND IMPORTANT INSIGHT

As we have already discussed, Maritain's early use of the term "Poetry" reflected an ambiguity concerning its cognitive and creative dimensions. From 1927, both aspects appear together. In 1935 and 1937, Poetry appears as ontologically prior to Poetic Knowledge, where the former retained the cognitive dimension and the latter expressed the creative dimension. Then in 1953, although Poetry's initial definition is cognitive, it is now Poetic Knowledge that Maritain refers to as possessing both a cognitive and creative dimension. Because Maritain's use of these terms is never consistent or precise, we might feel ourselves in a quandary were it not for his introduction of an important distinction that serves to resolve this long-standing ambiguity.

Maritain begins his discussion on the specific relation between Poetry and beauty—a discussion, he cautions, that is "perilous and the vocabulary inadequate"—by reflecting on the relation between Poetry and "the free (nonconceptual) life of the intellect and the free creativity of the spirit." He confirms that "the urge and tendency to express, manifest, and create . . . is one with the nature of the intellect."[10] Before developing this point, however, he reminds us that there is anoth-

9. Jacques Maritain, *An Introduction to Philosophy,* 195.
10. Jacques Maritain, *Creative Intuition,* 168.

er urge and tendency that is also one with the nature of the intellect: "the urge and tendency to know. Cognitivity and creativity are the two essential aspects of the intellectual nature."[11]

This distinction between cognitivity and creativity can be applied in "three significant instances: Science, Art, and Poetry." In the case of science, "the intellect knows by producing the 'mental word' or concept, and it produces the 'mental word' or concept by knowing—that is a single and indivisible operation: the creative function of the intellect is entirely subordinate to its cognitive function."[12] The mind conforms to reality. The opposite relation obtains in the case of art or creativity: "the cognitive function of the intellect is entirely subordinate to its creative function. The intellect knows in order to create."[13] In artistic activity, reality conforms to the mind.

When he comes to discuss these two functions in the case of Poetry, however, Maritain now combines clarity and brevity in a second important insight: "in the case of [P]oetry, the cognitive function of the intellect comes into play in [P]*oetic intuition* and the creativity of the spirit is *free* creativity."[14] In one stroke, all of the previously quoted passages that refer to the [P]oet without a poem suddenly make sense:

Poetry . . . is clearly no longer the privilege of [P]oets.[15]

One can be a [P]oet and still produce nothing.[16]

A man who has never written a poem, but who is truly a [P]oet.[17]

Poetry . . . can also be found in a boy who knows only how to look and to say ah, ah, ah, like Jeremiah.[18]

Poetry: That intercommunication between the inner being of things and the inner being of the human Self which is a kind of divination.[19]

And yet, when we recognize at the same time that the creativity of the spirit is a *free* creativity that inclines toward creation, though it

11. Ibid.  
13. Ibid.  
12. Ibid.  
14. Ibid., 169.  
15. Jacques Maritain, *Art and Scholasticism*, 129.  
16. Jacques Maritain, *Art and Faith*, 90.  
17. Jacques Maritain, *The Degrees of Knowledge*, 282.  
18. Jacques Maritain, *The Situation of Poetry*, 44.  
19. Jacques Maritain, *Creative Intuition*, 3.

*may not* actually bear fruit in a work, we can reconcile the appearance of incompatibility between those passages just quoted and the following set of previously quoted passages.

Now it is quite true that one may be a [P]oet without producing—without having yet produced—any work of art, but if one is a [P]oet, one is virtually turned towards operation.[20]

There can be [P]oetic experience with no poem. (Although there is no [P]oetic experience without the secret germ of a poem, however tiny it be.)[21]

As soon as [Poetic intuition] exists . . . it is, in the depth of the nonconceptual life of the intellect, an incitation to create. This incitation can remain virtual. . . . Nay more, a [P]oetic intuition can be kept in the soul a long time, latent (though never forgotten), till some day it will come out of sleep.[22]

No doubt one can be a [P]oet without producing any work; but if one is a [P]oet, one is virtually turned toward operation.[23]

By keeping these two important insights in mind, their complementarity sets us up for the final reconstruction of a notion of Poetic Contemplation. In its turn, the addition of this component to Maritain's aesthetics balances and completes it.

## POETIC CONTEMPLATION

The above two insights help us to understand why Maritain is so insistent that "contemplatives and [P]oets understand each other."[24] What they share is the *cognitive* tendency of the intellect's spiritual energy, though the object known and the means by which it is known is certainly different in each case. For supernatural contemplation, it is the infused nature of the Divine itself, Eternal and Abiding Love, while for the natural contemplation of beauty, it is that manifestation of the Divine that shines through God's glorious creation, or, in par-

---

20. Jacques Maritain, *The Situation of Poetry*, 52.
21. Ibid., 75.
22. Jacques Maritain, *Creative Intuition*, 134.
23. Ibid., 185.
24. Jacques Maritain, *Art and Faith*, 83.

ticipation with the spiritual nature of the human artist's own creative Self, it shines forth in a bona fide work of art. This kinship provides us with the first ground for referring to this type of contemplation as "Poetic Contemplation."

When we consider the *creative* tendency of the intellect in relation to contemplation, we see that supernatural contemplation produces in the one contemplating a burning love for the object contemplated. As Maritain says, quoting Albert the Great: " the contemplation of the saints is for the love of the one who is contemplated, namely, God: wherefore it does not stop in the intellect's knowledge as an ultimate end, but passes into the heart by love"—its termination is not a "verbal word" or *verbum mentis* as is the case with rational knowledge, but rather a *verbum cordis,* a word of the heart.[25]

When we turn to the creative tendency of the intellect in relation to the natural form of contemplation that we are calling Poetic Contemplation, we see that here, too, this contemplation terminates in love, though in this case, it is not a direct participation in Divine Love itself. Rather, it affects the heart with a "love and affective connaturality" that is a proper effect of the satisfaction of the intellect's natural desire for integrity, proportion, and radiance, that "reverberates back

25. Jacques Maritain, *Art and Scholasticism*, 153. See also Jacques Maritain, *Prayer and Intelligence*, 3: "In us as well as in God, love must proceed from the Word, that is, from the spiritual possession of the truth, in Faith.

And just as everything which is in the Word is found once more in the Holy Spirit, so must all that we know pass into our power of affection by love, there only finding its resting-place.

Love must proceed from Truth, and Knowledge must bear fruit in love."

And again, ibid., 23–24: "Thus mystical contemplation penetrates and secretly tastes divine things in Faith, *by the very virtue of the love* which makes us one spirit with God. . . . And contemplation is always ordained towards love, for *love is more unifying than knowledge* (I, ii, 28, I ad 3.), at least than any knowledge outside the Beatific Vision." See also Jacques Maritain, *Art and Faith*, 109: "This eye-covered love of intelligence, that is what you call the heart, isn't it? *The illuminated eyes of the heart,* say the Scriptures." Additionally, see St. Thomas Aquinas, *On the Truth of the Catholic Faith, Summa contra Gentiles,* Book Four, translated by Charles J. O'Neil (Garden City, N.Y.: Image Books, 1957), 140: "From the very fact of saying that the Holy Spirit proceeds by way of will and the Son by way of intellect it follows that the Holy Spirit is from the Son. For love proceeds from a word: we are able to love nothing but that which a word of the heart [*verbum cordis*] conceives."

on this emotion itself to intensify it, to give it content, to enrich it in a thousand ways."[26] This emotion? It is joy or *gaudium,* produced by spiritualized emotion that is the very form and content of that Poetic Knowledge[27] that is expressed by the Poet *if* the incitation to create is sufficiently strong and not perverted into a means of knowledge as an end in itself. When Poetic Knowledge becomes an instrument of knowledge or science, it is turned against its true nature and represents what Maritain calls "magical knowledge," claiming the surrealists as its typical example.[28] Poetic Contemplation is as far removed from magical knowledge as is the proper nature of Poetic Knowledge itself. Poetic Contemplation is not sought after for its own sake as a source of *knowledge,* nor does it terminate in truth or an understanding of some secret of reality revealed by means of it. As we have seen, Poetic Contemplation, arising through spiritualized emotion, satisfies a natural desire of the intellect and terminates in joy. As such, it is connatural, nonconceptual, and "more experience than knowledge."

We should be careful to note that this notion of Poetic Contemplation is not synonymous with the notion of "Poetic Intuition as Cognitive." The latter is a moment of Poetic Knowledge that finds its terminus in a work, while the former is a mode of connatural knowledge that terminates in joy through the instrumentality of spiritualized emotion. The participation in spiritualized emotion makes it Poetic; the termination in *gaudium* distinguishes it as a mode of contemplation that is connatural and nonconceptual.

There is, finally, still one additional reason why *Poetic* Contemplation is a more legitimate and more desirable expression than *Aesthetic* Contemplation. Consider the following remark that Maritain makes concerning the relationship between Poetry and beauty: Poetry "is with beauty on terms of coequality and connaturality, and therefore cannot live except in beauty."[29] This declaration echoes the very same

26. Jacques Maritain, *Art and Scholasticism* (1935 edition only), 165.

27. See Jacques Maritain, *Creative Intuition,* 119–25.

28. For a discussion of "Magical Knowledge," see Jacques Maritain, *Creative Intuition,* 184–95.

29. Jacques Maritain, *Creative Intuition,* 173.

language that Maritain employed a page earlier: "Poetry tends toward beauty, not as toward an object to be known or to be made, or a definite end to be attained in knowledge or realized in existence, *but as toward that very life of yours which is in the one whom love has transformed into another yourself.*"[30]

I suggest that the clue to understanding this statement is that beauty, as a transcendental, is a property of being, "distributed" like being itself, according to the analogy of proper proportionality. It is participated in diversely by each being according to its own proper mode of existence; as such it is an object for the intelligence. Poetry, on the other hand, designates a certain intuitive *activity* of the intelligence, whether in its cognitive or creative functions. Accordingly, just as the lover tends toward the beloved, so does Maritain describe Poetry as tending toward beauty, though not as the intellect tends to an object to be conceptually apprehended. No! Maritain is here drawing upon a metaphor to hint at a relationship that is obscure, and he is expressly not "at ease with the vocabulary."[31] Rather, he uses the analogy of the mystery of love and connaturality to explain the relationship between Poetry and beauty: just as the lover is in some sense "one" with the beloved, so Poetry is "one" with beauty.

Maritain's struggle with language seeks to convey an insight that goes beyond the simple nature of each of these terms. He endeavors to break down the confines of beauty as a property of being and object for intelligence since, in its primary instance and signification, beauty is a Divine Name and, as such, it cannot be limited or confined as an object for an intelligence. As a result, Maritain, no longer in the realm of the problematic but in the spiritual realm of mystery,[32] refers to Poetry and beauty on terms of a coequality of love, "[P]oetry is in love with beauty, and beauty in love with [P]oetry."[33]

This is not to suggest that they are each in turn object and then

30. Ibid., 172 (emphasis added).
31. Ibid.
32. Ibid., 162. "The Schoolmen, when they defined beauty by the radiance of the form, in reality defined it by the radiance of a mystery."
33. Ibid., 173.

subject. Rather, as "lovers," Maritain endeavors to indicate that there is a measure of each "in" each—where there is one, there also will the other be found. As "lovers" they are in a sense one, yet two. Poetry, for example, as a mode of intuition (in either its cognitive or its creative exercise), does not aim at beauty as at an end. Rather it is "the end beyond the end for Poetry"—"as life and existence are for a runner running toward the goal"[34]—a copresence, if you will, for "Poetry cannot do without beauty, not because it is submitted to beauty as an object,"[35] but because they are in love with each other.

The role that love plays in the relationship between beauty and Poetry confirms the legitimate use of the word "Poetic" as the more preferred modifier of "contemplation." If the "perception of beauty," especially in Maritain's sense, is, in its highest form, a certain nonconceptual, intuitive, connatural, experiential contemplation putting us in touch with the inner being and mystery of things, it does so via that cognitive dimension of Poetry which is engaged in a mutual love affair with beauty and which terminates only in joy. It is a joyful contemplation of beauty and her secrets attained through Poetry. It is a Poetic Contemplation.

### THE COMPLETION OF MARITAIN'S AESTHETICS

The assertion that "Poetic Contemplation" is a more suitable and desirable expression than "Aesthetic Contemplation" deserves one last qualifying remark. Earlier in this study, we employed the term "aesthetic experience" to designate the experiences of the "audience," those who encounter works of art and the beauty of creation. As a generic reference, this terminology is fine since all of these experiences *are* aesthetic. However, because these aesthetic experiences display varying degrees of intensity, insight, and profundity, it would not be correct to refer to all of them as "Poetic experiences." An analogy from the relation of art and Poetry will make this point clear.

34. Ibid., 170.
35. Ibid., 173.

Art, understood as a work-making activity of the human mind, is ubiquitous. From craft (the "useful arts") to the fine arts, from the free play of childhood to the skill of the professional, from the spontaneously gifted to the technically trained, art displays a wide range of outward manifestations which in turn reveal varying degrees of perfection and proficiency. Bad art is still "art." As a *habitus* of the practical intellect, bad art may be poorly executed, insufficiently developed, or, lacking a Poetic gift, it may be uninspired or flatly academic. In the case of the useful arts, the work may be poorly made, failing to achieve its end well or completely. In the case of the fine arts, its academic quality or technical proficiency may lack an element of "mystery"—the artist has executed the work without possessing any penetrating insight and so the work "has nothing to say." All of this is equivalent to saying that the artist, and hence the artwork, lacks Poetry: that intuitive grasping of the inner being of things and of the artist's own inner Self that finds expression in the work. This is why Maritain says that Poetry is akin to "*mousikè,* the secret *life* of all of the arts."[36] Art without the gift of Poetry is still art, but it may be lifeless, tedious, and insipid.

This insight carries with it the further realization that when Poetry does truly *inspire* art, we are transported into the realm of the spirit, both as immanent and transcendent. Although we are beyond the realm of the superficial and the mundane, nonetheless, there are indeed many artworks, lacking Poetry, that appear to contain and convey a deep message but in reality do not. They merely play upon "the inexhaustible flux of superficial feelings in which the sentimental reader recognizes his own cheap longings, and with which the songs to the Darling and Faithless One of generations of poets have desperately fed us."[37] But this appearance is a mirage, and these "artworks" are little more than expressions of sentimentality and superficiality, and as such, they are hardly Poetic.

---

36. Ibid. For a more complete discussion of Maritain's use of *mousikè,* see ibid., 88–89: "Music . . . in Plato's mythology, does not mean only music, but every artistic genus which depends on the inspiration of the Muse. And he perceived that all the fine arts are the realm of *Mousikè,* and are appendent to [P]oetry"; ibid., 89.

37. Ibid., 113.

Moreover, just as there is this problem of objectively discerning good and bad art, so, too, from the side of aesthetic appreciation, there is a problem of subjectively discerning "genuine" from "nongenuine" aesthetic experiences, of discerning true sentiment from sentimentality.[38]

The good news is that this problem too may be solved by turning to Maritain's notion of Poetry, its connection with spiritualized emotion, and its relation to beauty and contemplation. For just as art may exist with or without Poetry, so too it is possible to distinguish those aesthetic experiences which encounter and resonate with Poetry from those that do not. Some *aesthetic* experiences are predominantly sensual delights to the eye or the ear. They are constituted by a beauty which, like fireworks, dazzles the beholder; they consort with the spectacular or, in the realm of the emotions, they are given by brute or raw emotions, depicted and aroused. The Scholastic principle that "something cannot give what it does not have" makes clear that those works that lack Poetry can hardly convey it. And yet, lacking Poetry, an aesthetic event and the experience of it may still be considered sensually or *aesthetically* enjoyable nonetheless.

Should the work possess Poetry, however, there is still no guarantee that it will be received. Just as beauty as a transcendental may appear "under certain aspects" only, so also some may discern an aspect of beauty that others may not. Similarly, some may discern genuine works of art infused with Poetry and be deeply moved by them. Others may not. This, too, is but an application of yet another Scholastic principle: "what is received is received according to the mode of the receiver." In this way, since the secrets of being that are captured by Poetry are limitless, each person in his or her own way will divine some secrets, *mousikè,* in the work that others may not. Some of those who encounter this work will "vibrate sympathetically" while others may not.

Thus, Poetic Contemplation distinguishes itself from the broader class of aesthetic experience on two counts. First, because it is Poetic

---

38. See chapter 4, pp. 56–57, for a discussion of the difference between sentiment and sentimentality, and their relation to "spiritualized emotion" and brute emotion.

and not merely aesthetic (since it captures and divines the Poetry that is in the work), it "causes the one who enjoys the work to participate in the *Poetic Knowledge* which the artist is privileged to possess."[39] Second, because, as we have seen from this chapter, it is a mode of natural *contemplation* and not simply an *experience*; it is a mode of knowledge that is connatural, nonconceptual, and an intellectual and affective intuition, which, by producing joy or an "irritated melancholy" through spiritualized emotion and a participation in Poetry, "brings tears to the eyes" as the "soul divines what splendors shine behind the tomb."[40]

⤙

As we observed earlier in this study, the tradition of realist or Thomist epistemology is generally but conspicuously silent on any forms of knowledge that are connatural, nonconceptual, affectively intuitive, and "more experience than knowledge." And yet these are the very characteristics of Maritain's notions of Poetry, Poetic Knowledge, and now, Poetic Contemplation. As this chapter has shown, the reconstruction of Poetic Contemplation is a legitimate extension of Maritain's philosophy of art. It is the integration of Poetry, beauty, and contemplation that gives Maritain's aesthetics its cohesion and originality. It deserves a degree of serious attention that it has not heretofore enjoyed. Not just for the Thomist tradition but beyond, Maritain's philosophy of art deserves serious attention because it answers difficulties that other theories do not, even as it advances insights about the spiritual dimension of human nature and the created universe, a "heaven in a grain of sand." The reaffirmation of these insights is particularly important for the early part of the twenty-first century, especially for a time that too often and too easily is entranced by a materialist reductionism that, with Bill Bryson, attempts to explain "nearly everything"—and explain away—"nearly everything else." Indeed, by contrast, the ingredients of Maritain's aesthetics— Poetry, Poetic Knowledge, beauty, and Poetic Contemplation—pro-

---

39. Jacques Maritain, *Art and Scholasticism*, 204, 1935 third edition only.
40. Jacques Maritain, *Creative Intuition*, 166.

vide a rational, philosophical explanation of both creativity and that aesthetic experience that terminates in spiritual enjoyment or delectation. When integrated, Maritain's philosophy of art helps us to make sense of the joy that results when, through our encounters with genuine works of art, we catch a glimpse of those marvelous "splendors [that] shine behind the tomb."

# Selected Bibliography

PRIMARY SOURCES

Adler, Mortimer. *The Time of Our Lives*. New York: Fordham University Press, 1996.

Aristotle. *The Basic Works of Aristotle*. Edited by Richard McKeon. New York: Macmillan, 1940.

Barré, Jean-Luc. *Jacques and Raïssa Maritain: Beggars for Heaven*. Translated by Bernard E. Doering. South Bend, Ind.: University of Notre Dame Press, 2005.

Bergson, Henri. *Creative Evolution*. New York: Random House, 1944.

———. *An Introduction to Metaphysics*. New York: Bobbs-Merrill, 1955.

Bloy, Léon. *Pilgrim of the Absolute*. New York: Pantheon Books, 1947.

Bryson, Bill. *A Short History of Nearly Everything*. New York: Broadway Books, 2003.

Cocteau, Jean. *Lettres à Jacques Maritain*. Paris: Librairie Stock, 1926.

Evans, Joseph W. "Jacques Maritain." *New Scholasticism*, 46, no. 1 (1972).

———, ed. *Jacques Maritain: The Man and His Achievement*. New York: Sheed & Ward, 1963.

Gallagher, Daniel. "Maritain, Eco, and the History of Philosophical Aesthetics." *Maritain Studies* 22 (2006).

Gallagher, Donald, and Idella Gallagher. *The Achievements of Jacques and Raïssa Maritain: A Bibliography, 1906–1961*. Garden City, N.Y.: Doubleday & Co., 1962.

Griffin, John Howard, and Yves R. Simon, eds. *Jacques Maritain: Homage in Words and Pictures*. Albany, N.Y.: Magi Books, 1971.

Kernan, Julie. *Our Friend, Jacques Maritain*. Garden City, N.Y.: Doubleday & Co., 1975.

Maritain, Jacques. *Antimoderne*. Paris: Editions de la Revue des Jeunes, 1922.

———. *Approaches to God*. New York: Macmillan, 1965.

———. *Art and Faith: Letters between Jacques Maritain and Jean Cocteau*. Translated by John Coleman. New York: Philosophical Library, 1948.

———. *Art and Poetry*. Translated by Elva de Pue Matthews. New York: Philosophical Library, 1943.

———. *Art and Scholasticism*. Translated by John O'Connor. New York: Charles Scribner's Sons, 1930.

————. *Art and Scholasticism and The Frontiers of Poetry.* Translated by Joseph W. Evans. New York: Charles Scribner's Sons, 1962.

————. *Bergsonian Philosophy and Thomism.* New York: Philosophical Library, 1955.

————. *Creative Intuition in Art and Poetry.* New York: Pantheon Books, 1953.

————. *Distinguish to Unite or The Degrees of Knowledge.* Translated by Gerald B. Phelan. New York: Charles Scribner's Sons, 1959.

————. *Education at the Crossroads.* New Haven, Conn.: Yale University Press, 1943.

————. *Existence and the Existent.* New York: Pantheon Books, 1948.

————. *Georges Rouault.* Translated by Campbell Dodgson. New York: Harry N. Abrams, 1952.

————. *An Introduction to Logic.* Translated by Imelda Choquette. London: Sheed & Ward, 1937.

————. *An Introduction to Philosophy.* Translated by E. I. Watkin. London and New York: Sheed & Ward, 1930.

————. *Liturgy and Contemplation.* New York: P. J. Kenedy & Sons, 1960.

————. *Man's Approach to God.* Latrobe, Pa.: Archabbey Press, 1960.

————. *Notebooks.* Translated by Joseph W. Evans. Albany, N.Y.: Magi Books, 1984.

————. "On Artistic Judgment." *Liturgical Arts* 11 (1943).

————. "On Knowledge through Connaturality." *Review of Metaphysics* 4 (1951).

————. *On the Church of Christ.* Translated by Bernard Doering. South Bend, Ind.: University of Notre Dame Press, 1973.

————. *On the Grace and Humanity of Jesus.* Translated by Joseph W. Evans. New York: Herder & Herder, 1969.

————. *The Peasant of the Garonne.* New York: Holt, Rinehart, and Winston, 1968.

————. *The Person and the Common Good.* South Bend, Ind.: University of Notre Dame Press, 1966.

————. "Poetic Experience." *Review of Politics* 6 (1944).

————. *A Preface to Metaphysics.* New York: Sheed & Ward, 1958.

————. *Quatre essais sur l'esprit dans sa condition charnelle.* Paris: Alsatia, 1956.

————. *Questions de conscience: Essais et allocutions.* Paris: Desclée de Brouwer, 1938.

————. *The Range of Reason.* New York: Charles Scribner's Sons, 1952.

————. *Ransoming the Time.* Translated by Harry Lorin Binsse. New York: Charles Scribner's Sons, 1941.

————. *Réflexions sur l'intelligence et sur sa vie propre.* Paris: Nouvelle Librairie Nationale, 1924.

————. *Réponse à Jean Cocteau*. Paris: Librairie Stock, 1926.

————. *Saint Thomas D'Aquin, apôtre des temps modernes*. Paris: Editions de la Revue des Jeunes, 1923.

————. *Science and Wisdom*. London: Geoffrey Bles/Centenary Press, 1940.

————. *Theonas: Conversations of a Sage*. Translated by F. J. Sheed. London and New York: Sheed & Ward, 1933.

————. *The Things That Are Not Caesar's*. New York: Charles Scribner's Sons, 1931.

————. *Three Reformers: Luther, Descartes, Rousseau*. New York: Charles Scribner's Sons, 1929.

————. *Untrammeled Approaches*. Translated by Bernard Doering. South Bend, Ind.: University of Notre Dame Press, 1997.

Maritain, Jacques, and Raïssa Maritain. *Prayer and Intelligence*. Translated by Algar Thorold. New York: Sheed & Ward, 1928.

————. *The Situation of Poetry*. New York: Philosophical Library, 1955.

Maritain, Raïssa. "Henri Bergson." *The Commonweal*, January 17, 1941.

————. *We Have Been Friends Together and Adventures in Grace: The Memoirs of Raïssa Maritain*. Garden City, N.Y.: Image Books, 1961.

*The Material Logic of John of Thomas*. Translated by Yves R. Simon, John J. Glanville, Donald Hollenhost, with a Preface by Jacques Maritain. Chicago: University of Chicago Press, 1955.

McInerny, Ralph. "Maritain and Poetic Knowledge." *Renascence* 34, no. 14 (1982).

Pieper, Josef. *Leisure: The Basis of Culture*. Translated by Gerald Malsbury. South Bend, Ind.: St. Augustine's Press, 1998.

Plato. *The Collected Dialogues of Plato*. Edited by Edith Hamilton and Huntington Cairns. New York: Pantheon Books, 1961.

Sikora, Joseph J., S.J. *The Christian Intellect and the Mystery of Being*. The Hague: Martinus Nijhoff, 1966.

Sullivan, Sean M., T.O.R. *Maritain's Theory of Poetic Intuition*. Unpublished doctoral dissertation, University of Fribourg, Switzerland, 1963.

Thomas Aquinas, Saint. *On Being and Essence*. Translated by Armand Maurer. Toronto, Canada: Pontifical Institute of Mediaeval Studies, 1949.

————. *On the Truth of the Catholic Faith: Summa Contra Gentiles*. Book IV. Translated by Charles J. O'Neal. Garden City, N.Y.: Image Books, 1957.

————. *Summa Theologica*. Translated by the Fathers of the English Dominican Province. New York: Benziger Brothers, 1947.

SECONDARY SOURCES

Brennan, Robert Edward, O.P. *Thomistic Psychology*. New York: Macmillan, 1941.

Donceel, J. F., S.J. *Philosophical Anthropology*. New York: Sheed & Ward, 1967.

Fay, Cornelius Ryan, and Henry F. Tiblier, S.J. *Epistemology.* Milwaukee, Wis.: Bruce Publishing Company, 1967.

Gardeil, H. D., O.P. *Introduction to the Philosophy of St. Thomas Aquinas: Vol. 3. Psychology.* St. Louis, Mo.: B. Herder Book Co., 1956.

Hart, Charles Aloysius. *The Thomistic Concept of Mental Faculty.* Washington, D.C.: The Catholic University of America Press, 1930.

Hassett, Joseph D., S.J., Robert A. Mitchell, S.J., and Donald J. Monan, S.J. *The Philosophy of Human Knowing.* Westminster, Md.: Newman Press, 1953.

Hoenen, Peter, S.J. *Reality and Judgment According to St. Thomas.* Chicago: Henry Regnery, 1952.

Klubertanz, George P., S.J. *The Philosophy of Human Nature.* New York: Appleton-Century-Crofts, 1953.

O'Neill, Reginald F., S.J. *Theories of Knowledge.* Englewood Cliffs, N.J.: Prentice-Hall, 1960.

Peifer, John Frederick. *The Concept in Thomism.* New York: Bookman Associates/ The Record Press, 1952. Reprinted as *The Mystery of Knowledge.* Albany, N.Y.: Magi Books, 1964.

Phillips, R. P. *Modern Thomistic Philosophy,* vol. 1. Westminster, Md.: Newman Press, 1948.

Rader, Melvin, ed. *A Modern Book of Aesthetics.* New York: Holt, Rinehart and Winston, 1965.

Regis, L. N., O.P. *Epistemology.* New York: Macmillan, 1959.

Royce, James E., S.J. *Man and His Nature.* New York: McGraw-Hill, 1961.

Sparshott, F. E. *The Structure of Aesthetics.* Toronto: University of Toronto Press, 1963.

Van Steenbergher, Fernand. *Epistemology.* New York: Joseph F. Wagner, 1949.

Wilhelmsen, Frederick D. *Man's Knowledge of Reality.* Englewood Cliffs, N.J.: Prentice-Hall, 1965.

# Index

Eco, Umberto, 6–7
Epistemology, 4, 9–10, 36, 40–53, 77–78,
88–90, 104–19, 139–40, 153, 166–67
Études Carmélitaines, 46
Existence and the Existent (Jacques
Maritain), 47–48, 51f, 59

Favre, Jules (grandfather), 14
Favre-Maritain, Geneviève (mother), 14
Fowlie, Wallace, 13

Gallagher, Daniel, 6–7
Gallagher, Donald, 13
Gallagher, Idella, 13
Gardeil, H. D., 139
Garrigou-Lagrange, Father Reginald, 25
Gide, André, 25
Gilson, Etienne, 25
Green, Julien, 25
Griffin, John Howard, 25
Grünewald, Matthias, 76

Henrion, Father Charles, 25, 97
Holy Spirit, 133, 141, 143, 150, 152
Human knowing, 67–70
Hume, David, 29

Intuition, 5, 9, 12, 32, 36–37, 40–46,
50f3–1, 51f, 52, 56–59, 72, 89, 101,
109–10, 117, 123, 126–29, 131–32, 134–35,
137, 149, 158–59, 163, 166; and Bergson,
9, 27–32, 39

Jacob, Max, 25
Journet, Abbé Charles, 25

Kant, Immanuel, 7, 29–31, 34–36
Klubertanz, George P., 139

La Femme Pauvre (Léon Bloy), 18
Lacombe, Oliver, 25
Leisure: The Basis of Culture (Josef Pieper),
146
Lettres à Jacques Maritain (Jean Cocteau),
97
Little Brothers of Jesus, 25–26

Liturgy and Contemplation (Jacques
Maritain), 144
Lourié, Arthur, 25

Man's Approach to God (Jacques Maritain),
144
Marcel, Gabriel, 25
Maritain, Jacques, 25; and aesthetic con-
templation, 105–6, 133, 141, 144, 152–53,
161, 163; and aesthetic experience, 3–5,
9, 53–70, 88–90, 101, 112, 116, 118–19,
134, 163–67; and Bergson's influence,
27–36; and Catholicism, 1, 5, 18–20, 24,
26–27, 32–33, 150–53; and concept of
beauty, 4–6, 10, 12–13, 23, 40, 55, 57–58,
63, 67, 72–73, 79–80, 95–96, 100–102,
106, 110, 112, 116–19, 120–67; and con-
cept of creativity, 4, 12, 22, 54, 73–74,
79–80, 83–84, 96, 100, 105, 114–15,
120–22, 139, 157–59, 167; and concept
of Self, 15, 59–67, 69, 71–73, 75–77,
80, 82–84, 86, 89, 93–94, 100, 110, 158,
160, 164; and concept of Things, 59–67,
69, 72–73, 75–77, 82, 86, 89, 93, 100,
147; and connaturality, 5, 8–9, 45–49,
51f, 52, 72, 74–75, 80, 86–87, 89–90,
92–93, 105, 110–11, 133, 138, 148, 160–62;
and Divine, 25, 44, 63, 66–67, 84–85,
93–100, 107, 140, 147, 151, 156, 159–62;
and epistemology, 4, 9–10, 36, 40–53,
77–78, 88–90, 104–19, 139–40, 153,
166–67; and human knowing, 67–70;
and imitation, 99–100; and intuition,
5, 9, 12, 32, 36–37, 40–46, 50f3–1,
51f3–2, 52, 56–59, 72, 89, 101, 109–10,
117, 123, 126–29, 131–32, 134–35, 137,
149, 158–59, 163, 166; and philosophy of
art, 1–9, 26, 53–70; and philosophy of
human nature, 2–4, 9, 22, 63, 67–68,
81–82, 99, 123, 132, 138, 166; and Poetic
Contemplation, 10, 90, 96, 101–2,
118–19, 122, 133, 135, 138, 140, 149, 152,
159–67; and Poetic Knowledge, 9–10,
32, 38–39, 47–48, 51f3–2, 52, 70–93,
95, 100–101, 103–20, 127, 133–37, 140,
148, 157, 161, 166; and Poetry, 9–10,

*Poetry, Beauty, & Contemplation:*
*The Complete Aesthetics of Jacques Maritain* was
designed and typeset in Garamond by Kachergis
Book Design of Pittsboro, North Carolina. It was
printed on 55-pound Natural and bound by
Versa Press of East Peoria, Illinois.